Art and the City

Art and the City

Civic Imagination and Cultural Authority in Los Angeles

SARAH SCHRANK

PENN

University of Pennsylvania Press

Philadelphia

Published by
University of Pennsylvania Press
Philadelphia, Pennsylvania 19104-4112

Printed in the United States of America on acid-free paper

10 9 8 7 6 5 4 3 2 1

Library of Congress Cataloging-in-Publication Data

Schrank, Sarah.
 Art and the city : civic imagination and cultural authority in Los Angeles / Sarah Schrank.
 p. cm.
 Includes bibliographical references and index.
 ISBN 978-0-8122-4117-4 (alk. paper)
1. Public art—Political aspects—California—Los Angeles. 2. Art and society—California—Los Angeles. 3. Los Angeles (Calif.)—Cultural policy. I. Title.
N8845.L67S37 2008
701'.030979494—dc22

 2008012685

For Bill, Bernice, Joe, and Rachel

Contents

Introduction

One year before millions of people took to the streets to protest new federal policies mandating the criminalization of undocumented workers in the United States, Los Angeles hosted its own demonstration of anti-immigrant sentiment. In the spring of 2005 the group Save Our State called on the city of Baldwin Park, a largely Latino municipality within Los Angeles, to remove offending language from Judith Baca's public artwork *Danzas Indigenas*. Installed at the Baldwin Park Metrolink station in 1993, the piece, which resembles eroding Spanish mission archways, is inscribed with passages from Chicano literature and Native American folklore. *Danzas Indigenas* had been commissioned by the city of Baldwin Park, which asked Baca, a University of California at Los Angeles professor, nationally acclaimed public artist, and youth activist, to create a monument that reflected the different voices of its community. According to Save Our State spokesman Joseph Turner, the offending passages included "It was better before they came" and a quotation from author Gloria Anzaldúa, "This land was Mexican once, was Indian always and is, and will be again."

On May 14, 2005, members of Save Our State showed up at the Metrolink station waving American flags, carrying signs protesting "hate speech" and the "reconquista," and loudly proclaiming their support for the vigilante border patrollers known as the Minutemen. The protesters numbering around forty shouted at the largely Latino counterprotesters to "go home." Over the course of the day the protests became more heated, with more than six hundred people showing up, the vast majority in opposition to the Save Our State demonstration. Though as a precaution Baldwin Park spent $250,000 on helicopters and police overtime to protect Save Our State, no violence occurred. By the end of June, Baca and the residents of Baldwin Park had claimed victory when the city presented the artist with a written proclamation promising to keep *Danzas Indigenas* intact and protect it in the future.[1]

It is both meaningful and ironic that Save Our State, a group that had previously received national attention when it attacked a Spanish-language radio station for its billboard reading "Los Angeles, CA Mexico," would choose as its next protest site a public sculpture that had been

Figure 1. Judith F. Baca, *Danzas Indigenas*, 1993, shown here with riot police, Baldwin Park, California, May 14, 2005. © SPARC www.sparcmurals.org.

displayed in a well-traveled transportation hub for twelve years without comment or controversy. In many ways it was a poor choice. At a Metrolink art installation in Los Angeles County, where, more than any other social group, people of color, immigrants (documented or otherwise), working people, and the poor ride public transportation, Save Our State was protesting in front of passing trains filled with the most unsupportive of audiences. Save Our State organizers also clearly overlooked the fact that the city of Baldwin Park had commissioned an artwork *popular* with residents and taxpayers who resented the incursion of an outside group attempting to rile up anti-immigrant hysteria in their own neighborhood.

Though the *Danzas Indigenas* controversy is important for how it reveals the ongoing problem of xenophobia in U.S. society, it is also significant for what it tells us about the complicated relationship between art, public space, and cultural authority, the subject of this book. Public artwork and the visual arts, more generally, were part of a complex cultural and political discourse in the Los Angeles metropolitan area for the better part of the twentieth century. Daunting social issues such as

Figure 2. Detail from *Great Wall of Los Angeles* (begun in 1976) by Judith F. Baca. California's San Fernando Valley Tujunga Wash, © SPARC www.sparcmurals.org. Photograph by the author, 2003.

racism, poverty, urban renewal, and claims to public space played out in the realm of the arts, from the 1903 Municipal Art Commission's policies of urban aesthetics to Baca's "at risk" teen painters of the 1976 *Great Wall of Los Angeles*. For the commission, led by businesspeople and Hollywood elites, deploying aesthetics as a political tool was a means to preserve its members' social status in the face of urban growth and articulate a civic vision of the city as exclusively white and well heeled. For Baca, 1970s murals in Los Angeles challenged the civic and political invisibility of different cultural groups who, while demographically significant, lacked socioeconomic power. When Save Our State chose *Danzas Indigenas* to make a political statement using a modern art installation, it entered into a historic discourse with deep roots in the city. That it failed in its agenda in the face of an even larger counterprotest is not surprising, given the fraught political nature of art in Los Angeles.

Art and the City chronicles this story of public art and municipal politics. In doing so, it examines the lesser-known history of visual culture

in Los Angeles prior to the era of protest art in 1970s southern Califor-
nia. That period, characterized by Judith Baca's *Great Wall* project, Los
Four, the Compton Communicative Arts Academy, Judy Chicago's *Wom-
anhouse,* and others, represented a sea change in civic art discourse, a
change that, as this book demonstrates, built over the course of the
twentieth century. Moreover, in its focus on Los Angeles, *Art and the City*
demonstrates the centrality of public art in shaping the contours of
urban culture. Indeed, this same story could be told in other cities, such
as Chicago, Philadelphia, and New York. In Los Angeles, however, artists
such as Judson Powell or Judith Baca not only had to fight against racial
and gender prejudice, but they also created art in a city with an enor-
mous historical investment in controlling its visual imagery. In Los
Angeles, because art played such a significant role in how civic leaders
imagined their city, public art controversies, especially those focused on
questions of modernism, galvanized civic debate and municipal and
county politics for the better part of fifty years. *Art and the City* tells how
art became a tool of elite boosters and other social groups competing
for space and representation in an emergent metropolis.

Carved out of the desert to function as an irrigated urban paradise,
Los Angeles was expensive to build, and investors wanted assurance that
they had not misplaced their money. With no useful natural harbor and
with commercially lucrative crops still in the future, the Mexican ranch-
ing town was in need of a hard sell, and boosterism became the local
export. Thus, the first civic art of Los Angeles was found in the promo-
tional imagery painted on trains, printed on Chamber of Commerce
propaganda, and slapped on produce crates to eventually become color-
ful, collectible ephemera. The promise of these images proved inade-
quate to attract enough middle-class residents, however, and early civic
leaders felt that the city's landscape needed to look more like the pic-
tures for their city to grow. Thus the Municipal Art Commission, one of
the first government bodies of its kind in the United States dedicated
solely to urban aesthetics, was born in 1903. With its purpose to make
reality match the civic imagination, literally to create an "official" urban
aesthetic, a snug relationship between visual culture and capital invest-
ment developed. This relationship profoundly affected how civic iden-
tity evolved in Los Angeles and how artists formed creative communities
in which to practice and promote their craft. Over the next century, art
would serve as both booster tool and booster foil as control over the civic
culture of Los Angeles was never certain.[2]

As obsessed with civic identity as Los Angeles may be, it is a city whose
popular notoriety lies in its dark tales of corruption, false promises,
smoggy sun, and relished artifice. In contemporary urban scholarship,
Los Angeles is both celebrated for its postmodern eclecticism and criti-

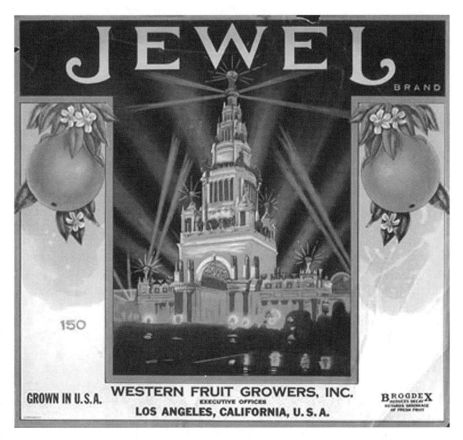

Figure 3. Crate label, ca. 1920s. Collection of the author.

cized for a historical amnesia that stands to erase legacies of social strug-
gle and community building.[3] It is a city that has lost a river, misplaced
a mass transit system, and razed, removed, and rebuilt entire neighbor-
hoods. A native Mexican population has been recast as a foreign inter-
loper. A history of colonialism, bloody conquest, and land appropriation
has been reincarnated as whitewashed Spanish revival architecture, visi-
ble in the omnipresent red tile roof.[4] The visual vocabulary of Los
Angeles also stands out from that of other cities because of the signifi-
cant influence of the film industry. Due to these filmic versions of the
city, people often feel they know Los Angeles in a way that they do not
other cities, even if they have never been there. In Los Angeles, as the
historian Dolores Hayden has so aptly put it, "the sense of civic identity
that shared history can convey is missing."[5]

Thus, for all the early efforts to forge a visually based civic identity, Los Angeles was known for lacking civic institutions, or any civic culture at all, a situation that corporate interests have attempted to rectify. Until 1965, when the Los Angeles County Museum of Art opened in Hancock Park, along with the Music Center including the Dorothy Chandler Pavilion (1964) and then Ahmanson Theater (1967) and Mark Taper Forum (1967), there was little beyond the original County Museum of History, Science, and Art in Exposition Park to lend the city much-desired cultural status equal to that of the country's cosmopolitan centers. The founding of the Los Angeles Museum of Contemporary Art (MOCA) in 1979 and its opening in 1986 established a civic cultural stronghold in a downtown that had galvanized elite urban development efforts early in the century.[6] The opening of the Richard Meier-designed Getty Museum and Research Institute (1997) and Frank Gehry's Walt Disney Concert Hall (2003) helped round out the art and music offerings, adding space and prestige to civic cultural projects begun in the 1960s. With its star-studded architectural prowess, Los Angeles is now, according to press releases, a "World City," with civic culture that "will celebrate the diverse cultural traditions reflected in the Los Angeles population and welcome the community at large."[7]

It is significant, if ironic, that this recent civic cultural explosion represents a continuation of the projects begun just as Los Angeles attracted worldwide attention as the host of one of the worst civil uprisings in American history, the Watts riot of August 1965. The week of burning, looting, arrests, and shootings, with broadcast images of the National Guard in the streets of south Los Angeles, ushered in an era of urban uprisings in the United States and forever dimmed the city's image. In response, the city and county of Los Angeles turned to cultural institutions to restore media-friendly representations of civic stability. Shortly thereafter the Los Angeles County Museum of Art opened on Wilshire Boulevard, and construction continued on the downtown Music Center. In 1971 John Paul Getty's Roman-styled villa opened as a privately endowed art museum in Pacific Palisades, free to the public. The latest crop of major civic culture institutions adds to new international trends in the "super civic," by which major cities hope to mark their position in the global marketplace with the tourist troika of a Frank Gehry building, an aquarium, and a Holocaust memorial. The immensely popular reopening of the Getty villa in 2005 after years of renovation and retro-fitting represents an emblematic return to the civic boosterism of an earlier period. Its ancient architectural stylings above sand and ocean reach backward toward a fantasy past marked by antiquity, premodern ruins, and art as an uncontested display of wealth and power. This disturbing turn in Los Angeles' long saga of articulating civic identity both reflects

and contributes to an equally long and conflict-filled relationship with artistic modernism.

"Modernism" can mean many different things to different people depending on context. In this book "modernism" and "modern" generally refer to two distinct discourses: that of artistic modernism in the twentieth-century United States and Europe, and that of a political discourse surrounding abstract art, social programs such as public housing and public art, and urban growth and development in post–World War II Los Angeles. For many readers, this may seem an awkward and arbitrary set of definitions, given art history's marking of modernism's origins with the self-reflexive and political art following the French Revolution and the urban explorations and anxious repulsions of mid-nineteenth-century impressionism or, in the American context, anything painted or sculpted in New York after World War II.[8] My definitions also might seem unnecessarily narrow given the broad parameters of the cultural and social theory that the critic Marshall Berman, for example, lovingly deploys to define "modernism" as a confusing maelstrom against which we "struggle to make ourselves at home in a constantly changing world."[9] I have tried to narrow the scope of "modernism" because the subjects of my study—artists, art enthusiasts, politicians, and local residents—often articulated personal and quite specific meanings of the term that were expressed in ways that might be characterized on the one hand as progressive, inclusive, and creative or, on the other, as retrograde, resistant to change, and intolerant. In Los Angeles' local political context, "modernism" could have been a reference to Russian expressionism, American abstract expressionism, pop art, jazz, freeways, Jews, African Americans, sexuality, urban renewal, or a public housing project. "Modernism" could have been wielded as a weapon with which to red-bait artists in early 1950s Los Angeles, or it might have be worn as a legitimate mantle of progress by architects and planners who sought socially attuned projects that would make housing affordable for everyone.[10] The term might also include urban projects that displaced, relocated, and destroyed neighborhoods in the name of renewal and redevelopment. In *Art and the City*, "modernism" refers to schools and styles of twentieth-century art as well as programs for social, cultural, and urban development.

Major studies of modern art in Los Angeles focus on the post–World War II era, with a few notable exceptions.[11] Cécile Whiting's work is perhaps the most provocative, arguing that pop artists contributed in important ways to Los Angeles' "urban identity as an emerging art center while avoiding the clichés of either the city's boosters or its detractors."[12] My work offers an alternate interpretation suggesting that rather than sidestepping clichés about the city, pop fit perfectly into early

twentieth-century booster claims of Los Angeles as a city of prosperity, leisure, and endless consumer possibility. Pop was perfectly poised for appropriation by elite art collectors and business interests as it neither challenged nor competed with traditional representations of the city. The more interesting question is: What happens when we posit Los Angeles' emergence as the nation's "Second Art City" within the context of a long history of rejecting modern art as part of its civic identity rather than viewing it as the inevitable outcome of a pop-culture- savvy metropolis? That contemporary art was to be claimed in the 1960s as representative of the city speaks less to how artists depicted Los Angeles' urban identity than to what broader sociopolitical transformation had taken place to make the modern, even the postmodern, acceptable. Had the civic undergone a remarkable transformation by the 1960s, or had modern art ceased to function politically in the way it had in the city for decades?

Art and the City owes much to the generative labor of scholars such as Lawrence Weschler, David James, Kevin Starr, and Victoria Dailey for establishing the extent of modernism's eclecticism in Los Angeles before World War II, and yet it diverges somewhat as the story herein does not always support their contention of the radical nature of the modern in Los Angeles.[13] Here, the art itself was secondary to the struggle to exhibit it. In essence, this book argues that modern art, and the public discourse surrounding it from approximately 1903, when the Municipal Art Commission was formed, through the late 1960s, when the emergence of vocal and visible ethnic and feminist protest art radically changed the role of art in local politics, served as an elastic and exceedingly useful tool for diverse social groups intent on defining (or subverting) the city's civic culture. As Los Angeles grew in geographic size, economic power, and demographic diversity, art became an increasingly volatile site for public debate over what kind of city Los Angeles would be and who would control its cultural terrain.

Chapter 1 examines the simultaneous development of the promotional civic arts movement and the modern arts community in the first two decades of the twentieth century. While the California Art Club, Artland, and other elite organizations promoted a vision of an urbane, art-based city with both traditional Edenic aesthetics and sophisticated cultural taste, politically progressive modernists worked in tandem with iconoclasts such as Aline Barnsdall while negotiating for exhibition space and a stake in the city's civic identity. As dominant as booster images of the city were in the first decades of the twentieth century, inclusive modernist visions shadowed them.

Chapter 2 examines the emergence of a visible public modernism in the 1930s. This chapter focuses on the Mexican muralist David Alfaro

Siqueiros's theory of painting and its implementation on the walls of the city. I examine Siqueiros's predeportation celebrity in Los Angeles, complicating any sharp break between provincial antimodernist political players and liberal advocates for a revitalized civic art culture by showing how both groups loved having him there. Although Siqueiros's Communist politics would force him out of the United States, his six-month stint heralded the beginning of the popular front in Los Angeles and created a space for nonwhite, ethnic, and modernist artists to show their work; the 1930s saw the city's first African American museum and gallery shows. This is also the era when Hollywood became increasingly involved in public art, manifesting two different impulses: one toward building what the cultural historian Michael Denning calls a "Hollywood Popular Front," and the other uniting Hollywood money with elite civic cultural projects.

Chapter 3 examines how the federal government's deployment of the American avant-garde during the cold war played out locally in surprising ways. While the red-baiting in Los Angeles, especially with regard to the Hollywood Ten, was intimately connected to McCarthyism at the national level, anxieties about the aesthetics of locally produced art and communist influences in the municipal government led to the closing of public art spaces in the city. In the immediate postwar period, art was the tool not of civic culture advocates but of conservatives attacking modernism as a harbinger of progressive, multiracial, and socialist urban policies.

Chapter 4 chronicles the emergence of the Venice Beach and West Hollywood art culture in postwar Los Angeles. Contrary to popular notions that the city's bohemian scene grew out of a sudden and isolated burst of creative energy, these communities grew out of self-conscious efforts on the part of Los Angeles' young avant-garde to market their work as part of a cool, masculine southern California lifestyle typified by custom cars, surfing, and sex. At the same time, other artists such as Wallace Berman and Ed Kienholz had to work extremely hard to make creative use of the few urban spaces afforded them. Dank Venice apartments, vacant theaters, the back rooms of antique stores, and underground journals proved the only sites available during the late 1950s era of strict municipal surveillance of public art space. Even those who later became the darlings of American art criticism were in constant negotiation with the city to exhibit and sell their work. While *Life* and *Look* magazines publicized Venice Beach bohemians and the national art press celebrated the newly revitalized art scene, the city of Los Angeles planted undercover police officers in galleries and curtailed the arts by passing restrictive ordinances against late-night poetry readings and bongo drumming on the beach.

Chapter 5 explores the complicated relationship between the Watts Towers' preservationists, the surrounding neighborhood, and the municipal government. Created by the Italian immigrant Sabato Rodia over a thirty-three year period, the Watts Towers are located historically and geographically at the nexus of the city's suburban promise and socioeconomic failure. Once seen by thousands of daily train commuters, the towers faded from the landscape as new freeway routes and rapid economic decline in the 1950s contributed to Los Angeles' "urban erasure."[14] As automobiles replaced trains and trolleys, the towers and the neighborhood disappeared from the city's popular consciousness. This presumably vanished artwork proceeded to morph over fifty years from an Italian immigrant's backyard fantasy to an iconic symbol of American blackness and a politically fraught civic landmark. In the struggle to render them visible to a local as well as an international public, the towers have become an important tool in understanding Los Angeles conflicts over civic identity, the city's politics of race and representation, and the significance of art in an often-avoided neighborhood.

Art and the City reveals that a broader public than previously appreciated—one representing diverse ethnic, economic, and political groups—participated in the debates over the meanings of art and civic identity in twentieth-century Los Angeles. This population is not included in the municipal or county government, the social elite, or art colonies and is difficult to research. It includes people who wrote letters to City Hall or the newspapers lauding or despising a particular artwork, anyone who picketed Los Angeles' museums, and those who tried to organize an arts and cultural center in a poor neighborhood. Personal letters to the city council were especially revealing, as were hearing transcripts and memoranda from city council files housed in the Los Angeles City Archives. As readers will find, I relied significantly on newspapers and art journals for accounts of art controversies and Los Angeles' role in national conversations about art, culture, and urban growth. While these sources are not always factually accurate and certainly are not objective accounts of historical events, for most Americans, art and the conversations and controversies it generates exist in the press. If newspapers and art journals did not talk about art shows, museum exhibitions, exorbitant amounts paid for incomprehensibly simple paintings, and the line between sexuality and obscenity, few would know anything about art at all. This is true now, and it was true in Los Angeles throughout the twentieth century. Thus, the newspapers and the art press played an important role in making art a significant part of the civic imagination and in articulating the hopes and fears Angelenos held for their city.

The critic Rosalyn Deutsche has claimed that "the city is art's habitat."[15] Art and artists affect, and benefit from, the political economy of

place, while cities provide art's audience and patronage. It could be suggested that in Los Angeles the visual arts form the city's habitat: art offers a site for political, ideological, and territorial struggles that have few other spaces in which to play out. Using the visual arts as civic space is critical in a city that delights in motion and transition at the expense of history and collective memory.[16]

Boosters, Early Moderns, and the Artful Civic Imaginary

The seeds of Los Angeles' postwar modern art conflicts were planted in the early twentieth century when the visual arts, in the form of painting and commercially produced prints, were deployed by booster engines such as the Los Angeles Chamber of Commerce, the Civic Bureau of Music and Art of Los Angeles County, the *Los Angeles Times*, the Sunkist marketing cooperative, and the Municipal Art Commission to sell the city and the surrounding region. Early in the city's promotional history, art, both in its physical form as paint on canvas and as a conceptual product of cultural capital, became politically and economically useful in creating specific images of Los Angeles and articulating its future as fruitful, ever growing, and prosperous.[1] The civic and the artistic were thus carefully linked in the political history of the city, and in efforts to please aesthetically and never offend, leaders of the civic arts movement preferred traditional visual forms over those of emergent modernists. This meant that painting and sculpture, especially any that represented the city or county in museums or other public art displays, would be placed under a scrutiny that other cultural forms were not as they fell outside the interests and strategies of the Los Angeles growth machine.

As civic interests controlled the institutions in which art was shown to the public, it was possible to limit the growth of a public modernism. The Fine Arts League, founded in 1906, was commissioned by the Los Angeles County Board of Supervisors to build a collection and oversee the classification of traditional artworks for the public. Within a few short years, major fallings-out took place between the Fine Arts League membership and the Board of Governors of the new County Museum of History, Science, and Art, leading to the resignation of the League's chairwoman, thereby beginning a long history of internal administrative battles between art staff and museum officials.[2] With a decrepit art department from the start, the new museum, which opened in 1913, was soon notorious for its exclusive and stodgy exhibitions. In a 1928 review the best that Arthur Millier, the *Los Angeles Times* art critic from 1926 to

1958, could write was that while the museum "let through a few scraps of meaningless 'modernism' it must be congratulated on the clean sweep it made of dull artless pictures."[3] Artists working outside mainstream forms struggled for space in the city, and the building of a museum or art center conducive to contemporary and experimental work became a long-term and hard-fought-for goal.

Los Angeles emerged as a city with conflicted and contradictory art interests from the beginning: an emergent modern arts culture was forced to function independently of civic support at precisely the same time that boosters spent inordinate amounts of energy promoting the region as an art center and soliciting funds to institutionalize highbrow culture. Newspaper, real estate, agribusiness, and retail interests called for a "high art" that often resembled commercial imagery and their own marketing strategies. Los Angeles was both a city and a county, a metropolis and an extensive agricultural area. Thus, regional promotion and artful aspiration became entwined, as in a 1927 Civic Bureau of Music and Art of Los Angeles County survey: "Splendor of landscape and charm of climate always have inspired man to eloquence in art. This is the eloquence born of happiness. The work of artists done under joyful living conditions in an inspiring environment, breathes joy and success. . . . One must be convinced that Los Angeles county is the center of a vigorous art culture, which is broadening and enriching the lives of her citizens and is destined to add worthy records to the history of the spirit of man."[4]

The effect of such marketing hyperbole was to depict Los Angeles as an artistic and cultural backwater at the same time that the visual arts became central to local political debate and scrutiny. Modern works, especially abstract painting and nonrepresentational sculpture, became controversial vessels for political discourse and territorial struggles for claims to the city in the post–World War II period. Ironically, the artists involved rarely had political intentions in producing their work, but abstractionist forms of modernism, lending themselves to multiple interpretations, were easily plucked up and made the subjects of local political battles concerning race and representation, public housing, and urban renewal, among other issues. Clues as to why modern art would play such a marked role in municipal politics in the mid-twentieth century lie in its strategic marginality in the early 1900s.

The marginality of modernist painting marked a sharp contrast to the success of other contemporary arts. Early twentieth-century Los Angeles was, in fact, a healthy place for the avant-garde in the fields of architecture, photography, and film. The success of major modernists such as Irving Gill, Frank Lloyd Wright and his son, Lloyd, Richard Neutra, Rudolph Schindler, Edward Weston, Edmund Teske, and Sergei Eise-

nstein in Los Angeles have been well documented, establishing that this
creative community was supported enough by the surrounding culture
industry to allow it to innovate and flourish up to and through World
War II.[5] Aline Barnsdall, a wealthy philanthropist and supporter of mod-
ern theater, dance, and architecture, moved to Los Angeles in 1919, hir-
ing Frank Lloyd Wright to design her a home and an art and cultural
center to share with the city. Given that Los Angeles was at the forefront
of new visual technologies because of Hollywood's film innovations, new
artist-created set designs, and recently formed communities of immi-
grant talent, it would seem natural that modern painting and sculpture
would receive similar support. Modern art, however, fared less well in
developing a base with the kind of public support received by architects
and filmmakers in the same period.

This is not to say that there were no modern artists or modern art in
Los Angeles.[6] Peter Plagens's frenzied assertion that "Los Angeles'
important art appeared only after the city suffused itself in smog and
trash architecture," while still holding firm in some circles, obscures an
interesting and eclectic art history of early California and Los Angeles
modernism.[7] By 1915 the effects of New York's 1913 Armory Show had
spread west and were felt at the massive exhibition at the Panama-Pacific
International Exposition in San Francisco. While this show was no mod-
ernist equivalent to that of the Armory (the exposition exhibited mostly
conservative contemporary painting from California and the broader
United States), it did feature several dozen examples of French and
American impressionism and postimpressionism, as well as forty-nine
futurist paintings from Italy never shown at the Armory.[8]

The well-attended northern California exhibit prompted Los Angeles
artists to develop a more organized modern art scene at home. In 1916
several artists, including Bert and Meta Cressey, former Robert Henri
students who worked with the Ashcan school master in New York,
formed the Los Angeles Modern Art Society. According to *California
Graphic*, the core members included the Cresseys, Helena Dunlap, Edgar
Kellar, Henrietta Shore, and Karl Yens. The Modern Art Society
eschewed the popular jury system, preferring to let each member and
invited artist choose his or her own entry.[9] This was not only a more
democratic way of running an exhibit; it also proved to be a strategic
way to avoid the traditional art mission of the California Art Club,
founded in 1909, which mandated the large juried annuals held at the
county museum and, later, at Barnsdall Art Park.[10] The club, the largest
in Los Angeles, promoted landscape and representational painting, cre-
ating forums and meeting spaces for classically trained artists. With
membership lists that included the business elite and proponents of
major civic enterprises, at its high point the California Art Club unilater-

ally controlled much of the exhibition space in the city and the county, restricting the showing of contemporary avant-garde work for the better part of the 1910s and 1920s. In an era before the city had an art museum or more than a couple major collectors, art clubs made up of professional and amateur artists, patrons, and businessmen were the only artistic cultural arenas. They functioned much like salons, with regularly scheduled gatherings to hear invited lecturers, present art exhibitions, study art history, and discuss local politics and civic projects.[11] The Los Angeles Modern Art Society's first show attracted seven hundred visitors, but by 1919 the group had absorbed new members and renamed itself the California Progressive Group, hosting its only exhibit that same year at Los Angeles' Lafayette Tea Room.[12] Though the group was short-lived, the formation of the Modern Art Society spoke to local interest in the questions and contexts raised by the European schools of modernism.

The best-known modern painter in Los Angeles in the 1910s and 1920s was Stanton Macdonald-Wright, who earned international recognition for synchromism, an abstractionist form deploying some of the color and painterly techniques of traditional Asian artwork. Synchromism is considered part of the canon of European modernism, merging cubist fragmentation with the bright colors of the fauves.[13] Macdonald-Wright studied in Paris, returning to the United States in 1918, and his influence in Los Angeles was certainly felt. When modernists had trouble getting into county museum shows, Macdonald-Wright helped to rectify the situation by organizing an exhibit there in 1920, in what has been described as an "unprecedented" appearance of moderns including Man Ray, Arthur Dove, Joseph Stella, and Thomas Hart Benton.[14] Macdonald-Wright wrote years later that the 1920 modernist show was the "cause of a near riot" but that it did excite interest in the challenging contemporary art of the era.[15] In fact, the American modernists show was well received by the press, if not particularly well understood. The *Times* art critic Antony Anderson found many of the paintings quite beautiful and highly recommended the show but admitted "that I understood very little of what I looked at. I had inklings, glimpses, small flashes of meaning-but that was all. I am still in the dark as to what it's all about, though Stanton Macdonald-Wright made earnest efforts to enlighten me."[16]

In 1922, Macdonald-Wright became the director of the Art Students League of Los Angeles and taught at the newly opened Chouinard Art Institute, introducing a new generation of artists, including some women, to modernist forms and ideas, as well as elements of Eastern religion, culture, and spirituality. Macdonald-Wright worked with Mabel Alvarez, who also became a noted modern. Alvarez was based in Los Angeles, a practitioner of yoga from the 1920s forward, and an impor-

Figure 4. Stanton Macdonald-Wright, *Synchromy in Purple*, late 1918–early 1919. Los Angeles County Museum of Art, Los Angeles County Fund. Photograph © 2006 Museum Associates/LACMA.

Figure 5. Mabel Alvarez, *Dream of Youth*, 1925. Courtesy of Glenn Bassett, Mabel Alvarez Estate.

tant experimenter with modernist canonical forms such as art nouveau and symbolism. One of her best-known works, *Dream of Youth*, incorporated these themes, showing muted lines and colors with women's bodies in meditative poses.[17]

Major collectors of modern art were few in early twentieth-century Los

Angeles. The Huntingtons, one of the wealthiest families in the city and donors of The Huntington Library and Art Galleries, were primarily collectors of rare books and eighteenth-century English portraiture—Arabella Huntington purchased major works of French decorative art, adding Italian and Flemish classical works to their collection before her death in 1924.[18] William Preston Harrison, the son of five-time mayor of Chicago Carter Harrison, was another wealthy collector with initially little interest in the avant-garde, though he later cultivated a taste for contemporary and American work. Harrison and his wife started collecting native objects and artifacts from the South Pacific in the first decade of the twentieth century but turned to American painters, many of whom had held shows at the Art Institute of Chicago.

The Harrisons soon became important donors to the new county museum, presenting museum director Frank Daggett with twenty-eight American works in 1918.[19] Among these were the moderns George Bellows and Leon Kroll, as well as American impressionist Charles Davis.[20] When Stanton Macdonald-Wright staged the American modernist show at the museum in February 1920, the Harrisons refrained from purchasing any of the works on display, seeming to share the hesitant praise of the local art critics. When Harrison did eventually purchase a work by a local artist, it was a painting by William Wendt, the only National Academy painter in the city.[21] Though William Preston Harrison started as an investor and collected what he thought would make him money, he and his wife soon became respected supporters of civic culture and the arts, contributing small sums annually to the California Art Club and, more importantly, endowing several galleries at the county museum. The Harrisons were certainly not vitriolic antimodernists. *California Graphic* reported that Harrison actually had modern works ("flat, vivid coloring and studied distortions") on the walls of his house; indeed the writer was somewhat startled that the collector held "sympathy with those earnest workers who may be developing the Art of tomorrow."[22] In 1926 the Harrisons donated their collection of French early moderns, a group of works that included eighty-six drawings and paintings by major artists such as André Derain, Raoul Dufy, Camille Pissarro, Rodin, and Paul Signac.[23] The accompanying exhibition was well received by the press despite occasional complaints that the works were "insane and revolting" and dismay that American artists were eclipsed by Europeans.[24]

Despite the energies of the Harrisons, in the 1920s the only significant collectors of contemporary modernism were the Arensbergs and Galka Scheyer. Walter and Louise Arensberg, a Massachusetts couple with vast amounts of family money made in textiles and metal, began collecting after visiting the Armory show. They moved to New York City in 1914 and for the next seven years collected over seventy works of Russian,

European (mostly French), and American avant-garde artists.[25] The Arensbergs became friends with many of them, fostering a particularly close relationship with Marcel Duchamp. In 1921 they moved to Los Angeles, where they continued collecting, lending their artwork to museums, and serving as modern-art educators. Earl Stendahl, owner of one of the most prominent galleries in the city, confessed that he learned about the moderns, and their value, directly from the Arensbergs.[26] Because of the dearth of public exhibition space, the Arensbergs generously allowed most visitors to their home to view and study the collection. They extended hospitality to the European intelligentsia arriving in Los Angeles between the wars, and their Hollywood Hills home was a main destination for modernists such as Oscar Fischinger and Edward Weston.[27] The couple played active roles in many local art associations in the 1930s and the 1940s. In the mid-1940s they tried to give the collection first to the county museum and then when that institution declined the terms of the donation, to the University of California, Los Angeles with the stipulation that an appropriate museum would be built after the war. It was not and the city lost the single best modern art collection in the United States to the Philadelphia Museum of Art in 1950.

The Arensbergs were by far the dominant modern art collectors in Los Angeles, but a close colleague of theirs deserves attention. In the mid-1920s, the German immigrant and private dealer Galka Scheyer brought with her to America works by her contracted artists Alexei Jawlensky, Paul Klee, Wassily Kandinsky, and Lyonel Feininger, known collectively as the "Blue Four." Scheyer traveled a lecture circuit with the paintings, hoping to move product for her clients. The first exhibit was held in New York in 1925, and the works made it to Los Angeles in the fall of 1926. There, the show was well received by the critic Arthur Millier, who delighted, however, in reporting how much the public disliked it. Two local women, students of art and music, found the show "disgusting" and a reminder "of crawling things-of worms, of things moldering in the ground. Ugh! It was awful." Millier gently reminded his readers, "There is much that is beautiful and much aesthetic pioneering in the work . . . but it runs so counter to most of our preconceived notions of art that we have to search for it."[28] In Los Angeles, Scheyer organized other Blue Four shows for the Hollywood art dealer Harry Braxton, cosponsored by the film director and modern art collector Josef von Sternberg. The outbreak of the war meant that Scheyer would stay in the United States, and she lived the rest of her life in a Richard Neutra–designed home in the Hollywood Hills.[29] Like the Arensbergs, Scheyer tried to give her collection to UCLA on the condition that a suitable building be erected for its display. The building did not materialize and the collection was dismantled for sale, with 450 paintings going to the

permanent collection of the Pasadena Art Institute, now the Norton Simon Museum.[30] Overall the 1920s in Los Angeles constituted a meager period for serious art collecting, especially that of the contemporary avant-garde. Circumstances would change in the 1930s, when Hollywood became an important player in local art culture, supporting modernists from abroad and also beginning to collect local work.

Far more than in the museums or galleries, Los Angeles' modernist discourse took place within the institutional infrastructure of the art schools. It was as teachers and students that artists in Los Angeles developed and discussed their craft. The first institution to have far-reaching effects on modern art in southern California was the Art Students League of Los Angeles, which had been founded by Hanson Duvall Puthuff in 1906.[31] Its faculty included Stanton Macdonald-Wright and Rex Slinkard. Art Students League members and affiliates formed the Group of Independents, who held their seminal show in the winter of 1923, boldly issuing a manifesto featured in the *Los Angeles Times* "Of Art and Artists" section. Breaking with the landscape-nature "Eucalyptus School" so dominant in the region, Boris Deutsch, Max Reno, Peter Krasnow, Nick Brigante, and Ben Berlin sought "to bring together experimental and creative artists and, by holding frequent exhibitions of their work, afford opportunity to the public to follow the progress made in the field of artistic research. . . . The group maintains that artistic manifestations such as Cubism, Dynamism, and Expressionism are sincere intellectual efforts to obtain a clearer aesthetic vision. . . . The apparent preference in the past, for dead form, is not so much a preference arising from free selection as a habit due to the fact that any new work of an evolutionary character has been refused to exhibitions and thereby withheld from public view."[32] The Group of Independents understood perfectly well the problem inherent in the city's cultural infrastructure; this notorious exhibition was not held at the Los Angeles County Museum but the MacDowell Club, a smaller venue with a built-in art audience.

Following the Art Students League were the Otis Art Institute (founded in 1918) and Chouinard Art Institute (founded in 1921), which emerged as the two major institutions for the fostering and development of commercial, fine, and contemporary arts in the city.[33] Otis was established by the owner of the *Los Angeles Times*, Gen. Harrison Gray Otis, who gave his house and the surrounding grounds to the people of Los Angeles County. The deed from January 29, 1917, specified that Otis's boosterish goal in donating the property was the promotion of the fine arts in Los Angeles. In a letter to the Los Angeles County Board of Supervisors, General Otis stated specifically that he hoped "to make the place ultimately a popular resort and center where art loan

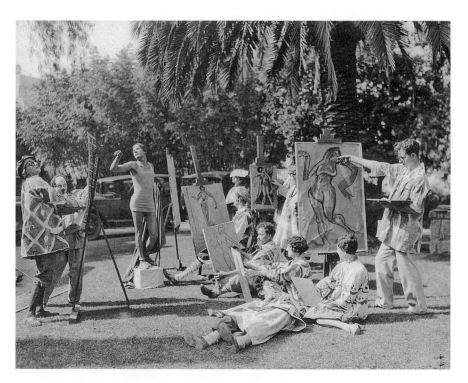

Figure 6. Painting at Otis Art Institute, n.d. Security Pacific Collection / Los Angeles Public Library.

exhibits may be held and artists may freely congregate."[34] Many of the faculty members were classically trained academic painters, traditional in their aesthetic tastes and teachings. Others were drawn from innovative programs around the country, such as those found at the Art Institute of Chicago and Pratt, in Brooklyn, New York.[35] The Otis Art Institute, run by the County Board of Supervisors and affiliated with the County Museum of History, Science, and Art, would become one of the largest art schools in southern California. After the war, Otis became a more conducive environment for modernist experimentation. Peter Voulkos, one of the school's most famous faculty members, established the Ceramic Center at Otis in 1954, making a critical educational site for experimental sculpture and pottery.

One Otis faculty member, Nelbert Murphy Chouinard, an instructor of art history and former Pratt student, was particularly popular with students. Unhappy with the crowdedness at Otis, her class, many of whom were World War I vets, encouraged her to start her own art school. In

1921, together with another Otis teacher, F. Tolles Chamberlin, she did, establishing art classes temporarily in a house in downtown Los Angeles at 2606 West Eighth Street.[36] Eventually the school would have more permanent lodging in a new building on Grand View Street, near MacArthur Park. Within two years it had grown from 35 students to 180.[37] When the veteran enrollment declined, Chouinard started a scholarship program to attract new students. The early recipients made up an impressive roster of now-renowned Los Angeles talent including Phil Dike, Herb Jepson, and Millard Sheets (who had gone on to become one of the most prolific muralists in the region).[38]

Hollywood created a boon for trained commercial artists, and by the mid-1920s Chouinard was offering entire programs in the commercial arts, including advertising design, fashion illustration, interior decorating, and lettering.[39] Walt Disney began sending young illustrators to Chouinard in 1929 for professional training, and by the early 1930s Chouinard had become a major school for fashion and costume design, producing prominent film industry designers such as Oscar-winner Edith Head.[40] Instruction from prominent modernists such as Hans Hofmann, Macdonald-Wright and briefly in 1932 the Mexican muralist David Alfaro Siqueiros made the growing art school a protective haven for modern experimentation and professional training. With such a notable faculty and eclectic educational programs, Chouinard became a widely respected art school. Many of the postwar artists who would make Los Angeles an international center for pop art attended Chouinard, remembering it as an extraordinarily creative bohemian enclave. In 1961, in a controversial and hotly disputed move orchestrated by Walt and Roy Disney, the Los Angeles Conservatory of Music and Chouinard Art Institute merged to create California Institute of the Arts (CalArts). In 1971, CalArts opened its doors in Valencia, California, where it remains one of the nation's top art schools.

Despite these centers of active modernism, the lack of public exhibition space meant that modern art was lost amid the landscape painting and commercial imagery typical of the region, and southern California's arts scene became an inside joke for the American literati. In 1935 M. F. K. Fisher scathingly described the Laguna Beach colony, a beachside artists' community featuring painting classes for tourists: "They paint as they did those years gone, trees and rocks and an old mission in a garden."[41] Not until the final chapter of *Southern California Country* does Carey McWilliams, in his classic 1946 study of Los Angeles' storied dialectic between environmental artifice and cosmopolitan promise, turn briefly to the role of artists in the region's cultural history. Almost as an editorial afterthought, McWilliams suggests that the one social group who ought properly to see Los Angeles and its surroundings

seemed to have the most trouble doing so: "One can imagine hundreds of these early Southern California landscapes of sunlight flickering though eucalyptus groves, of the flush that swiftly passes over the mountains before the sun falls into the sea, and recognize nothing except the strenuous, largely futile, forced effort that went into the attempt to picture a scene not yet familiar."[42]

Brought west by the railroads in the 1880s to produce promotional imagery published in brochures and travel guides, painters such as George Burgess, Ferdinand Lungren, and James Madison Alden produced colorful and attractive representations of a region that belied traditionally accepted standards of the American sublime. Chaparral, dry arroyos, and constantly shedding eucalyptus trees cast under an overly brilliant sky fascinated artists at the same time that these features made realistic landscape painting a difficult task. Regional landscape painting was driven to dominance by the constant demands of a booster machine that used the images to fuel the 1880s real estate boom and continue attracting white upper-class settlers and new-age health seekers into the next decades. The advertising crowed loudly that "the Los Angeles of today is confessedly one of the most beautiful cities in America—and it grows more beautiful everyday."[43] Harrison Gray Otis's *Los Angeles Times* and Charles Fletcher Lummis's *Land of Sunshine* sought promotional painters and sketch artists to back these claims, and artists needed exposure and showcases for their work. Thus, Maynard Dixon, one of California's best-known cowboy-and-Indian painters, got his professional start when Lummis published his sketches and watercolor landscapes in a December 1898 issue of the well-known journal celebrating the American West.[44] Herman Hansen's similar works were widely circulated during the same period while he was working for the Crocker Lithograph Company in San Francisco. Elite art clubs such as the Ruskin, the Society of Fine Arts, and the Fine Arts League promoted specific artists, encouraged art collecting, and raised money to attract exhibitions and painters to the city. They did this so successfully that the famed French watercolorist Paul de Longpré settled in Hollywood in 1898. Years ahead of the first movie studios and film stars, de Longpré became a major celebrity as the "king of the flower painters," attracting huge crowds in the tens of thousands to his estate's extensive gardens and annual exhibits of his floral still life watercolors.[45] He was nineteenth-century Los Angeles' Thomas Kinkade. Landscape paintings were also produced for the high-end tourist industry. By the turn of the century hotels including the Biltmore, the Ambassador and the Beverly Hills all had art galleries.[46] As much as art was part of elite cultural status in turn-of-the-century Los Angeles, it was fundamentally connected to promotional commerce.

These images of romanticized landscapes were reinforced in the

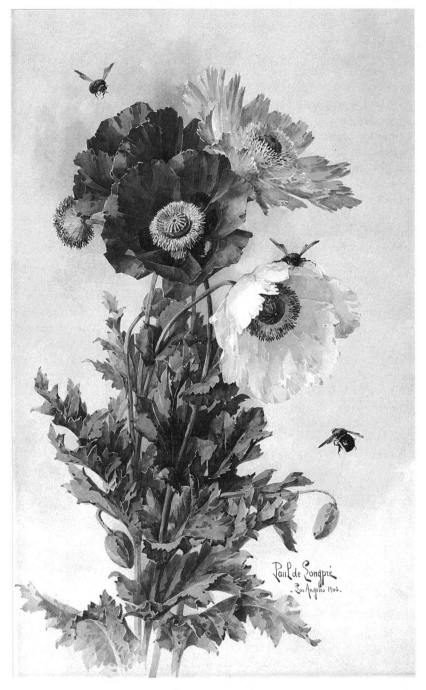

Figure 7. Paul de Longpré, *Poppies and Bees*, 1906. Los Angeles County Museum of Art, purchased with funds provided by Art Museum Council Fund. Photograph © 2006 Museum Associates/LACMA.

abundant advertising produced by competing citrus companies and the marketing innovations of Sunkist, the Southern California Fruit Growers Exchange, originally formed at a Los Angeles growers' convention in 1893.[47] The labels attached to crates carrying oranges, grapefruits, and lemons eastward emphasized images of laborless harvests and concealed a long, racialized history of exploited migrant farm labor, strikebreaking, and violence in the fields. The artfully produced advertising dominated national ideas about what southern California looked like and what it offered as an imagined rural alternative to the struggles of urban life.[48] The ads, and their ethnic imaginary, reflected an Anglo preoccupation with mission revival architecture, Spanish place names, and fiestas featuring white bourgeois Angelenos in Mexican drag. The California Art Club hosted annual affairs where white guests dressed in Spanish garb and ate "authentic" dishes of rice, beans, and corn. For one dollar admission at the annual Spanish Fiesta in Barnsdall Park, "one [might] see bona fide Spanish musicians strolling about the club's beautiful grounds, gape at fortune tellers, buy nicknacks [sic] from vendors, watch Spanish dancers and be served refreshments by 'dashing señoritas.' Spanish costume is optional."[49]

This taste for civic fantasy was largely the unintentional effect of Helen Hunt Jackson's 1884 sentimental and socially progressive protest novel *Ramona* and the popular pageants and plays that reenacted it. Jackson intended to draw national attention to the plight of California's decimated Indian population by focusing on Alessandro's struggle to hold on to his family's tribal lands during the period following the Mexican-American War. In an effort to challenge American racist stereotypes of Indians and mixed-race people, Jackson made her key protagonist, Ramona, a half Anglo, half Indian beauty raised in ignorance of her actual cultural heritage. Spectacular narrative gymnastics also made Ramona the unwanted stepchild in a wealthy Mexican family headed by the bitter and aging Señora Moreno. The ill-fated romance between Alessandro and Ramona is set against the decline of the landed Californio class, the ruins of the Spanish missions, and a stunning natural landscape whose shape and beauty matches that of the novel's heroine:[50] "The almonds had bloomed and the blossoms fallen; the apricots also, and the peaches and pears; on all the orchards of these fruits had come a filmy tint of green, so light it was hardly more than a shadow on the gray. The willows were vivid green, and the orange groves dark and glossy like laurel [.] The countless curves, hollows, and crests of the coast hills in Southern California heighten these chameleon effects of the spring verdure."[51]

If the landscape were not adequately romantic, kindly padres trimming the crumbling mission buildings of a relentless overgrowth, sym-

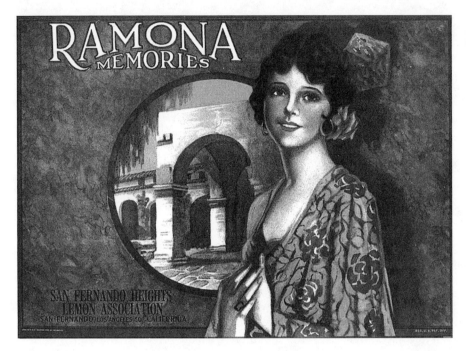

Figure 8. "Ramona Memories" crate label. Seaver Center for Western History Research, Natural History Museum of Los Angeles County.

bolic of the decline of the mission system, devastated readers, who demanded to see Ramona's home and meet the characters. The public passion for Ramona led to a tourist boom for San Diego, Riverside, and Ventura Counties, the main settings of the book.[52] Sunkist could not have asked for better copy, and despite Jackson's criticism of the antagonist Señora Moreno's narrow-minded racism and her own condemnation of Anglo-American land appropriation, the novel was enjoyed by millions of readers as regional tourist literature rather than political treatise.

The *Ramona* myth easily found its way into the visual arts. On the occasion of the Panama-Pacific International Exposition in 1915, California artists took the opportunity to display their wares to the rest of the country. Volumes of text celebrating their effort were published in the following year or two. In *Art in California*, published in 1916, Alma May Cook, Los Angeles art critic and educational director of the California Art Club, placed southern California within the canon of Western art, and art itself is shown to be active in the colonial project: "With the high ministry of the art of architecture, beautiful paintings and impressive

chants brought from the old world, did the padres civilize and Christian-
ize their Indian charges."[53] By 1927 mission fantasies had also been fea-
tured in Los Angeles County's promotional literature: "The historic past
of Los Angeles . . . is a source of inspiration for art. The picturesque old
missions of the Jesuit and Franciscan padres . . . tell eloquent stories.
These and the memories of heroic American pioneers, who endured
hardships when California was a wilderness, form a splendid back-
ground . . . which, like a magnificent stage setting, inspires all to better
work in the modern drama of life by the sunset sea."[54]

In the civic imagination, Los Angeles' history became a set, a painterly
landscape against which history could be artfully enacted, fostering a
nostalgia that did not simply add regional flavor to a tourist trade but
institutionalized a celebratory public memory of colonial conquest and
acted as a salve in the face of modern urban development.[55] Such prose
is not surprising, given that promotional materials from the 1920s often
featured conflicted impulses toward celebrating metropolitan growth
("unparalleled building activity") and presenting soothing images of an
undisturbed landscape ("warm fragrant valleys with the ever-green
groves of oranges and lemons, and tawny rounded foothills with oaks
and boulders").[56]

If the Spanish fantasy past would not do, the civic-minded art clubs
played with the themes of the international and the exotic emulating
the civic imaginary portrayed on produce labels and promotional litera-
ture used to attract white middle-class residents to southern California.
At a 1928 Glendale Art Association banquet to raise support for "the
cultural education of the community," each table was decorated to
represent a different country and each "hostess" was dressed in the
"costume characteristic of that land." Amid the Chinese, Swiss, Dutch,
Russian, Spanish, and American tables, local artists waxed nostalgic on
the topic of the evening, "the Latin Quarter of Paris." At the center of
the breathless international theme was the speakers' table, "symbolic of
California . . . with bowls of yellow marigolds, tiny kumquat trees, acacia
blossoms, and two horns of plenty spilling forth oranges."[57]

Together, booster landscape painting, citrus marketing, and the
Ramona-inspired Spanish fantasy past created powerful, commercial
visual imagery, and the promotions worked. Between 1880 and 1930 the
population of the city of Los Angeles swelled from eleven thousand resi-
dents to over a million.[58] Though the city had been nationally advertised
as a white Protestant Eden by civic boosters such as Lummis, who in 1895
wrote, "The ignorant hopelessly un-American type of foreigner which
infests . . . Eastern cities is almost unknown here," Los Angeles was
diverse and growing fast.[59] All of this promotional imagery swirled
through the popular consciousness as the art clubs reassured themselves

that the region would eventually manifest emblems of authentic urban-
ity. The California Art Club's Alma May Cook wrote that they should not
be embarrassed by their immature art culture, for "Greece was not
hoary with age when she became the crown jewel in the diadem of art
. . . Not alone is California young in the arts."[60]

The richly colored booster images made southern California an
attractive destination, blending evocations of the exotic with a lush land-
scape that naturalized the presence of a nonwhite agricultural labor
force while rendering it unthreatening and confined by the limits of fab-
ricated historical fantasies. Civic imagery also helped temper fears of Los
Angeles coming to resemble a congested, dirty, nineteenth-century
industrial city, a progressive-era-urban growth fantasy that Greg Hise has
called an "imaginative geography."[61] Indeed, in the early twentieth cen-
tury the civic arts movement was influenced by City Beautiful, a program
of urban planning that emerged from progressive reformers' agitation
for civic beauty as an antidote to urban malaise. By 1890 landscaping
had merged with the new professions of architecture and engineering
to advance modern urban planning in the United States. City Beautiful
plans, originating with the 1893 World's Exposition and Daniel Burn-
ham's Plan of Chicago, enhanced civic design with centralized gardens
and fountains and promoted order and efficiency with the development
of boulevards and scenic arteries.[62] By the 1900s City Beautiful plans had
been enacted in cities throughout the country.

In Los Angeles, Rev. Dana W. Bartlett, superintendent of the Bethle-
hem Institutions, was the principal voice of City Beautiful. An artist and
member of the California Art Club, Bartlett called on Los Angeles to
maintain its natural beauty, build parks, and ensure healthful living for
all its residents.[63] In his writings Bartlett encouraged the newly formed
Municipal Art Commission to secure the services of an architect who
could design a City Beautiful plan for the city.[64] The commission heeded
his request, and in 1907 Charles Mulford Robinson, national proponent
of City Beautiful, presented the group with a plan for Los Angeles,
promising to ease problems such as traffic congestion and litter—a plan
that suggested improvements that included removing eyesores from city
streets and keeping parks and walkways clean and orderly.[65] The com-
mission seized upon civic improvements such as public art, decorative
buildings, fountains, and other art-based aesthetic concerns but failed
to incorporate the plan's call for public space.[66] City Beautiful was short-
lived in Los Angeles, with the movement's focus on squares, plazas, and
other traditional civic landmarks never being realized.[67]

Instead, the concept of civic art became a significant part of Los
Angeles' body politic. The Municipal Art Commission, a citizens' com-
mittee formed and active in planning policy by 1903, did not actually

receive a city charter officially establishing it until 1911, at which time Los Angeles became one of the first American cities to have a civic body overseeing urban aesthetics.[68] Progressive reform, civic identity, art, and boosterism merged in the eight-member commission, which included Mayor George Alexander, the chief building inspector, the city engineer, and five unpaid citizens appointed by the mayor. Most citizen members appeared in the society pages or in the exclusive social directory, *The Los Angeles Blue Book,* and some such as commission president F. W. Blanchard and Edwin Bergstrom, were members of the Chamber of Commerce.[69] Like Bartlett, some shared membership with the art clubs. Hollywood heavyweights were involved as well; two of the most recognizable members of the commission were the movie-palace owner and innovator Sid Grauman and Mrs. Cecil B. DeMille, wife of the famed film director.[70]

Art display was only one aspect of the commission's role. Members also saw themselves as participating in a control mechanism over the entire infrastructure of the city, from the height of public buildings to the design of every lamppost found on city streets. Instead of seeing artwork within the broader physical layout of the city, the commission saw all urban structures as part of greater artistic design, with civic advancement the ultimate goal. In a 1924 annual report, the commission members stated their responsibility for approving the design and construction of every "public building, bridge, approach, fence, retaining wall, lamp, lamp post or other similar structure proposed to be erected by or under the authority of the city." Design and construction also meant the commissioning and mounting of any public artwork. The commission's definition of a "work of art" was broad and included "all paintings, murals, decorations, inscriptions, stained glass, statues, bas reliefs and other sculptures, monuments, fountains, arches, gates and other structures of a permanent character intended for ornament or commemoration." Not only was the Municipal Art Commission concerned about what city structures and art would look like upon construction or installation, but it also wanted to maintain control over what happened after the item was in place. The commission declared in 1929, "No existing work of art belonging to or in the possession of the city shall be removed, relocated or altered in any way without the approval of the board."[71]

In its decisions about civic projects and public artworks, the commission exhibited a keen interest in European building styles and the Spanish architectural revival alive in Los Angeles since the 1880s. Municipal Art Commission plans of approved projects from 1921 to 1929 mention a "Roman Doric"-style power substation, an "English Cottage"-style library, and miscellaneous buildings in the baroque style of northern

Spain or in Tuscan, Roman, and mission styles. A publicized design plan for the city's art museum and cultural center featured a complex built to early modern English specifications including turrets, stone walls, and a drawbridge. The *Los Angeles Examiner* reported that "one of the main features [was] the large Shakespearean theater constructed in the mode of the time of the Bard of Avon."[72]

With close ties to the Municipal Art Commission, the city's art clubs grew into powerful political entities that continuously sought cultural legitimacy. Spurred on by the specter of international humiliation when the Olympics opened in Exposition Park in 1932, the civic elite began another big push for Los Angeles' recognition as an urbane art center. In 1920 prominent businessmen dissolved the California Fiestas Association, formed in 1919 with the sole purpose of reviving the Spanish fantasy parades and festivals so popular in the late nineteenth century, and reorganized it as the Community Development Association (CDA).[73] CDA president William May Garland traveled to Europe, where he joined the International Olympic Committee and campaigned to get the 1932 games.[74] Garland, in the meantime, also served on the Civic Bureau of Music and Art of Los Angeles County, which was busily promoting the region as a cultural Mecca.[75] Bringing together the region's wealthiest and best-connected business and political elites, including Louis B. Mayer and Harry Chandler, the Civic Bureau of Music and Art hosted a huge convention at the Southern California Music Company Building.[76] The 1925 meeting gathered civic art representatives from cities throughout southern California, from Santa Barbara south to San Diego, with the intention of hosting a series of art festivals building up to an Eisteddfod to be held concurrent with the Olympic games.[77] Out of this civic art movement came the Artland Club, an energetic, short-lived, and conservative organization. Claiming to be a thousand members strong, Artland established itself on a fifteen-acre property on Venice Boulevard, "where plans [were] underway [*sic*] for a garden theatre, picture galleries, and country club comforts."[78] With competitive juices flowing, Artland's members announced in their June 1926 newsletter that Los Angeles must build a civic center worthy of the Greeks, a veritable "Temple of Art," if the city were to grow and prosper as its boosters hoped. Calling for "a million dollar fund" to build a museum and purchase art collections for the city, Artland spokesman and sculptor Robert Merrell Gage asked members to buy only "pedigreed" California art rather than either "fake old masters" or the "ultra-moderns" and charged a four hundred dollar annual membership fee. The newsletter pointed out that "dilettantes will not pay this price, nor will the buyers of jazz phonograph music and cheap chromos."[79]

With every civic organization in southern California rallying behind

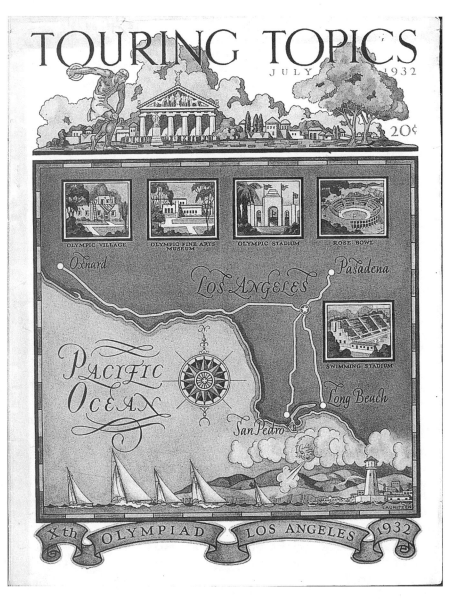

Figure 9. *Touring Topics,* July 1932, Xth Olympiad special issue featuring the "Olympic" Fine Arts Museum. Courtesy of Seaver Center for Western Research, Natural History Museum of Los Angeles County.

the Olympic cause, the Civic Bureau of Music and Art stepped in with its publication *Culture and the Community* to promote the sophisticated side of Los Angeles and to "offset the idea gained in other parts . . . that Los Angeles county has nothing to offer beyond opportunities for material aggrandizement."[80] The publication, the idea of recent Chamber of Commerce president Arthur S. Bent, ignored modern art, but traditional landscapes were well represented with five by William Wendt, Guy Rose, Kathryn Leighton, James Gardner Soper, and Edgar Alwyn Payne, the only artists featured in the painting section.[81] With the civic elite galvanized to make art the key to Los Angeles' cosmopolitanism, the papers swooned with praise for the cultural progress being made, and by 1929 the *Los Angeles Examiner* could unblushingly write, "The glory that was Greece was the glory of its unparalleled achievement in the arts. Our artists are earnestly endeavoring to make a similar achievement known the world over as the glory that is Los Angeles."[82]

By the mid-1920s cracks began to appear in the city's civic camouflage, along with a growing sense that booster advertising and tourist landscapes were not building the art culture the city needed.[83] Not everyone felt confident that an artificial European architectural landscape or aspirations to Greek classicism were tickets to urbane sophistication. In a glowing review of *Culture and the Community*'s promotional efforts, the *Examiner* nevertheless expressed unease with the state of art and architecture in southern California: "We are outgrowing both the imitation of indoor styles unsuited to our outdoor life and the freakishness that was partly fake and partly the ostentation of suddenly acquired wealth."[84] The editorial suggested frustration with the inability of civic leaders to do more than enthusiastically endorse "culture," particularly in an era of grand civic planning. Increasingly a self-consciousness about cultural distinction descended on middle-class and elite Angelenos in the wake of thirty years of consecutive boom-bust construction cycles and a flourishing film industry that made many people a lot of money but also left an anxiety that the city was déclassé and cheaply outfitted. Hollywood scandals such as the Fatty Arbuckle rape case and Sister Aimee Semple McPherson's "kidnapping" haunted the headlines. *Los Angeles Times* critic Arthur Millier complained that the local art exhibitions smacked of kitsch,[85] and H. L. Mencken, in a piece for the *Baltimore Evening Sun* on Sister Aimee, the celebrity evangelical minister, wrote of his disappointment in her giant church in Echo Park: "The whole building is very cheaply made. It is large and hideous, but I don't think it cost very much. Nothing in Los Angeles appears to have cost much. The town is inconceivably shoddy."[86]

Accentuating this unease was one of the most characteristic visual qualities of Los Angeles' urban landscape: the plethora of large, elabo-

rate, and often tacky retail structures catering to the burgeoning auto-
mobile culture. While other cities had gas stations and shops, Los
Angeles had super service stations with numerous filling bays, conve-
nient multiple entrances, and drive-in markets selling food and other
retail goods.[87] As these expensive business enterprises competed for cus-
tomers, they featured larger and larger signage and billboards, which
featured the cultural themes found on produce labels, booster pam-
phlets, and other commercial images of the period. Thus, the ubiqui-
tous drive-in markets had Spanish-style tile roofs, Chinese pagodas,
classical nudes atop fountains, or "Moorish" architectural stylings.[88]
Other classics of the Los Angeles vernacular landscape included the
Hoot Hoot I Scream shop, designed to look like an owl, and the Tamale,
a restaurant shaped exactly like its main dish. The roadside eateries in
helpfully obvious shapes certainly offered a distinctive local flavor, which
cut through the bright glare for the motorist speeding down the boule-
vard while blinded by the sun.[89] Up close, most seemed shabby as build-
ers used flimsy materials such as corrugated, galvanized iron, cheap
stucco, and spray paint. Yet, despite the growing resentment against
these kitschy buildings, they intrigued modernist architects such as Rich-
ard Neutra and Rudolph Schindler, whose own designs influenced retail
architecture across the country. These émigré architects, unlike the
European exiles who would follow them to Los Angeles later in the
1940s, were smitten with the region's vernacular landscape and took
pleasure in incorporating local materials and ideas into their modern
designs.[90] In an ironic aesthetic turn, while the city's elites struggled to
make a case for Los Angeles' sophistication to attract investors, often
repressing modern art in the process, high modernist design was well
received in the commercial realm and found its way into art deco and
later streamline *moderne* embellishments on car washes, hamburger
stands, and Laundromats throughout Los Angeles.[91]

Modernist influences notwithstanding, these retail structures did not
support the civic boosters' agenda; nor did the growing taste for public
entertainment. Cultural entrepreneurs tried to promote highbrow pur-
suits in line with the civic art agenda, but audience demands led them
to create visual attractions at odds with the civic vision of European
architecture and "pedigreed" California landscapes represented by the
art clubs. As much as highbrow culture was the goal, the convergence of
urban commercial entertainment with a capricious vernacular land-
scape earned southern California a reputation as the "home of the hard
sell."[92] In 1900 a former colleague and travel partner of Helen Hunt
Jackson, the developer Abbot Kinney, re-created the canals and architec-
tural specialties of Venice near the beaches of Santa Monica in an effort
to create a bourgeois resort with outdoor orchestras, dramatic perform-

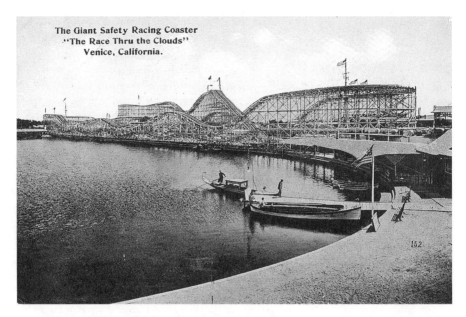

Figure 10. Venice Beach postcard, ca. 1920, featuring a gondola and a roller coaster. Gift of Brett Mizelle.

ances, and gondolas. However, when the highbrow tourists did not mate-rialize in sufficient numbers, he added a Ferris wheel, a roller coaster, and other amusement-park attractions, which brought thousands of resi-dents of all classes to the beach. Whoever his audience, Kinney was unable to convince anyone that Los Angeles was Venice, and eventually the canals grew stagnant. In 1927 the city paved over most of them.[93] While Kinney tried to attract Angelenos to highbrow pursuits, they, like most Americans, were more attracted to the urban entertainment that Kathy Peiss has called "cheap amusements."[94]

While Abbot Kinney mixed opera with roller coasters, the business-man Hubert Eaton merged art and death and capitalized on a commer-cial culture of mourning with the 1917 building of Forest Lawn Memorial Park in Glendale. The combination of cemetery and theme park still attracts thousands of tourists with the invitation "it's all possi-ble at Forest Lawn . . . where examples of the world's greatest art have been brought together within a beautiful park-like setting. Best of all it's free."[95] Not only can visitors experience a lovely parklike cemetery but they also can see "real" European art in the form of full-size reproduc-tions of masterworks such as Ernesto Gazzeri's *The Mystery of Life*, the Venus de Milo, and Michelangelo's *David*. The centerpiece of Eaton's

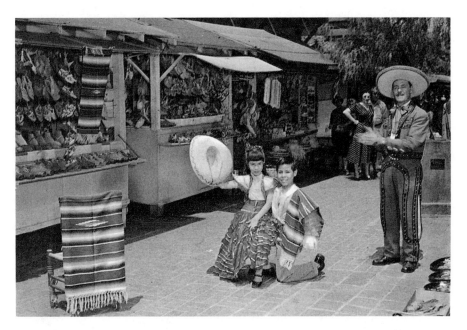

Figure 11. Olvera Street postcard from the 1950s. Collection of the author.

art collection was a full-sized reproduction of Leonardo da Vinci's *The Last Supper* in stained glass, created by Italian artisans and shipped to Los Angeles in 1930.[96] The window is kept behind a velvet curtain, and several times an hour visitors can sit and watch as it is unveiled while listening to a recorded message of spiritual uplift. Eaton essentially plopped "authentic European art" onto the urban landscape with no other context than that it should appear perfectly normal to combine a visit to a cemetery with a visit to an art museum. Kinney and Eaton's commercial art-themed landscapes were early precedents for the enormous success of Disneyland but poor substitutes for an established art museum of the type found in major American cities.

Olvera Street, when unveiled in April 1930, offered the "authentic" Mexican-themed urban experience, mixing art and commerce, costume and cuisine. Two years later, however, when David Siqueiros presented civic and business leaders with *América Tropical,* his modernist vision of an Indian peon crucified under the imperialist U.S. eagle, the work was promptly covered and whitewashed and the artist unceremoniously sent home. In a revealing slip of the pen, *Los Angeles Times* critic Millier referred to the Olvera Street mural as "Tropical Mexico" in an article in which he, though sympathetic to Siqueiros, nevertheless expressed

his opinion that muralists should paint "strong, harmonious images which reveal our nobler qualities."[97] On the cusp of the Olympics, the Laguna Beach art colony hoped to lure paying Depression-era audiences and boost civic pride with its annual summer arts festival and the main attraction, the "Pageant of the Masters," featuring "living reproductions of famous paintings and pieces of sculpture."[98] The festival continues to this day, with pricey tickets selling out each summer so that audiences can thrill to the fabulously costumed *tableaux vivants*.

The Great Depression and the dust bowl migration that brought thousands to Los Angeles exacerbated anxieties about class and cultural status. Carey McWilliams has facetiously offered that what appalled Angelenos was less the size of the Okie migration than the type of migrant it brought to town.[99] Many brought with them a popular culture infused with strong community ties to southern Baptist practice and the radical fringe of evangelical Protestantism and they were attracted to new churches such as Aimee Semple McPherson's Angelus Temple. McPherson, a shameless self-promoter who hired planes to drop celebrity photos, rode a motorcycle down the aisle of her church, faked her own death, and returned to life (and Los Angeles) with a new lover, received particularly harsh criticism because of the enormous crowds her services continued to attract.[100]

In a sharp split between the modern-art community and Los Angeles' popular culture, Chouinard graduate Barse Miller ridiculed McPherson in a huge 1932 parody, *Apparition over Los Angeles*, which portrays the evangelist in the nude flanked by her mother and her lover, all floating on a cloud of money bags over her church in Echo Park. The representational imagery, apparition notwithstanding, won a local prize for "the best interpretation of the Los Angeles scene," but McPherson was not impressed. While on the fringe of Los Angeles high society, McPherson garnered enough clout to bar the painting from being shown at the county museum, whose director William Alanson Bryan felt that the work was too controversial for display in a public institution.[101] The California Art Club, however, rallied behind the work and, gloating loudly in the papers, displayed it in their Barnsdall Park clubhouse, where they enjoyed the unflattering portrayal of a successful and sexually promiscuous woman. McPherson, a modern professional woman with broad appeal to working-class Angelenos proved a political challenge for the civic elite, whose unity of the 1910s and 1920s had clearly begun to fracture. The controversy over Miller's painting publicly united a modern artist with the civic arts movement and divided the museum and the California Art Club, foreshadowing a major split that would take place after World War II. Ironically, the later split occurred when the museum

Figure 12. Barse Miller, *Apparition over Los Angeles*, 1932.

pushed the California Art Club out of its galleries for being too conservative.

The overlapping worlds of bohemia, modern art, boosterism, civic art, and progressive reform collided in the effort to establish the city's first civic center, Barnsdall Park. In 1926 the California Art Club leaped at the opportunity to acquire the oil heiress Aline Barnsdall's Olive Hill property when she offered eight of her thirty-six-acre Hollywood estate to the city. A feminist and follower of Emma Goldman's radical views on marriage and love, Barnsdall made a name for herself as a patron of Chicago's Little Theater in the early 1910s.[102] Dedicated to avant-garde drama, the Little Theater presented work by Henrik Ibsen, plays by the Irish Abbey Theater, and modernist renditions of Greek classics.[103] After a trip to California to visit the Panama-Pacific and Panama-California Expositions, Barnsdall decided to relocate to southern California and take the Chicago Little Theater with her. She reasoned that Los Angeles' modernists would support her efforts to build a utopian artists' colony,

while the city, a seeming civic vacuum, would benefit from her ideas for an arts and culture center. However, Barnsdall could not convince the Chicago Little Theater to move, so in 1916 she chose to go to Los Angeles alone and take over an existing theater. It seems that her energy was greater than her production skills, and the theater's first season was also its last. Nevertheless, she decided to stay in Los Angeles, during which time her father died, leaving her the multimillion-dollar Barnsdall oil fortune. That same year, 1917, Aline gave birth to her daughter, "Sugar Top," whom she chose to raise alone. Overcome with wanderlust, Barnsdall took her daughter and traveled throughout the United States and Japan. When her restlessness ceased, she returned to Los Angeles in 1919, bought Olive Hill, and hired Frank Lloyd Wright to design and oversee the construction of her dream artists' community. The original plans for Barnsdall Park reveal a hankering for an independent city within a city: an idealized and decadent view of civic art as the everyday experience of urban living, with Aline Barnsdall overseeing it all from her house on the hill.[104]

Her precise instructions were for the land to serve as a public park and art center for all of the city's residents, in particular its children and working-class women. As reported by the *Los Angeles Express*, Barnsdall "strenuously objected even to the use of the word 'culture' lest the public get an idea that there might be some snobbishness about it."[105] The property, located on Vermont Avenue between Sunset and Hollywood Boulevards and bordering Edgemont Street, is in the center of Hollywood with a spectacular view of the city. Barnsdall and Wright's original design included dozens of buildings for artists' residences and theaters, a children's school, a playground, a petting zoo, a movie theater, shops, and Barnsdall's own spectacular residence, Hollyhock House.

Soon, however, disagreements broke out between architect and client, and Frank Lloyd Wright succeeded in completing only three buildings: Hollyhock House and two smaller houses known as Residences A and B. Disheartened and annoyed, Barnsdall gave up on her fantasy of her own resident theater company and art colony and first offered the buildings and the surrounding land to Los Angeles in 1923. Barnsdall spent years trying to get the city to accept the land, which neither the city council nor the Parks Commission wanted because of her conditions that the land be left unchanged for fifteen years and memorials only to artists could be erected, preventing war memorials or statuary.[106] The city also dragged its feet because of Barnsdall's outspoken support of organized labor and leftist causes; her feminist, unorthodox lifestyle; and her seeming preoccupation with modern art.[107] In 1926 the city took the property but did not do anything with it ostensibly because of Barnsdall's land-use restrictions.

With the city hesitating, the California Art Club courted Barnsdall, hoping that she would grant them use of her home as a clubhouse, which she did in an agreement that gave them Hollyhock House for fifteen years.[108] Under the progressive leadership of President Edwin Roscoe Shrader, the California Art Club used the property to sponsor lectures, host photography and poster exhibitions, and serve as local cultural deacons. Within a few months after the club took over the house in August 1927, the club members' eclectic activities included an open-house for all local art clubs, "a luncheon for lithographers and printers, [a] luncheon for art teachers, a tea for high school teachers, a Spanish-feature musicale, an East Indian dancing exhibition and philosophy talk, addresses by noted art collectors, anthropologists, American Indian experts, explorers, a Philharmonic Society reception, and innumerable small group meetings having to do with widely varied forms of cultural work."[109] Shrader also arranged, with the assistance of Los Angeles resident Dr. Elzora Gibson, to host a 1929 show of African American art. The exhibit, which originated in Chicago, could be held in Los Angeles only because of the Barnsdall Park facility. The county museum would not host a black artist until 1935.[110]

After the California Art Club successfully built an audience for its projects, hosting close to five thousand visitors since taking over Hollyhock House, club member Francis Vreeland hoped to convince Barnsdall to give away more of her property. Combining progressive-reform lingo with calls to the civic imagination, Vreeland wrote:

One of these days Los Angeles is going to be the "world-beating metropolis," according to our enthusiastic boosters. Day by day, the spreading epidemic of steel, brick, stone, concrete . . . which substantiates that boast as possible of fulfillment is rapidly stamping out the loveliness that a generous nature lavished upon these beautiful hills and dales . . . When that time comes, the perfume of our garden flowers and orange blossoms will have given way to the permeating stench of decomposing garbage, and the thousand and one ungodly odors that, even in this day of modern sanitation, are characteristic of every spot in the world upon which mankind swarms in millions. When that time comes what a priceless thing will be a bit of God's reality. . . . Therefore, in the name of civic pride, in the cause of a city beautiful let us have parks and recreation centers in the midst of our "world-beating metropolis."[111]

Vreeland proved persuasive. In March 1929 Barnsdall announced that she would donate another eight acres of her Olive Hill property (a piece that fronted Sunset Boulevard) as long as the land housed an art museum that would be built with funds raised independently from the municipal government or other "political ties."[112] With that gesture Aline Barnsdall again became the toast of Los Angeles' social circles as the city's cultural elite jockeyed to be at the forefront of the fund-raising

to create Los Angeles' first art museum.[113] Barnsdall understood that the city would benefit from a multiuse facility and suggested that the design for the museum buildings should be in a modern open-air style rather than re-creating the traditional mausoleum effect.[114]

The momentum to develop Olive Hill stalled permanently and abruptly in 1930 when, to the horror of Los Angeles' high society, Aline Barnsdall renewed her commitment to the beleaguered Tom Mooney by placing huge signs on her property demanding that the California courts release him. Mooney, a labor organizer, had been jailed on questionable evidence for his participation in the 1916 San Francisco Preparedness Day Parade bombing, which took place during a longshoremen's strike. The bombing killed ten men and injured forty. Mooney was arrested, tried, and convicted of the crime on perjured testimony. Nevertheless, he was not pardoned until 1939, and his case became a cause célèbre for American labor activists and the leftist intelligentsia throughout the 1920s and 1930s.

Barnsdall's public political stand on the Mooney case was a huge embarrassment for the local elite and the city, whose Board of Park Commissioners frantically wrote letters to the *Times* explaining that the Mooney billboards were in fact on Barnsdall's own land and not the parts of Olive Hill belonging to the city.[115] Carey McWilliams, however, loved her for it. He wrote "I close my eyes and I see Olive Hill . . . with its colonnade of eucalyptus trees and the pugnacious signs in which Miss Barnsdale [*sic*] warns the British to free India as she once warned California to free Tom Mooney."[116]

Realizing that allowing Barnsdall to hold on to parts of her land while meting out acreage had potentially unpleasant political implications, the Board of Park Commissioners announced in early 1931 in the local papers that plans were being made to acquire another substantial piece of Barnsdall's property. Under the new agreement, the Park Commission became the owner of Olive Hill and the lessee of another twelve acres of Barnsdall land that included Aline Barnsdall's Residence B. Barnsdall reiterated that war memorials must not be erected and insisted that her home be used to "provide recreation and social assistance for maids, housekeepers, and nursemaids on their day off."[117] The American Legion promptly filed protests against the prohibition of war memorials on city property.[118] Though the Park Commission could not renege on the war statuary provisions, the American Legion withdrew its protest when the city attorney's office declared the "gift-lease" arrangement illegal because the city charter amendments prevented any city department from entering into agreements longer than three years.[119] In short, the city's legal advisers made the case that the previous gift of Hollyhock House was fine and use of the land was fine but that under the terms of

the agreement between Barnsdall and the Park Commission, her restrictive conditions were unacceptable.

Barnsdall, who was living in Paris, grew infuriated and wired the Park Commission that if no satisfactory decision were reached, she would take back her land and convert it into "a radical center by giving land to radical groups in the city whom I have long wanted to help."[120] She then had her lawyer begin proceedings to sue the city to retrieve her property. The legal fight continued for nine years until, in 1940, the city council agreed to let her have her Edgemont Street house back while Barnsdall offered to waive her long-standing restrictive provisions. During this time the California Art Club had made private use of Hollyhock House while the Playground and Recreation Department ran a public playground in another part of the park.[121] Barnsdall moved into Residence B, where she continued to do battle with the city over traffic issues and her twelve cocker spaniels, which she allowed to run around the park unsupervised and unleashed. She died alone in her house on December 18, 1946, leaving a small fortune to her dogs and a sizable modern art collection to her grandson.[122] Over the years Barnsdall had quietly gathered over 160 works including top-notch pieces by Braque, Cezanne, Chirico, Dufy, Gauguin, Kahlo, and Matisse, as well as several by Monet and Renoir. With such a charged relationship with the city and county and anger over the mishandling and neglect of Hollyhock House, Barnsdall did not loan any pieces in her collection to the county museum until 1940. With works rotating in and out of display, the art remained there until 1946 when her heirs moved it to the Santa Barbara Museum of Art. Because of peculiarities in her will and mishandling by her family, the collection was eventually sold off and permanently lost to Los Angeles and Santa Barbara.[123]

Despite her longtime vision of making her property a center for modern art and a community cultural enterprise for the public good, nothing resembling a museum would emerge until the early 1950s, when the City Planning Department drafted a schematic master plan for the development of Barnsdall Park. By this time the grounds and Hollyhock House were in terrible disrepair, and there were no public funds that could go toward the restoration. Kenneth Ross, director of the newly formed Municipal Arts Department, visited Frank Lloyd Wright at his home in Wisconsin and asked him if he would help with the master plan. Wright agreed to work free of charge, and within two months, he had prepared and sent the Municipal Art Patrons drawings for a 228-foot-long gallery adjoining Hollyhock House, a parking lot, and landscaping. In June 1954 the city's first municipal art center opened in Barnsdall Park; it would be one of Wright's last projects before he died.[124] In 1967

the Junior Arts Center opened. At long last, forty years after the fact, Aline Barnsdall's wish for children's art classes was finally implemented.

The failure of the city and the county to share Barnsdall's vision of the arts in public life and the inability of the modern art community to support it make the story of Barnsdall Park an exemplar of Los Angeles' narrow view of what "art" could mean. Producing manageable civic imagery was far more important, with the result that public modernism was hobbled through the restrictive uses of exhibition space and the dominance of the booster imaginary. The story of Barnsdall Park also speaks to the way modern art effectively shadowed the city. It would soon eclipse landscape art and increasingly obsolete boosterism, which Los Angeles would not need as much after the 1920s, with the population boom growing faster than construction companies could build or water could be brought to the city. In the first decades of the twentieth century, however, control of the visual was a means to metropolitan power, and the civic arts movement was loathe to relinquish it, even when the Depression era would force the emergence of a newly public modernism through the interventions of the Federal Arts Project and the increasing role of Hollywood in the arts. These broader social and economic changes deeply affected the unity of the elite civic arts movement in Los Angeles, thereby creating spaces for modern art to be seen and progressive social visions to be discussed but also building tension between the art clubs, the county museum, and new, well-heeled modern art organizations like the Los Angeles Art Association. Thus, on the surface the 1930s would appear to have enormous potential for building a progressive and collective civic culture, but fractured allegiances among traditional art interests and growing resentments would prove dangerous for modernists on the Left and anyone perceived as a threat to the traditional civic imagination.

Chapter 2
Modernism in Public Spaces

In early twentieth-century Los Angeles, the civic arts movement shaped a regional identity grounded in conventional assumptions about high art and its accompanying cultural capital. Despite a close community of modern and contemporary artists, there was little in the way of a gallery scene or a museum to encourage a diverse visual culture in Los Angeles, and booster fantasies of civic grandeur continued to dominate representations of the city. In the early 1930s the critical commentator Morrow Mayo could still write, "Daily the Angel City propagandizes itself as 'the Athens of the Western World, the Cultural Center of the West.' But it has, in fact, very little to back up its claims except the gushing and gurgling of a multitude of female culture-stalkers, the check-books of retired capitalists, and a publicity bureau."[1]

Los Angeles' modernists worked rather unsuccessfully to counter this impression. In 1929 Jake Zeitlin moved his bookshop into larger quarters designed by Frank Lloyd Wright's son, Lloyd, and began hosting modern art shows of prints, lithographs, and photographs by Edward Weston, Henrietta Shore, and others.[2] Zeitlin also began his publishing career, printing five hundred copies of Merle Armitage's *The Aristocracy of Art*, a short pamphlet transcribing his 1929 speech before the California Art Club. Though Zeitlin held populist views on art, Armitage's conservative treatise spoke of a critical distinction between the modern appreciator of art and the commoner who fails to understand sophisticated cultural expression: "The aristocracy, the world which I wish to visualize, is an aristocracy of the mind and the spirit, and particularly the spirit. . . . I am not dividing my classes according to either learning or wealth. I am making a spiritual division. . . . To attempt to make art understandable and appealing to the people, is to take from it the very elements that make art. Bring a thing down to the level of popular understanding, and you bring it down below the timber line of aesthetic worth."[3]

Armitage placed great distance between himself and Los Angeles' art world of traditional painting and booster kitsch, coining the derogatory term "Eucalyptus School" to describe the plethora of landscape artists

working in southern California. As canonical as artists such as Edward Weston are now, in late 1920s Los Angeles it was primarily in private quarters and small gallery spaces that such modern works were shown.[4] This was because of the restrictive nature of the limited public exhibition spaces extant in the city and, in part, because of the exclusive nature of the modernist community. Distancing themselves from the kitschy artistic mainstream made modern artists obscure (perhaps more than they had hoped) and certainly helped push their art more deeply into the shadow of showy regional landscape painting. The essential privacy of the modern art scene also made it a safe haven for beleaguered supporters of the Left and members of the Los Angeles' gay community. Daniel Hurewitz has identified Edendale, a neighborhood nestled in the hills above downtown Los Angeles, as a modern-arts colony with a close network reaching members of Hollywood, radical political groups, and queer circles throughout the city.[5]

The Depression did mark a cultural transition in Los Angeles. Whatever the tastes and civic desires of a predominantly white Protestant elite, tastes and choices of both artists and audiences had shifted from homogenous conceptions of the "highbrow" to a combination of socialist avant-garde aesthetics and American commercial culture. An eclectic and public modernism soon flourished in the work of Mexican muralists and their students, Hollywood filmmaking and collecting, and the efforts of a new organization, the Los Angeles Art Association, to create an audience and public exhibition space for modern and contemporary art. Due to Federal Arts Project financing and creative energy, the increasing popularity of movies, and the appearance of murals on public buildings, a growing audience for modern art challenged Los Angeles' conservative civic culture of classical painting and exclusive clubs and rendered the old civic arts movement obsolete. Robert Merrell Gage, an outspoken proponent of Artland's snobby civic vision in 1926, had by 1932 joined David Siqueiros's Bloc of Mural Painters, along with Paul Sample, president of the California Art Club, and other art club members. Ultimately, the 1930s represented a conflict between progressive modernism, manifesting itself through Hollywood collectors and popular front artists, and reactionary municipal authorities, who, by wielding whitewash brushes and bullets with impunity, attempted to erase public modernism from the urban landscape.

Nothing heralded the beginning of a visible public modernism in Los Angeles like the arrival of David Alfaro Siqueiros in the spring of 1932.[6] His commissions for private and public art projects pushed modern art onto the urban landscape, leaving behind an important, and complicated, cultural legacy for the city after his departure just six months later. Siqueiros, an outspoken Communist who had spent a year in inter-

nal exile in Taxco, Mexico, brought an energetic surge into Los Angeles'
art world and was widely received by many—from members of the
California Art Club to those of the John Reed Club, a circle for Commu-
nist writers and artists. Siqueiros was a monumental figure, one of the
"Big Three" Mexican muralists along with José Clemente Orozco and
Diego Rivera, and Los Angeles was glad to have him. Newspapers cele-
brated the presence of such a heavyweight intellectual and covered his
meetings with Hollywood directors, the Chouinard Institute, and the
California Art Club as they would a visiting dignitary.[7] Though now
remembered as the aggrieved and deported painter of *América Tropical*,
at the time Siqueiros was welcomed by both art clubs and Hollywood
leftists, and he reveled in the attention.

Precisely how Siqueiros came to be in Los Angeles is unclear. Cer-
tainly Diego Rivera's San Francisco mural commissions painted the year
before must have stimulated interest from Siqueiros and his patrons
alike.[8] Some scholars suggest that his life was in danger and he came
to the United States as a political refugee. Word of his presence spread
throughout the southern California art community, and through vari-
ous Hollywood and civic connections, Siqueiros met Chouinard faculty,
possibly Millard Sheets, who invited him to paint his first of three Los
Angeles murals.[9] Others have subsequently argued that it was Mrs.
Chouinard's invitation to Siqueiros to teach a fresco course that brought
him to Los Angeles. Chouinard met the artist in Taxco and, wishing to
move her school in a more progressive direction, commissioned the
painting of an exterior mural that would include the training of a small
class of students.[10] The trip to Los Angeles was perhaps as much a result
of political pressure from the Mexican government as it was Siqueiros's
desire to hold an exhibit in the United States.[11]

We do know that while in Taxco he met many American and United
States-based artists, including Russian director Sergei Eisenstein, who
was on location filming *¡Que Viva Mexico!*[12] The epic film was heralded
in leftist circles as a deep contemplation of Mexican history, the damage
of colonialism, and the immense beauty of the natural landscape. Eise-
nstein's film assistant, Agustin Aragon Leiva, described it as "a poem of
sociological character" that captured disparate regional struggles ren-
dered one "by revolution through which the Mexican people has striven
to build up its collective unity—and still is striving."[13] Eisenstein, capti-
vated by the painterly aspects of the Mexican landscape and visually
influenced by the works of Rivera and Orozco, understood the filmic
technique of montage as critical for the artful exploration of dialectics.
Mexico, as Eisenstein saw it, with its sharp juxtapositions between the
modern and the ancient, nature and industry, was a perfect setting for
pushing the limits of revolutionary avant-garde aesthetics.[14] In the wake

of his conversations with the director, Siqueiros started writing about the revolutionary potential of large-scale exterior murals using the newest industrial technologies, such as film projectors, airbrushes, spray guns, waterproof cement, and blowtorches used in designing and building movie sets.[15] The space and tools necessary to execute his innovative vision of political art were concentrated in Los Angeles, the center of the U.S. film industry. Mexican politics may have created the impetus and Nelbert Chouinard the means, but it was Siqueiros's desire to improvise and devise what he called the "vehicles of dialectic-subversive painting" that made Los Angeles the optimal destination.[16]

Once in Los Angeles, Siqueiros promptly showed two exhibitions of his work: one of lithographs at the Jake Zeitlin Bookshop and the other at Earl Stendahl's Ambassador Hotel Gallery.[17] The Stendahl show was much larger in scope, including paintings and mural designs as well as lithographs.[18] In commenting on contemporary California taste for things Mexican, including Ramos Martinez's visit to Los Angeles, Orozco's mural at Pomona College, and Diego Rivera's work in San Francisco, *Los Angeles Times* critic Arthur Millier's comments foreshadowed the trouble that civic leaders would have with Siqueiros's work. Impressed, and yet overwhelmed, Millier described art that was "massive," "dark," and "tragic." His first impression was of "brutality and darkness, of a complete absence of any 'charm'—that pleasing manipulation of pigment which means so much to the English and Americans."[19] On closer inspection, the critic was especially taken with a painting entitled *Deported Mexican*. Declaring it a masterpiece, "a revolutionary epic in a single figure," Millier identified its strength as "a great and tragic work without an ounce of superficial painting in it. It depends for its effect entirely on the disposition of the forms and colors."[20] There is a fateful irony that Siqueiros would be a deported Mexican when the U.S. government refused to renew his six-month visa.[21]

In the meantime, many in the Los Angeles art world seemed to be attracted to Siqueiros's dark vision and his celebrity. The California Art Club feted him, the Plaza Art Center exhibited his work, and Hollywood loved him.[22] If Eisenstein inspired Siqueiros's interest in film technology, other industry members found the visiting artist equally compelling. Josef von Sternberg, a modern-art collector and director of *The Blue Angel* and *Blonde Venus*, films that made Marlene Dietrich internationally famous, helped Siqueiros get himself and his artwork over the border and into the United States.[23] Once Siqueiros was in Los Angeles, von Sternberg commissioned a portrait of himself to be hung in his private collection at Paramount Studios. Siqueiros obliged and produced a painting that showed "von Sternberg at his desk, ugly, intent, commanding—yet curiously, it [was] more like him than any of the others."[24] Through these

Hollywood friends Siqueiros met film director Dudley Murphy, for whom he painted an interior mural in his home. Major film-equipment firms such as Otto Oleson, the company that provided the giant floodlights for movie premieres, contributed scaffolding, cement, airbrushes, lights, and tracing paper to the mural endeavor.[25]

The Hollywood reception did not end there. The Hollywood chapter of the John Reed Club invited Siqueiros to give a lecture on his experiences painting the Chouinard mural. He spoke about the work of his twenty assembled painters, a group he called the "Bloc of Mural Painters." The bloc included mostly Chouinard students and faculty but also other local artists and art club members who wanted to learn Siqueiros's fresco technique.[26] According to Siqueiros, the group was participating in a "technical revolution" of painters "struggling in an organized way for the supremacy of monumental [mural] painting over easel painting."[27] The fact that Siqueiros could assemble a disparate group of art students and art club members certainly spoke to his celebrity, but it also reflected a political transition that some artists were making from the conservative civic arts movement toward the progressive modernism of popular front public art.

Following Siqueiros's lead, the Bloc of Mural Painters painted directly onto walls rather than producing works on large canvases and later attaching them. Siqueiros viewed direct application of the paints and cement as fundamental for creating significant political art because the work could not be removed or sold. An affixable mural, on the other hand, could be taken down and distributed while its media of oil and canvas made it "spurious and fragile."[28]

In fact, the production of the Chouinard mural, titled *Workers' Meeting*, proved to be quite fragile as an experiment in the modernization of mural technology. The wall (24 ft. by 19 ft.) was in the courtyard of Chouinard Art Institute with its top portion visible from the street. The wall was divided by windows, which Siqueiros incorporated into the mural's design of workers sitting on scaffolds listening intently to a speaker below. The means that Siqueiros employed were technologically innovative. He used film projectors to create a massive stencil that allowed him to incorporate perfectly the architectural idiosyncrasies of the wall. Pneumatic drills created a roughened texture to which waterproof cement could properly adhere. Then airbrushes (using an electric compressor) were utilized to spray colored paint into the plaster. In effect, Siqueiros was adapting to a contemporary context the ancient fresco process of painting watercolor into wet sand and lime. What normally would have taken months was completed in two weeks, and what could have survived historically only on an inside wall could now, presumably, have a long life outdoors, in the city amid the traffic, and

"abandon itself entirely to millions of people."²⁹ The moving of an indoor art form outdoors, the deployment of ancient techniques together with modern technology, and the evolution of a bourgeois and religious art form into secular political art for the masses made the Chouinard exterior mural precisely the vehicle of dialectic-subversive painting for which Siqueiros was looking.

Unfortunately, neither the public reception nor the materials proved steady enough to sustain the artwork. When it was unveiled in July 1932, local art critics and newspapers reported that the mural of a labor union meeting was too political and too closely resembled agitprop art.³⁰ Within a year the mural was whitewashed, although it is unclear precisely why. Robert Merrell Gage has said that local police told Mrs. Chouinard that the mural had to be covered, while other bloc members have claimed that Siqueiros's experimental fresco technique failed to survive its first southern California rain, chipping so badly that the wall was painted over.³¹

Whatever the reason for the whitewashing of the Chouinard mural, Siqueiros's radical artist persona captivated Los Angeles' civic imagination. While still creating *Workers' Meeting*, Siqueiros accepted an invitation from F. K. Ferenz, director of the Plaza Art Center on Olvera Street, to organize another class of students and paint an even larger mural (18 feet by 82 feet) on the second-story wall of the old Italian hall.³² The mural project was initiated by Dean Cornwell, a longtime cartoonist and commercial illustrator who had begun a five-year stint of mural painting in California in 1927, including one well-known piece at the Los Angeles Public Library. The mural, to be painted in a reconstructed urban district where Mexican American residents enacted their "Mexican past" for the benefit of Anglo tourists, was lauded in the newspapers as a well-chosen aesthetic complement to Olvera Street's commercial cultural theme. The *Times* ran photographs of young pretty women artists demurely standing on ladders, while art columnists promised a "Mexican tropical jungle . . . [in which] Indians will form colorful notes amid the green foliage."³³ The mural would assuage concerns of the tourist district's backers, Christine Sterling and Harry Chandler, and remind Anglo visitors that "Mexicans on Olvera Street were docile rather than dangerous," a concern underscored by the federal government's repatriation campaign, which was prompting angry protests in the plaza.³⁴ Moreover, Siqueiros's project would bring attention to Los Angeles' cultural prowess, pleasing proponents of the civic arts movement to no end. Cornwell, a widely respected professional painter, anticipated that "Los Angeles is seeing the birth of a new movement in mural painting destined to sweep the United States," a prophetic statement, given that the Federal Arts Project was still two years away.³⁵

Figure 13. Reproduction of David Siqueiros's *América Tropical* by Agustín Espinosa. © 1989 J. Paul Getty Trust. All rights reserved.

Siqueiros, however, had themes in mind other than a decorative tropical landscape with parrots, pumas, and colorful natives. The wall overlooking Olvera Street gave him the remarkable opportunity to paint in a genuinely public place (as opposed to a private school's courtyard) and once again try his new style of dialectic-subversive painting. He thus painted a tropical jungle whose roots are portrayed as thick as flesh and as lithe as serpents as they surround an ancient temple. In the upper right-hand corner of the mural a Peruvian Indian and a Mexican campesino prepare their firearms for an attack on the American imperial eagle perched above the mural's startling centerpiece: an Indian tightly bound to a double cross. Temple ruins and pieces of statuary litter the ground. Siqueiros's point was not subtle; nor did he intend it to be. He described *América Tropical* as a purposeful, anti-imperialist statement: "It is the violent symbol of the Indian peon of feudal America doubly crucified by that nation's exploitative classes and, in turn, by imperialism. It is the living symbol of the destruction of past national American cultures by the invaders of yesterday and today. It is the prepatory action of the revolutionary proletariat that scales the scene and readies its weapons to throw itself into the ennobling battle of a new social order."[36]

Siqueiros condemned the United States as the controlling force of Latin American colonialism and economic imperialism abroad and the exploitative employer of Latin American labor at home. Savage acts lay behind the U.S. occupation of Mexico and continued in the 1930s through brutal nonunionized labor practices and repatriation. Siqueiros saw the act of producing the mural to be as significant and political as its content was. Its value was in its collectivity, its size, and its public accessibility: "It is eloquent proof of how the intrinsic work of art respective to the current moment can be uniquely of revolutionary conviction. It is an eloquent display of the superiority of the collective work of democratic art in action over the wretchedly small efforts of the individual. It is the emergence of an expressive vehicle requiring monumental murals in the open air, facing the sun, facing the street, for the masses. It

is a technical forecast of a near future's art, the art of a new communist society."[37] As powerful and provocative as the enormous image of a crucified Indian was in the context of a commercial shopping district in downtown Los Angeles—in the shadow, no less, of City Hall—Siqueiros came to regret his decision to depict a cross. Even with its double laths, Siqueiros felt that a cross in Protestant America "lent itself to ideological confusion."[38]

América Tropical was unveiled on October 9 under a shroud of secrecy as Siqueiros let none of his students or the press see the central figure.[39] According to Arthur Millier, who attended the unveiling, the audience gasped at the shocking scene before them.[40] Shortly thereafter Ferenz painted over the fifteen feet of the mural visible from Olvera Street but left the rest of the mural intact, including the central image of the bound peon, symbolic of "the oppressive double cross of the people of Hispano-America."[41] Though the rest of the mural would be white-washed a couple of years later, Siqueiros took pleasure in producing it and provoking the city officials who, anonymously it seems, would order that *América Tropical* be covered.[42] His writings later in life reflect concession to the political climate in 1930s Los Angeles and acceptance that an obviously anti-imperialist, antiracist statement would have been read as anti-American and would have unlikely survived the whitewash brush. The real value of the mural was in its execution. It was huge; it was truly public; it was produced through a collective effort; and the very reaction that destroyed it laid bare the value of monumental, dialectical political art.

Its legacy is certainly proof of this. Artists and critics loved it. Arthur Millier followed Siqueiros throughout his Los Angeles stay and concluded that *América Tropical* "is a Mexican's picture of this own troubled land. . . . Interpret it anyway you like, it is a work that first arrests and then holds the mind through the strength and simplicity of its forms."[43] Though he would change his tune later, arguing that murals were no place for personal convictions and that Siqueiros's work was little more than Communist propaganda, at the time *América Tropical* was revealed, Millier believed it to be a fine and important work of art.[44] Leftist artists, of course, were thrilled to have a revolutionary voice booming from downtown Los Angeles. Seymour Stern, Hollywood editor of *Experimental Cinema*, marveled at Siqueiros's audacity in bringing his radical philosophy "to life on the walls of one of the most conservative art asylums in the United States."[45] The art clubs remained surprisingly quiet during the public reaction to the mural, possibly reflecting internal strife or simply protocol as some of their members were involved in its production.

As well connected as Siqueiros became in Los Angeles, his supporters

were unable to keep the mural from being whitewashed, nor could they prevent his deportation in November 1932.[46] Before leaving, however, Siqueiros painted one more Los Angeles mural, a private project for avant-garde Hollywood director Dudley Murphy.[47] Eisenstein had introduced the two, and with an expired visitor's visa, Siqueiros was in need of a reprieve away from the social limelight. Murphy offered his Malibu home and Siqueiros, together with Fletcher Martin, Luis Arenal, and Reuben Kadish, painted a smaller mural (8 feet by 32 feet) on Murphy's garden patio. The painting, *Portrait of Mexico Today*, revisits anti-imperialist themes, depicting Mexican president Calles as a masked bandit and J. P. Morgan as one of the critical forces of corruption in Siqueiros's home country. The mural's centerpiece includes two women and a child with a young revolutionary soldier on the sidelines, rifle drawn to protect the oppressed from the corrupt and aging figures on the right.[48] It was an optimistic revolutionary vision. Because it was privately commissioned, *Portrait of Mexico Today* is the only one of Siqueiros's Los Angeles murals to survive intact. It was eventually donated and moved to the Santa Barbara Art Museum, where it was revealed to the public in October 2002. Its survival in southern California, on Murphy's property, is emblematic of the important role that members of Hollywood's culture industry played in encouraging and protecting modern and, in this case, also socially progressive art. When Siqueiros created outside Los Angeles' civic sphere, his work survived. Within it, civic leaders rejected his modernist political vision and destroyed it, and this rejection could take a violent turn. After his departure, the Bloc of Mural Painters lent their support to the John Reed Club's campaign on behalf of the Scottsboro Nine, black youths in Alabama facing death sentences for trumped-up rape charges. The artists produced a series of portable mural panels depicting racial violence and bound black bodies, which were to be exhibited in Barnsdall Park. The night before the show, the Los Angeles Police Department Red Squad confiscated the unveiled mural panels and returned them full of bullet holes.[49]

Workers' Meeting was discovered recently under layers of paint at the old Chouinard, now a Korean Presbyterian church. Efforts are being made to restore it with the cooperation of the congregation. *América Tropical* reentered the civic imaginary in the 1970s, this time as a symbol of the growing Chicano movement and a call to Aztlán, the mythical homeland of Mexican Americans and their indigenous ancestors. Rediscovered almost forty years after its creation, the mural pushing out from under layers of peeling whitewash represented a return of the oppressed, the emergence of a younger and louder politicized Mexican presence in Los Angeles, and a triumphant reclaiming of public space. The mural's second life continues as a complicated conservation and

exhibition saga with high hopes that the Getty and city-funded project will soon be open to the public. It is a darkly ironic testament to Siqueiros's theories of dialectic-subversive painting that one of the most famous artworks in the city is also the least seen.

Siqueiros's significance as an artist exceeds his role in Los Angeles politics and the city's struggles for a civic identity; he helped build the cultural front in the United States, an amalgam of progressive political visions, actions, and cultural goods produced by the nation's working classes and spread through mass popular entertainment into the American mainstream.[50] Siqueiros's murals, created with the technologically advanced tools borrowed from the film industry, reflected the cultural front's progressive views about social justice in a public, commercial venue. Similarly, Hollywood was crucial in fomenting left-wing cultural politics and creating the forums in which to express it, from the early days of the Works Progress Administration through World War II.

Hollywood participation in civic arts programs, however, did not necessarily mean advancing a progressive political agenda; nor did Los Angeles' civic arts culture change overnight. Rather, subtle changes took place, including a growing emphasis on inclusion and cultural diversity and a slow but steady involvement of movie moguls in the old civic arts movement. For example, in 1934 the Los Angeles Chamber of Commerce's Women's Community Service Auxiliary sponsored the enormously popular Southern California Festival of the Allied Arts. Essentially every major woman's club throughout the southland rallied funds and facilities to create what had to be one of the largest competitive art festivals in the country. By its second season, the festival had more than six thousand artists, dancers, singers, actors, and musicians competing in a myriad of categories to win coveted exhibition space in civic facilities ranging from the county museum to the Hollywood Bowl. The range of visual possibilities and cultural juxtapositions was remarkable, from an exhibition of five hundred African American artists at the Polytechnic High School in downtown Los Angeles to the California history pageant sponsored in part by the Native Daughters of the Golden West and performed before a crowd of thousands on the steps of City Hall. Amid the scholarships and prize money granted by local schools and business establishments, unnamed film studio contracts were awarded to winners in the animation and acting competitions.[51] While this veritable civic culture orgy was celebrated in the papers, Louis B. Mayer stole some headlines when he hosted French dignitaries, touring them through his studio and pointing out that many European artists, in fact, worked in the California film industry.[52]

While civic festivals dominated headlines, leadership and budgetary problems plagued the county museum. In 1934 the Board of Supervisors

closed the museum because of budgetary constraints, and immediately over a thousand residents gathered on the museum steps in protest.[53] Samuel H. Kress, the New York City department store mogul and art philanthropist whose own collection of Italian masters hung inside, agreed to pay to open the museum for two weeks, and thousands more took advantage of his generosity.[54] The bumbling of the Board of Supervisors drew the attention of Edward Bruce, secretary of the U.S. Treasury Department advisory committee on fine arts, who pointed out that "one of the most important art movements in this country is . . . developing now in Los Angeles."[55]

In an effort to prevent another fiscal disaster, the attorney Walter Holsinger orchestrated a plan to build an art center in Hancock Park on land donated to the city for civic purposes. With free land and proposals to raise millions in private funds, Holsinger presented his ideas to the Los Angeles County Board of Supervisors in the spring of 1936 and included letters of support gathered from movie studio heads. Howard Franklin, former president of Fox West Coast Theaters, wrote:

At present, Los Angeles has fallen short of developing all of such elements required for success in the theatrical and amusement business. What is wanted is an interaffiliation between the various arts, supported by beautiful buildings equipped for modern and distinguished presentation of art objects and especially grand opera and spectacle plays. . . . I am especially attracted by the opportunity afforded to the motion picture industry. From conversations with my friends, leaders in motion pictures, I gather an earnest ambition to advance their craft as fine art. The [Hancock Park] plan gives them a place among the fine arts with superb facilities to advertise that position.[56]

Franklin clearly perceived civic culture and commercial amusements as potentially part of the same entertainment business. More significantly, Franklin's response makes clear that the film industry was anticipating the opportunity to legitimate itself as an art form; there was an incentive, whether the accumulation of actual profits or acquisition of cultural capital, for the movie studios to define their commercial products as art.[57] The nurturing of a civic art culture in Los Angeles not only served the promotional goals of the boosters but also increasingly created a cultural foothold for the film industry, which sought legitimation as a mainstream economic force rather than a marginalized immigrant craft. Max Factor, a Jewish immigrant from Lodz, Poland, became Hollywood's foremost studio and commercial makeup innovator, inventing greasepaint more flattering to the camera's eye and the identity of "make-up artist." In 1932, a few years before his death, Factor donated a collection of photographs to the county museum for an archive that preserved a record of his makeup studio and factory and also highlighted his role as an artist painting the faces of movie stars and starlets.[58] In the 1930s,

Figure 14. Max Factor paints the face of actress Marion Marsh as camera crew looks on, ca. 1931. Seaver Center for Western History Research, Natural History Museum of Los Angeles County.

then, two Hollywood impulses emerged. The first was a Hollywood popular front linking the labor movement to leftist artists, writers, and craftspeople in the movie studios, many of whom were veterans of New York's socialist theater and Weimar's left-wing cinema.[59] The other was a consolidation of studio power connecting Hollywood money to massive civic

projects that would not materialize fully until well into the postwar era. Within these efforts, Hollywood's immigrant talent could make claims to previously unattainable social and cultural status, a fact that made civic investment a priority for some of Hollywood's heaviest hitters.

The most significant change that the civic arts movement made in the 1930s was a shift away from building the singular museum or art center that had earlier obsessed the art clubs. In 1933, led by key civic leaders William May Garland, Harry Chandler, and UCLA founder Edward Dickson, the former Museum Patrons Association broke away from the county museum and reorganized as the Los Angeles Art Association (LAAA). The Depression had devastated museum resources and continued internal fighting among its directors led to the further atrophy of the art program. Moreover, longtime art patrons such as William Preston Harrison were growing increasingly impatient that the county museum's art department was run not by an art curator but by the Los Angeles County Board of Supervisors.[60] No longer beholden to the museum, the group of twenty trustees registered as a nonprofit and therefore could receive bequests, gifts, and other philanthropic contributions on behalf of the people of Los Angeles. As Arthur Millier put it, this was a hard-headed lot with tremendous investment in major cultural and civic institutions. Although it started out with all the civic hyperbole common to such art endeavors, announcing in the papers that "the dream held by so many civic leaders in the southwest [to] make Los Angeles the Athens of America was soon to be realized," the LAAA soon developed a more creative vision of both civic culture and modern art in general.[61]

The LAAA's first agenda item was to solicit as much help as possible from the Hollywood community. Its first exhibition, held in downtown's Central Library, featured modern works from the private collections of the actors Edward G. Robinson and Marion Davies, while Cecil B. DeMille, Samuel Goldwyn, Norma Shearer Thalberg, and Hal Roach served as sponsoring patrons.[62] Its second agenda item was to establish itself in a separate institutional setting and build a permanent collection, harnessing continued support from Hollywood. In a flurry of publicity, the LAAA announced its interest in acquiring the property of Edwin T. Earl, publisher of the old *Los Angeles Evening Express*. The mansion on Wilshire Boulevard was adjacent to the former residence of Earl's bitter newspaper rival, General Otis, the new Otis Art Institute.[63] In joining the two magnates' properties, the Earl mansion would provide the LAAA with its own institutional headquarters and create a public art gallery apart from the county museum while expanding the county's landholdings. The LAAA and the Los Angeles County Board of Supervisors tried to get federal funding through the WPA but were

declared ineligible by the local WPA office.[64] Nevertheless, in 1938 LAAA president William May Garland secured the option for $99,000 and petitioned the county to put aside $950,000 to cover the costs of developing the property. With the support of Mayor Fletcher Bowron, Harvey Mudd, Harry Chandler, the Arensbergs, Darryl Zanuck, Samuel Goldwyn, Sam Katz, and Jesse Lasky, the LAAA put forth a roster of huge names in politics, movies, and the arts in support of a new public art gallery and eventually succeeded in getting money from the county.[65] The county museum's Board of Governors fiercely objected to the purchase of the Earl property, arguing that another art museum was unwanted and unwarranted. Since the forming of the LAAA, the museum's director, William A. Bryan, had campaigned against the creation of any alternative public art galleries, going so far as to create his organization, the Los Angeles Museum Association and handing out brochures to museum visitors explaining his position.[66] Given the closure of the museum in 1934 and the notorious difficulty in having modern or contemporary art exhibits there, the Board of Supervisors had little trouble squelching the protest, although it would rear up again during the war when the rumors spread that the museum planned to take over the Earl property, close the gallery, and kick out the LAAA.[67] The association stayed put until 1957, when the mansion burned down, and the LAAA relocated briefly to Beverly Boulevard until its permanent relocation to La Cienega's Gallery Row in 1960. By having the LAAA so successfully connect city and county art interests with Hollywood, a new art space was created and protected, one that permitted modern and contemporary artists, most of them local, to have a place to show their work. Because of the grumblings of the county museum, the LAAA could not show traditional and classical work even if it wanted to, thereby competing with the museum's collections, so by the 1940s the association focused solely on the contemporary and avant-garde, with Man Ray's work forming one of its first big shows. With its commitment to modern exhibitions, and especially local artists, the LAAA moved in an increasingly independent direction, leaving behind its county affiliations almost entirely in 1944 when the wealthy *Art in America* critic Helen Wurdemann took over as Executive Director. Marking a sharp split with the county museum and the old civic arts movement, Wurdemann invited Lorser Feitelson, a well-known "hard edge" abstractionist, to help her run the LAAA.[68]

Despite the growing influence of Hollywood in all of its iterations and the best efforts of the Los Angeles Art Association, by far the largest supporter of the arts in this period was the federal government. The Public Works of Art Project (1933–34) and the Federal Arts Project (1935–43), both under the aegis of the WPA, became the largest art programs ever

undertaken in the United States, with over 10,000 artists across the country hired to produce over 120,000 paintings, sculptures, and murals, not to mention thousands of posters and photographs.[69]

The Federal Arts Project in southern California and the Los Angeles branch of the American Artists' Congress actively encouraged the production of populist artworks in the form of historical murals on the walls of public places such as libraries, hospitals, and government buildings.[70] Many of these murals were painted by well-known local modernists such as Lorser Feitelson and the surrealist Helen Lundeberg but in content, they often recreated conventional historical scenes such the signing of the Magna Carta or the landing of Cabrillo, the first Spaniard to arrive in California.[71] Artists were encouraged to paint scenes and incorporate themes that would appeal to a broad American audience and were strongly discouraged from experimenting with avant-garde images or painterly methods. Southern California regionalism's leading proponent, Millard Sheets, promoted depictions of rural life, using representational forms rather than abstract ones. Fletcher Martin, who had worked with Siqueiros on the Dudley Murphy mural, was deeply influenced by both the Mexican master and Thomas Hart Benton, depicting beautiful bodies at work in a wide range of contexts. His 1938 post office mural in San Pedro shows the physicality involved in mail transportation across the United States, while contrasting urban industrial contexts with that of the rural South and the Pacific Northwest. Many WPA artists working in Los Angeles, as well as those in other cities across the United States, tried to include labor issues and social inequality as themes in their work as part of a broader popular front politics but often faced opposition from within the WPA. Stanton Macdonald-Wright, the regional director of the Federal Arts Project in southern California from 1935 to 1940, harshly disapproved of their efforts and censored the social content of the Los Angeles murals, going so far as to paint out political symbols himself.[72] He later denigrated the Federal Arts Project as a bastion of amateur artists who set American art back 150 years.[73]

During the darkest years of the Depression, leftist supporters of the WPA art projects saw Siqueiros's muralism as a public art that could represent a radical, democratic vision for the United States, as well as provide work for people using particular talents and skills.[74] One WPA artist, a Siqueiros protégé named Myer Shaffer, attracted public wrath because he incorporated the Communist hammer and sickle and the international protest symbol of a raised, clenched fist, an image associated in the 1930s with supporters of the beleaguered Spanish Republic.[75] Shaffer, previously a Chouinard pupil, had been a member of the bloc that Siqueiros assembled to create *América Tropical*. At twenty-three, he was heralded in the local press as one of the best new talents in southern

Figure 15. Fletcher Martin, detail, San Pedro Post Office mural panel, 1936. Photograph by the author.

California. The praise followed from the unveiling of Shaffer's *The Social Aspects of Tuberculosis* at the Los Angeles Tuberculosis Sanitarium in 1936. The three-panel mural "depict[ed] the denials of food essentials, which [were] the cause of the disease, the cure of the disease, and the return of those who [were] cured to their original causal environment, there being no provision made for employment or rehabilitation after their release from sanitariums."[76] Unlike many muralists who painted anonymous subjects or, as the historian Michael Kammen has pointed out, imagined suitable subject matter without doing the research to support their choices, Shaffer spent time with patients in the sanitarium, consulting with them about their experiences as tuberculosis sufferers in southern California.[77] Emphasizing the class dimensions of illness rather than desert-climate cure-alls for the wealthy, Shaffer's murals undermined traditional booster images of the region as a health resort and challenged the idea of the sanitarium as a middle-class refuge. Instead, he emphasized the causes of tuberculosis that existed in southern California as well as in more crowded American cities: nutritional deficiencies,

poor working conditions, and poverty. Two years later Shaffer would complete another three panels of *The Social Aspects of Tuberculosis* illustrating the class dynamics of the fight against the disease.[78] Rather than reinforcing local mythology, Shaffer used public art to bring attention to real social issues in Los Angeles.

In July 1937 Shaffer completed a new hospital mural, this one at the Mount Sinai Home for Chronic Invalids. At four hundred square feet, *The Elder in Relation to Society*, was far larger than anything he had previously done. Like the tuberculosis series, Shaffer used his artwork to draw attention to social crisis, this time that of elder care. He explained in the *Hollywood Citizen-News* that he placed the Jewish biblical figures Judas Maccabee and King David in the foreground to demonstrate "that age does not incapacitate."[79] Yet, the mural delivered a much stronger social message, for in the upper detail of the fresco Shaffer painted five figures depicting different racial and ethnic groups and a sixth figure clearly representing death. The mural implied that since age and death do not discriminate perhaps people should not either. A writer for the *Jewish Community Press* noted that the mural extended "a plea for united understanding and a closer brotherhood of the white, black and yellow races."[80] Shaffer's message of brotherly love was clearly too much for a convalescent hospital; several months later the administration whitewashed the mural. Shortly thereafter the Los Angeles Tuberculosis Sanitarium also whitewashed the clenched fist from one of the panels of *The Social Aspects of Tuberculosis*.[81] As in the whitewashing of *América Tropical*, it is unclear precisely who deemed the murals inappropriate.

As a contemporary of Siqueiros, Shaffer could not have been surprised by the uneasy reception of his own murals. He credited the Mexican master with bringing a genuine excitement to the Los Angeles art community and viewed Siqueiros's subsequent deportation as detrimental to a growing art movement in a city previously devoted to benign landscapes and apolitical civic art. Shaffer credited the Federal Arts Project with encouraging public art in the city but kept track, in the *Jewish Community Press*, of the increasing number of murals painted over by the Los Angeles Board of Education and other local authorities.[82] Shaffer noted in the local paper that one of the critical problems with civic art in Los Angeles was its lack of historical accuracy or relevance and its uncritical celebration of its colonial past. Defending Siqueiros's artistic and political choices for the Olvera Street mural while wincing at Los Angeles' regionalism, Shaffer wrote, "Another fallacy that we find in numerous murals is the disregard of the truth of historic events. An example of this is the Spanish colonization of the West, where we find portrayed the Indians and Spanish Padres in a Mission setting. A mural

should be as powerful and moving as a symphony in form and color, not a pretty melody in paint."[83]

Los Angeles was certainly not the only city in the United States that had problems with muralists in the 1930s but it was the major city in which public art controversies were sustained as the critical sites for other ideological and political conflicts during the decade.[84] These controversies no doubt involved grander metaphysical questions about what constitutes art and what kind of art is appropriate for public spaces. However, the consistency with which Los Angeles struggled with art in public places before, during, and after the great era of 1930s WPA murals speaks to the problems posed by modernism into which public artists invariably stumbled, whether purposefully or not, and their relationship to the specific local political and social issues that played such a fundamental role in defining the city's civic identity. That Los Angeles had constraints on public modernism at the same time that it innovated public art methods underscores the tension between art practice and art politics in the first decades of the twentieth century. Art generally, and art in public spaces more specifically, served as the tools through which social complexities of modern urban life would be worked out by artists, politicians, residents, and critics. Modern art proved an elastic vessel, again and again, into which broader political discourses could be placed.

Given art's myriad roles in Los Angeles, Myer Shaffer was certainly not alone in experiencing the difficulty of publicly displaying a progressive modernist vision of racial equality and social justice. Many Angelenos saw the changes in galleries, on walls, and exhibited in museums as a vulgarization of the highbrow ideals that the Municipal Art Commission and Artland, among others, had tried to instill in the city's polity in the first decades of the twentieth century. In response to a modern-art exhibit at the county museum, one disgruntled artist wrote the *Times* to say that the "exhibition look[ed] . . . like a freak show and a product of either the savages of darkest Africa, the cannibals of Papua Island in the South Seas or the inmates of an insane asylum."[85] The same exhibit also drew fire from other members of the traditional arts community, mostly for the exhibition of paintings done in the Mexican modern style of representational figures depicted in rounded shapes surrounded by surrealistic scenes and vibrant colors.[86]

Such inherently racist reactions contributed to the struggles of other art communities in Los Angeles, particularly the African American arts scene. The first documented show of black art in the city was in 1929, hosted by the California Art Club in Barnsdall Park. The exhibit was not indigenous to California but was organized in Chicago and traveled throughout the country. Three local black artists, Constance Phillips,

Paul Williams, and A. F. Taynes, were represented in the exhibit, which was brought to Los Angeles by Dr. Elzora Gibson. The show was described as a collection of "seventy canvases of the leading negro artists of the United States" and was widely advertised in the local papers.[87]

The show was well received by visitors, and yet it mystified Los Angeles' foremost critic, Arthur Millier, who could not reconcile his pre-conceptions of what "negro" art looked like and what he saw exhibited in the Barnsdall Park gallery: "It is difficult to find anything specifically negro in most of the works shown. There is, to be sure, some good paint-ing and at least one excellent piece of sculpture. . . . But, in general, the trained artists of the group exhibit almost nothing to suggest the distinctive qualities of their race."[88] As pedantic as this was, Millier did not stop there. In his lengthy review, he salvaged some "negro naiveté" and "negro warmth" from paintings by John Wesley Hardwick and Wil-liam Edward Scott but on the whole Millier was clearly disappointed and frustrated that an essentially African American artistic trait did not emerge from the exhibition. He continued to ponder why this was so: "It is amusing to consider the temporarily topsy-turvy state of art in the world. Here we see the cultivated negro working in a purely European tradition, while the leading modernists of Europe and America have modified their whole conception of design to admit the works of [. . .] African sculptors of an older day, in many cases imitating the very shapes of bodies and faces carved by these ancient dark brethren. It would be much easier to assemble what looked like a negro art exhibit from among white artists than from the artists here represented."[89]

As condescending and racist as Millier's comments were, they are use-ful in how they belie the certainly vast distance between Los Angeles' white bourgeois art world and the African American scene as no one well acquainted with black art would describe it this way. The review also lays bare Millier's naive reading of modern art, as the moderns to whom he makes broad allusion (Picasso, most famously) were not deriving their African inspiration from "the ancients" but from contemporary painters and sculptors. Given that there were no public exhibits of black art in the city until 1929, Millier's expectations of black artistic authen-ticity may have been fueled by W. E .B. Du Bois's promotion of the Los Angeles staging of his theatrical pageant *Star of Ethiopia* in 1925. The widely publicized pageant, which was performed at the Hollywood Bowl, depicted the decline of Ethiopia and the tragic descent of Africa into the slave trade, traced the entrenchment of American slavery and cele-brated, ultimately, the rise of the "New Negro" in the 1920s. The black papers and the *Los Angeles Times* promoted the pageant as a significant contribution of the African American community to the city's civic cul-ture. However, as Doug Flamming argues, the staging of *Star of Ethiopia*

in Los Angeles also connected local black artists to the rising New Negro arts movement. This helped black artists feel that they too were part of a broader art world and that Los Angeles might actually be moving out of its position as a cultural backwater vis-à-vis New York and Chicago. For a politically marginalized community, the cultivating of the New Negro arts movement locally was profoundly important because, as Du Bois had been pointing out for two decades, art was indeed political. If white racism rested on assumptions of black inferiority, then it fell upon black artists to innovate new artistic forms and undermine those assumptions. As Flamming notes, "By the end of the 1920s, most of the younger generation of New Negroes would dismiss this simple political formula; but in 1925, Du Bois's idea fired the imagination of the Junior Branch and set *Star* in motion."[90] The actual staging of *Star of Ethiopia* proved highly controversial within the black community, laying bare a significant generational divide in Los Angeles' black middle class. Despite the enthusiasm of the press, the pageant was poorly attended and organizers mortified.[91] Nevertheless, there were tremendous social and political implications at stake in inserting black modernism into Los Angeles' civic culture, and this import was lost on neither artists nor political leaders. That public viewing of *any* modern art was inhibited in the city put an exponentially greater burden on artists of color to show their work.

That black artists in Los Angeles had to slog through a mire of provincialism and racism during an era when public modernism was emerging out of the shadows reveals how deeply Los Angeles' struggles with modernism actually ran. It is significant that there were no black art controversies raging in the mainstream Anglo press; instead, black modernism was either disappointingly "inauthentic" or a naive craft unbecoming the city's high art aspirations. African American artists received more attention later in the 1930s, with Beulah Woodard emerging as a significant sculptor in her own right and becoming the first African American to have an exhibition at the county museum. The papers, however, derided her 1935 exhibit of Afrocentric masks and sculpted heads as a collection of "bizarre" artifacts rather than contemporary art. In addition, in 1937, when Woodard helped found the Los Angeles Negro Art Association, the group was invited to display at the prestigious Stendahl Gallery but on the back patio rather than in the main gallery space.[92] As feminist art historians have pointed out, the struggle with the social and spatial restrictions of racism, combined with the difficulties of being taken seriously as a woman, led Woodard's Los Angeles modernist career to be characterized by obscurity punctuated with occasional local, and even national, exposure.[93]

Given the controversy posed by Mexican and Jewish artists, the lack of concern regarding African American work quite likely speaks to the fact

that the white bourgeoisie did not feel particularly threatened by black art. Los Angeles' racial hierarchy and segregation patterns were firmly in place and maintaining that black modernist art represented historic "artifacts" rather than contemporary cultural and political expressions helped reinforce white conceptions of blackness as something exotic, foreign, and marginal rather than current, local, and part of the civic mainstream. In much the same way that Olvera Street and the trope of the Spanish fantasy past rendered Mexican Angelenos embalmed in a distant historical moment (at least in the Anglo aesthetic vision of Mexican culture), the discounting of African American art helped place the black community in a type of historical deep freeze. Race would prove more obviously problematic in art debates after World War II, when legal challenges to racial segregation were made loudly in the courts and the papers and racial marginality was made the critical political issue.

The cultural politics of the 1930s revealed a deep split in Los Angeles' civic imagination as modernism clearly emerged as the art of the Left while conservative civic leaders worked hard to repress it. At the same time, the maturing of the cultural infrastructure through the LAAA and Hollywood investors meant that old civic art clubs had lost ground and that growing support for modern and contemporary art lay on the horizon. The clubs would not go quietly, and the increasingly obsolete split between "traditional" and "modern" art would become politically charged in new and unexpected ways when cold war rhetoricians found themselves most comfortable bedfellows with the antimodernist proponents of censorship.

Chapter 3
Painting the Town Red

Immediately following World War II, the United States laid claim to a new episode in modern art, that of the hypermasculine, energetic action painting made famous by Jackson Pollock. Bolstered and promoted by the critic Clement Greenberg, who established the formalist parameters of postwar modernism, and an aesthetic feature seamlessly assimilated into *Life* and *Vogue* magazines, abstract expressionism dominated the national art scene. Of artists innovating this genre, Pollock was the best known in the United States, but he had famous fellow travelers in Willem de Kooning, Hans Hofmann, and Adolph Gottlieb, among others. Abstract expressionism as a national movement has been the subject of much study: as a direct historical continuation of the European moderns, as a defining moment in the solidification of an American bourgeoisie, and as an anti-Communist tool of the cold war. In postwar Los Angeles it was mostly derided and censured for its communist and subversive content. As paintings by Pollock, Arshile Gorky, de Kooning, and Robert Motherwell were circulated and celebrated abroad as examples of American freedom and superiority on the cultural front of the cold war, Los Angeles' civic art clubs and councilmen worked to run abstract expressionism, and modern art in general, out of town on a rail.[1]

The answer to why postwar modernism should have such a different reception in Los Angeles than in New York lies in the close connection between civic identity and art that Los Angeles maintained for the first decades of the twentieth century. At that time control of civic identity, control of art, and control of political life were all in the hands of the same people: boosters, businessmen, and civic leaders. That control slipped precipitously in the 1930s as murals highlighted the social inequities of southern California's political economy, Hollywood's images replaced produce packing crate labels as the region's key visual export, and marginalized modernists moved closer to the cultural mainstream. After the war the civic art clubs were overwhelmed by a demographically diverse and increasingly modern city. This modern urbanism could be found in the new freeways, the prefab suburbs, and a new municipal

bureaucracy that found it increasingly difficult to operate effectively in the fragmented and decentralized postwar city. One club in particular, the California Art Club, which had entertained modernism in the 1920s and 1930s, grew vulnerable, defensive, and politically nasty after the war, relegating modern art, and especially abstract expressionism, to the despised and dangerous category of "subversive propaganda."[2]

Those fearful of abstract painting's effects on civic culture were right in the sense that it was a flexible vessel for political discourse and cultural representation that could be appropriated by anyone. Abstract expressionism, in fact, occupied a highly politicized cultural space as the nation's "official" art. In 1946 the U.S. State Department purchased seventy-nine paintings to tour Europe and Latin America as a two-part exhibition entitled "Advancing American Art." The exhibition included well-known American moderns such as Stuart Davis, Arthur Dove, Jack Levine, Ben Shahn, and Max Weber and was intended to promote modernist paintings abroad as symbols of freedom, democracy, and consumer capitalism. It was promptly attacked in eighteen Hearst papers for being a "Red Art Show" and was recalled by the State Department.[3] One of the loudest opponents was Congressman George Dondero, Republican representative from Michigan, who on the floor of the House in 1949 targeted abstractionism as one of many "isms" that seemed foreign and un-American—vague, indeed, but useful at a time when even implied left-wing sympathies rendered a political opponent vulnerable to public derision. The art historian Fred Orton argues that Red Scare tactics aside, ultimately abstract art served as a useful tool for a fractured national bourgeoisie struggling for political and cultural representation—a struggle that found itself articulated in the ideologies of the cold war and the move by the United States to imperialism from traditional expansionism after World War II.[4] Abstract expressionism too could be harnessed to that cause. By 1954 even staunchly anticommunist President Eisenhower commended New York's Museum of Modern Art for promoting freedom in the arts, stating, "For our republic to stay free, those among us with the rare gift of artistry must be able freely to use their talent . . . As long as our artists are able to create with sincerity and conviction, there will be healthy controversy and progress in art."[5] Abstract expressionism's role as such a flexible, and ideological, political tool perhaps helps explain the intensity of antimodernism in 1950s Los Angeles as predominantly middle-class factions fought for space and power in the postwar city.

The decade following World War II marked a critical period in the spatial and cultural development of Los Angeles. As the city grew exponentially, and its widely publicized self-image as the paragon of American suburbia matured into a national fantasy of the good life, Los

Angeles ruptured into well-documented disputes over space.[6] Politicized struggles for space in Los Angeles, such as the red-baiting of public housing, slum clearances, and blatant residential segregation, also manifested themselves in the arena of civic art. The period from 1947 through 1955 was riddled with local controversy in which modernist abstract painting and sculpture first came under attack for containing subversive communistic political messages and later fell victim to race-baiting for failing to represent a uniformly white citizenry. As suburbanization, freeways, and decentralized sprawl fragmented the city, civic art, the visual form of civic culture, proved particularly contentious for diverse communities struggling for political power and cultural representation.

One of the new constituencies to enter the civic fray was war veterans. In 1944, Congress passed the Servicemen's Readjustment Act, known as the GI Bill of Rights, which offered stipends of up to five hundred dollars a year to allow returning soldiers to attend college or trade school.[7] The subsidy program put more than two million male students through school nationwide, many of them the first in their families to receive college education. The GI Bill would have important implications for American art as many of the male artists who became famous in the 1960s were war veterans who leaped at the opportunity offered by the federal government to attend art school.[8]

The GI Bill directly affected art politics in Los Angeles. The city's three art schools, Chouinard, the Art Center School, and Otis, filled to capacity as veteran enrollment ranged anywhere from 40 to 80 percent of the total student body.[9] The huge enrollments affected class availability and the curricula and the vets proved a vocal lot. Wearing their military uniforms, students picketed the Art Center School in May 1946 because of tuition charges in excess of the GI Bill subsidies and to protest the unfair dismissal of a colleague for misbehavior.[10] The Art Center School had been supportive of soldiers' art classes during the war, holding "Art for Defense" classes, in which students studied the art of war and defense posters, newspaper cartooning, caricature and animation, commercial art, and bomb shelter design.[11] The school went out of its way to schedule classes to fit defense workers' employment schedules and helped connect students to military art contracts. After the war, however, veterans felt that the school was not living up to its promise and made their discontent public.

Otis too suffered from overcrowding and inadequate housing as student enrollment swelled. In an effort to control the overcrowding, the county museum's Board of Governors proposed two options to the Otis Art Institute administrative staff.[12] The first asked the county to cut back on scholarships and class size in order to discourage enrollment at the

school. The second option required Otis to drop its commercial arts program.[13] Neither was acceptable, and Otis's Dean Edwin Roscoe Shrader, former member of the popular front American Artists' Congress and director of the California Art Club, understood the proposal to drop the commercial arts program as an underhanded effort to dump GIs from the school.[14] Led by U.S. Marine Corps veteran Milow Reckow, dozens of GIs organized a march protesting the Board of Governors' action. They were joined by members of the Otis Art Alumni Association and the California Art Club. In response to the protest, the Los Angeles County Board of Supervisors voted 3 to 2 to recommend that the county museum's Board of Governors to rescind its action to change Otis's curriculum.[15]

The protest action helped suspend the Board of Governors' action and it also marked the beginning of an unusual alliance between returning GI art students and the city's art clubs. While coming from different ends of the social spectrum (the GIs were overwhelmingly working class and male, and the art club members were upper middle class and both female and male), the two groups found themselves at the margins of Los Angeles' civic art programs as a result of a sea change instigated by the county museum. At the same time that the board proposed the curriculum change at Otis, it also ended the annual exhibits hosted for years by the city's art clubs in the museum's main galleries. The official reason was a lack of space due to the steady growth of permanent collections.[16] In his weekly column, however, *Los Angeles Times* critic Arthur Millier suggested that the real reason was that the art clubs' exhibits were of inferior quality and not up to the task of making Los Angeles the art center that booster and civic leaders had planned for decades. He wrote that the clubs' exhibits were "seldom very distinguished and [were] repetitious. No great museum [should] give them great galleries at the expense of its true duty to the community, which is to show the important art of past and present to the public."[17]

The art clubs involved—reactionary members of the California Art Club, the Painters and Sculptors Club, the Society for Sanity in Art, and the Women Painters of the West—loudly protested but to little avail. The clubs were welcome to participate in the county's annual Artists of Los Angeles and Vicinity exhibition, open to all resident artists, but they were no longer permitted to use the museum galleries.[18] This was a huge hit for the clubs as the museum-based shows provided maximum exposure for the artists involved and gave the clubs the forum for gaining new membership. Stodgy, perhaps, but the County Museum of History, Science, and Art was nevertheless still *the* civic art institution in the city and the only one that could attract celebrity audiences. During the war, for example, reigning pinup queen and Hollywood star Rita Hayworth

served as the first woman judge in the annual show of the Painters and Sculptors Club, earning both the club and the museum front-page visibility in the *Times*.[19] For the long-standing civic art clubs, access to the museum space was essential and exclusion tantamount to their end as significant in the broader cultural landscape. The museum, whose dominance was increasingly challenged by the Los Angeles Art Association's attention-getting modernist exhibitions, understood that the clubs' traditional landscapes were outdated and had to go. Seeing the writing on the wall, the clubs allied themselves with the bereaved GI art students. The California Art Club thereby sponsored the first annual GI art and crafts show. Heralded as an enormous success by the local papers, the show attracted over sixty thousand visitors in a month and included painting and commercial and industrial crafts such as interior design, cartoons, silverwork, and leather goods. The exhibit publicly made the point that commercial arts should be maintained as part of Otis's curriculum and kept the California Art Club's toe in the door.[20]

The removal of the art club exhibits from the county museum marked an important moment in the history of Los Angeles' civic art. In addition to the booster role they played in building a civic identity for the city as a sophisticated world metropolis, the art clubs had also represented an important political vehicle for the upper middle class whose local power extended to the Chamber of Commerce and the Municipal Art Commission. It was clear by the end of the war, however, that the art clubs no longer wielded the power they once had. In their place, the county institutions (the County Museum of History, Science, and Art and the Otis Art Institute) and the new Municipal Arts Department emerged as the central civic art organizations. The art clubs would not remain quiet about their exclusion from the museum and their perceived persecution for maintaining traditional painting styles, and they would eventually break into a politically reactionary group (Society for Sanity in Art) and a progressive group (Council of Allied Artists). In the late 1940s and the 1950s, the clubs struggled as they attempted to reestablish themselves as the heart of the city's civic culture.

The county museum's annual Artists of Los Angeles and Vicinity exhibition, held in Exposition Park, was one especially charged site for this local political struggle in an era remarkable nationally for frequent news stories about American art museums and questions of cooperation with municipal, state, and private institutions.[21] The organizers of the exhibit, started in the early 1920s, invited all interested southern California artists to submit oil paintings and sculptures to the museum's jury. This jury changed every year and consisted of artists, art critics, and museum directors, mostly from California. The jury's selections were shown in the exhibit, which generally lasted through the late spring and

summer months. Of the selected artworks, usually several hundred, a few dozen were chosen for awards and purchase prizes. The cash value of these awards by the late 1940s ranged anywhere from seventy-five dollars to five thousand dollars, with the prize money donated by private sources.[22]

These annual exhibitions became a point of contention for the California Art Club and the final straw in what members saw as an organized effort to push them out of civic affairs. In 1941 the club's lease of Hollyhock House in Barnsdall Park expired under the terms of the deed by which Aline Barnsdall had granted them use of her property.[23] With no municipally sponsored clubhouse, the California Art Club lost its institutional base. Then, in 1945, the art club members were excluded from their usual exhibition space when the county museum took back their allocated gallery. The final insult was what they believed to be the museum's efforts to replace traditional landscape painting and portraiture with more abstract works, undermining the clubs with a "radical" agenda and unfairly preventing their paintings from competing on even terrain. The two-year-long dispute with the museum must have reflected internal frustration and political strife within the California Art Club as many of its members had previously, in fact, been active on the Left and modern painters themselves. With Hollyhock House at their disposal (and free) and progressive leadership within a different political climate, club members could sustain their own "radicals" quite contently. Once Hollyhock House was gone, key popular front members moved on to other projects, and once the museum took away its exhibition space, the club grew vulnerable and defensive. The growing anger within the California Art Club was given voice in 1947 during the "Artists of Los Angeles and Vicinity" exhibition and the sensational art controversy that soon ensued.

On May 15, 1947, the county museum opened the show. Six painters and sculptors were awarded cash prizes by three judges, one of whom was the Hollywood actor and Modern Institute of Art founder Vincent Price.[24] Shortly thereafter the artist Roy Walter James placed himself on the front steps of the museum with two paintings, one a landscape and the other a still life. He also held two signs. One asked "Why give cash prizes to fakers and junk peddlers?" The other stated that "Degenerate junk should be thrown out—fine paintings rejected." Five days later James was joined by two hundred California Art Club members with easels and paintings, who joined the protest of the museum's display of "subversive propaganda" and art with a "communist taint."[25] Using language that Representative Dondero would make famous two years later, club president Edward Withers wrote museum director James Breasted,

Jr., that the California Art Club was interested only in the "promotion of art containing no 'ism' but Americanism."[26]

The demonstration attracted museum supporters, who mocked the protesters so voraciously that the police stepped in to prevent violent altercations. The incident was newsworthy enough to land Los Angeles in the pages of *Life*. "The outraged artists set up their own canvasses on the museum's steps and terrace and along the walls as examples of what should have been shown inside. Then they marched around the museum demanding that the director should resign. Instead . . . James H. Breasted Jr. remained in his oak-door office and quietly called the police. Three patrol cars rolled up to the museum's entrance and a swarm of police waded through canvases of sunsets, mountain land-scapes, pretty nudes, and Chinese vases."[27]

Life rather astutely concluded that "demonstrations of protesting art-ists are nothing new in the art world, but normally the protesters are modern artists fighting against being locked out by academicians. In Los Angeles, however, where normality is not normal anyway, the tradition was turned about. The museum protesters were a conservative group which turned out pretty, recognizable paintings."[28] Back in Los Angeles, where headlines blared "Red Hunt Shifts to Art Show" and "Police Cool Frayed Tempers, Avert Brawl at Art Exhibit," Vincent Price perhaps took the harshest line. In the *Los Angeles Times*, Price wrote, "It is partly the inaction of organizations like the California Art Club that has consigned Los Angeles to a relatively unimportant place among the nation's art centers. These clubs have attempted to dictate the taste of the commu-nity in the fine arts. They have . . . hidden their heads in the flower-blanketed sands of the desert they paint so prettily." [29]

Preceding the inquiry into Hollywood by the House Un-American Activities Committee (HUAC) by several months, the red-baiting by the California Art Club had little official effect other than embarrassing press for the city's art scene. There were no arrests, hearings, or censor-ship, and the county museum made no concessions. The Los Angeles County Board of Supervisors, however, unhappy with the negative pub-licity, passed a motion to move future contemporary art exhibits to the Los Angeles County Art Institute (formerly Otis) and to leave the "museum to exhibit old masters."[30]

Most broadly, the 1947 art controversy is important because it marked Los Angeles as the reactionary urban center for antimodernist politics and showcased the publicity one could receive when painting with the red-baiting brush. Furthermore, the controversy highlighted the "mod-ernism is communism" equation that underscored postwar McCarthyite cultural debates nationwide, thereby granting Los Angeles the rather dubious honor of being the nation's leader in antimodernist discourse.

Locally, the significance of the 1947 controversy lies in the fact that red-baiting was initiated by artists themselves, and the central issue was the institutionalizing of the modernism that had previously hovered on the margins of the city because of limited pubic exhibition space.

As the local civic institutional structure—represented by the county museum, the Municipal Arts Department, and the Los Angeles Art Association—followed national precedent and promoted modern art, the clubs dug in their heels and deployed newly fashionable red-baiting tools to try to reinstate themselves as the deacons of civic culture. The California Art Club was later joined by other conservative art clubs including the nationally organized Society for Sanity in Art, the San Fernando Valley Professional Artists Guild, and the Coordinating Committee for Traditional Art. Together, the conservative art clubs red-baited any civic entity that they felt unfairly excluded their landscape and still-life paintings in favor of modern art. In 1947 the county museum drew their wrath, in 1949 they objected to the appointment of the new Municipal Arts Department director, and in 1951 the art clubs attacked the Municipal Art Commission for allowing abstract art in citywide art competitions. By the early 1950s red-baiting in the art world became an even more effective tool for asserting conservative control over the city's civic culture because of the growing political tension surrounding the demographic explosion and the urban policies implemented to deal with it. Residential segregation and public housing were two of the most charged and challenged of these postwar urban issues.

Population growth, defense-based industrial development, and suburbanization took place in cities across the country but were especially pronounced in Los Angeles where state-managed industrial production fostered postwar prosperity at the same time that the characteristics of this prosperity (white flight, freeways, suburban lifestyle, mass consumption, and ethnic homogeneity) helped reinforce racial segregation and urban decline in minority areas.[31] Though racially restrictive covenants were found unconstitutional in 1948 by the U.S. Supreme Court in *Shelley v. Kraemer*, property owners and developers nevertheless found ways to limit nonwhite access to the suburbs. Unfettered racial discrimination in GI Bill housing projects proved one way around the ruling. In 1950 black veterans enlisted the help of the local National Association for the Advancement of Colored People (NAACP) branch to protest the "exclusive and restricted invitations to white veterans from the builders of the Sunkist Gardens project." The developers of Sunkist Gardens, a veterans' suburban housing project in southeast Los Angeles, priced housing tracts on a two-tiered, racially biased scale that placed the normally affordable housing out of a reasonable price range for black veterans. If the overpriced tracts did not prove enough of a deterrent, according

to the *California Eagle,* the "Negro vets who apply [were] told that the development [was] for white veterans only."[32]

Freeways too contributed to postwar Los Angeles' dual trends of suburbanization and segregation. Facilitating white access to and from the suburbs, the freeways cut through black and Latino neighborhoods, devastating property values and virtually assuring the decline of those areas. Los Angeles' freeway system began with the construction of the Arroyo Seco in 1938 but accelerated significantly with the federal government's passage of the Interstate Highway Act in 1956, which allotted $28 billion nationwide for road construction. As a result of the federal subsidies, between 1950 and 1970 the California State Division of Highways built a fifteen-hundred-mile freeway circuit in Los Angeles designed to serve over ten million vehicles. The growth of the freeway system in Los Angeles meant the death of a convenient, easily accessible public transit system, without which the city lost the integrated public spaces created by mass transit in other major American cities.[33] Without these public spaces, white Angelenos could simply enter the freeway from their own neighborhoods in the suburbs; travel across African American, Mexican, Chinese, or Japanese districts without ever knowing it; and end up exiting the freeway in other white neighborhoods, blissfully unaware of the racially segregated city surrounding them. The federally subsidized freeways not only contributed to the material decline of minority areas (both by cutting through those neighborhoods and by funneling even more funds toward suburban development rather than to inner-city areas) but also helped foster Los Angeles' white civic identity by rendering nonwhite Los Angeles practically invisible to commuting white suburbanites.[34]

Racial segregation was compounded by loyalty tests and HUAC hearings. After Truman's 1947 initiation of the federal loyalty program, the Los Angeles County Board of Supervisors voted for an investigation of its twenty thousand county employees, who were required to swear, under oath, that they had never been members of the Communist Party.[35] Then, in the fall of 1947, HUAC turned its attention to Hollywood and began its famed investigation of Communist infiltration of the motion-picture industry. Screenwriters, directors, actors, and producers were subpoenaed and brought before the committee to answer questions about their political affiliations. Those who pleaded the First Amendment and refused to testify to the satisfaction of committee chair J. Parnell Thomas became notorious as the Hollywood Ten. The Hollywood Ten served six-month prison terms for contempt of Congress and were blacklisted, along with more than a hundred others, from the movie industry.[36]

In the wake of HUAC's attack on Hollywood, red-baiting became the

most powerful political tool in Los Angeles as public housing and public art also came under fire by reactionary politicians. HUAC hearings with celebrity witnesses ensured widespread press for the committee members, and soon municipal councilmen craved the same. When a postwar housing shortage led to a broad-based movement for federally subsidized housing, red-baiting joined restrictive covenants and redlining as the primary means of privileging white middle-class home ownership. The drive for public housing, which began in the 1930s as part of New Deal relief programs, accelerated after the war as it became clear that the combined factors of a postwar population boom, returning GIs and Japanese internees, and restricted housing for blacks, Mexicans, and Asian Americans would cause a severe housing shortage.[37] As Los Angeles entered the postwar period, its government became divided between New Deal liberals and the anti-Communist conservatives who would dominate much of American cold-war domestic politics. Until its defeat in the 1953 mayoral election, public housing became an easy target for red-baiting conservatives on the prowl for supposed Communists in liberals' clothing. Antiunion supporters of conservative councilman Ed Davenport deemed public housing a "Russian Communist Socialistic Housing Project" that would destroy "our free enterprise system."[38]

With discriminatory urban policy the rule after the war, it became crucial for minority Angelenos to participate in civic culture in order to stake their claim for inclusion in the political and economic life of the city. Whereas in 1937 the Los Angeles Negro Art Association found itself relegated to the back patio of prestigious private art galleries, in 1950 advertisements for every type of community art and cultural project were posted in black papers, such as Charlotta Bass's *California Eagle*.[39] Bass encouraged participation in civic chorus programs to perform at the Hollywood Bowl, announced the formation of the Co-op Art Club, and rallied her readers when the Los Angeles Negro Concert Band performed at Exposition Park because the concert, sponsored by the Los Angeles Bureau of Music and Art and union locals, "mark[ed] an important facet of Los Angeles' project to provide 'more music for more people.'"[40]

Other groups focused on civic culture as a strategic political site, often forging interethnic connections in the process. The *California Eagle* regularly reported on events such as "Mexican Culture Nights" organized by Latino activists, councilman Edward Roybal, Rudolph Rivera of the Catholic Youth Organization, and Ignacio Lopez of the Los Angeles Housing Authority at the neighborhood Jewish Community Center. Sponsored by the Mexican Art and Cultural Committee, "Mexican Culture Nights" worked much like similar events hosted by the California Art Club: guests were treated to performances or art exhibitions, fol-

lowed by educational lectures about art history in general or the specific artists shown. Prizes of one-man shows at local art galleries and purchase prizes encouraged local artists to show their work and offered up much needed exhibition space.[41]

The *California Eagle* in particular showed Los Angeles civic culture to be a key site for political jockeying in the city.[42] The paper not only rallied ethnic Angelenos to participate visibly to prevent exclusion from civic life but also targeted civic culture as a racialized site where discriminatory urban policy might be overturned or, at the very least, publicized and renegotiated. Alongside the promotional announcements for cultural activities ran column after column describing racial discrimination in real estate and property sales. In one incident, described by the *Eagle*, the Los Angeles branch of the NAACP protested the building of a county-funded civic center in Lakewood because the property was covered by a restrictive covenant preventing black home ownership in that neighborhood. Approved by the Los Angeles County Board of Supervisors, county authorities intended to build an arts center with public funds in a neighborhood where no black person could own or rent. In its protest to the board, the NAACP argued that "the developers of Lakewood have consistently refused to sell, lease, or rent any property in Lakewood to Mexicans, Negroes, or Orientals." Moreover, the NAACP charged that every effort had been made to "impose residential segregation and the County's acceptance of a deed to property to be used as a civic center . . . with full knowledge of, and acquiescence in, racial restrictions help[ed] effectuate residential segregation."[43] In an era of court battles over residential segregation, a newly built, publicly funded civic center in a notoriously segregated suburb was a glaring example of racial discrimination.

At the same time that the housing boom benefited many white residents, an enormous housing shortage befell the city's nonwhite and working-class population. The shortage began during the war when defense industry workers flooded the city. The situation was so bad that whole families went without shelter, often sleeping on sidewalks.[44] The Los Angeles City Housing Authority privileged white defense workers and offered them what limited public housing existed against protests of racial discrimination by the Communist Party and the Citizens' Housing Council.[45] Black defense workers were limited to the black districts and "Little Tokyo," or what the local Communist Party reported as a "new slum area largely settled by newly arrived war workers after the evacuation of Japanese merchants."[46] Mexican defense workers were left to find housing in East Los Angeles, often far from their places of work, a frequent complaint from defense workers.[47] The need for housing was so severe that Aline Barnsdall offered her Olive Hill property, in the hands

of the municipal government since 1927, as a home for discharged soldiers.[48] The population explosion even led Los Angeles' great booster institution, the Chamber of Commerce, to announce that it "has long since abandoned its efforts of encouraging people to move here."[49]

In order to house everyone adequately, Los Angeles needed 280,000 housing units built annually. To meet this need, the Los Angeles City Housing Authority, the city council, organized labor, and the Los Angeles branch of the Communist Party rallied behind Mayor Fletcher Bowron, imploring him to seek help from Washington to build subsidized housing. Bowron did so, but it was not until the signing of the 1949 Housing Act that the Los Angeles City Council was able to approve $110 million for the construction of 10,000 units of public housing. Seemingly defeated by the Housing Act, anti-public-housing factions including the real estate lobby and the Chandler and Hearst newspapers, rallied corporate support, as well as support from within the city council, to paint public housing as a socialist scheme. Antihousing interests cast the controversy as a struggle between patriotic Americans and "Communist-front" organizations and between "free enterprise" and "socialistic public housing." The end result, and the goal of the antihousing factions, was Bowron's reelection failure in the 1953 mayoral race. The victor, Norris Poulson, immediately took measures to cut the housing program.[50]

By undermining public housing, conservatives did not simply target potential Communists (often ruining their careers) but also devastated the black and Latino communities, where residents lost their homes when urban renewal and redevelopment pushed them out of their neighborhoods. Rather than join the fight for public housing, most white Angelenos left the battle to ethnic minorities who were excluded from the suburban boom.[51] Public housing then became as much an issue about racial discrimination as it was a class issue about affordable housing. Angelenos of color understood that anti-public-housing measures targeted them by preventing the institution of affordable housing in Los Angeles and by encouraging the nemesis of all low-income neighborhoods, urban renewal. Instead of subsidized housing becoming the basis of a neighborhood's revival, urban renewal inevitably meant the removal of low-income residents and their replacement by either private, corporate development or white middle-class gentrification.

The postwar moment indeed marked the period in Los Angeles when corporate funding of the arts began to have a marked effect on the cultural geography of the city, particularly with the Bunker Hill redevelopment project and the building of the downtown Civic Center. Serious work began on the Civic Center shortly after the war and eventually included the Dorothy Chandler Pavilion, the Mark Taper Forum and the

Ahmanson Theater, and the Museum of Contemporary Art. These cul-
tural institutions continue to stand side by side with financial offices and
county and city administration buildings. To build these institutions of
high culture in downtown Los Angeles, Bunker Hill, an integrated,
working-class neighborhood, and home to hundreds of elderly pension-
ers, had to be razed and rebuilt. The end result was a segregated down-
town divided between the white, affluent banking and cultural sector at
the top of the hill and the predominantly poor Latino and Asian market-
place located at the bottom.[52]

In this tense atmosphere of pro- and anti-public-housing factions,
racial segregation, red-baiting, and cultural censure in Hollywood, Los
Angeles' civic identity came into question. No longer was Los Angeles
the self-promoting paradise of orange groves, exotic landscapes, and
"temples of art." Instead, Los Angeles was a city where white suburban
prosperity and newly built freeways hid an increasingly segregated urban
landscape and reinforced decentralized sprawl. What role could civic
culture play in a city so obviously fragmented and increasingly decentral-
ized? What role could art play in a city that no longer needed booster
imagery to grow? Civic culture served as a site where diverse Los Angeles
residents publicly played out the city's postwar tensions in different and
complex ways. As suburbanization, freeways, and racial segregation
worked in tandem to fragment Los Angeles, civic art, as the visual form
of civic culture, proved particularly contentious since it was impossible
to find one artistic image to represent the entire city.

Under the dynamic leadership of Municipal Arts Department director
and New Deal liberal Kenneth Ross, Los Angeles' civic culture transiti-
oned from private art clubs and museums to community-based art proj-
ects and outdoor festivals in the city's public parks. Ross took the
Municipal Arts Department, a rather rinky-dink operation responsible
for overseeing the city's meager art collection, and turned it into an
innovative city office with big plans for public art programs. Rather than
ignore Los Angeles' decentralized sprawl and blindly continue with out-
dated plans to build one highbrow museum to represent the whole city,
Ross opened civic culture to as many people as possible by creating a
network of publicly-sponsored community art projects. In the spring of
1951 the *Los Angeles Times* announced the Municipal Arts Department's
introduction of a "new approach to art with a program intended to
bring the enjoyment of art into reach of every person in the city."
Instead of one art center founded on the principles and ideologies of
elite Angelenos, the new program promised "to give art exhibits, lec-
tures, films, forums, painting demonstrations, and instructions in arts
and crafts in community buildings . . . in every community area."[53] Ross
was sensitive to the "decentralized character of the city" and strove to

serve residents of diverse urban neighborhoods instead of trying to mold an increasingly diverse city into a singular elite vision of civic grandeur.[54] In leading Los Angeles' municipal government to take a more active role in civic art after World War II, Kenneth Ross shifted urban cultural policy from private interests to public ones.[55] In doing so, Ross forced the cornerstone of Los Angeles' civic elite, the private art clubs active since the 1890s, to relinquish their cultural authority. This power shift prompted a nasty political backlash as Ross's efforts to decentralize civic culture and create interactive public spaces constituted a progressive social vision that was angrily attacked by conservative factions throughout the 1950s.[56]

The focus of Ross's community art approach was the All City Outdoor Art Show, an annual art festival that took place in ten of the city's public parks each fall. Introduced in 1950, the art show was Ross's response to the county museum's annual Artists of Los Angeles and Vicinity exhibition in Exposition Park. Ross found the museum's annual show too exclusive and stodgy and felt it did a disservice to the Municipal Arts Department's goal "to encourage public participation in the arts and to reach as many people as possible through the media of television, festivals, expositions, and decentralized exhibits."[57] Ross's art shows turned Los Angeles' public parks into decentralized civic arenas where Angelenos from different districts of the city could participate in their own communities or take bus shuttles to any (or all) of the other parks. The festivals were popular, attracting upward of fifty thousand people each year. Starting with the first one, Ross made a point of including black and Latino neighborhoods and artists in the festivals. He selected South Park, south of downtown Los Angeles between the Crenshaw district and Watts, as one of ten public parks to host the festival and appointed Beulah Woodard, director of the artists' cooperative 11 Associated as chairperson.[58]

The introduction of the All City Outdoor Art Shows signified an important change in Los Angeles' cultural infrastructure. Civic art, once the domain of private art clubs, officially became the province of the rejuvenated Municipal Arts Department with its expanded public art program. This infrastructural shift meant that Los Angeles' civic identity was up for grabs since the art clubs, having already lost ground during the Depression, found themselves on the margins of civic culture and municipal politics after the war.[59] The clubs' static and elitist vision of Los Angeles as the "Athens of America" with its "Temple of Art" would no longer dominate the city's cultural identity as it had since the early twentieth century.[60] Instead, community-based projects molded Los Angeles' civic art and brought together diverse people, images, and urban imaginations. The community emphasis of the Municipal Arts

Department also created a cultural space where ethnic minorities and working-class Angelenos could maneuver, if ever so slightly, into Los Angeles' civic arena. This change in civic art from elite boosterism to community-based art programs created political problems for Ross, who was accused by city councilmen and the most conservative of the art clubs of being a Communist at the peak of the McCarthy era.

Ross, who came from a background in adult art education, entered the Municipal Arts Department after close involvement with Hollywood's world of modern-art-collecting movie celebrities. After teaching art history at the University of Southern California, he served as director of the Pasadena Art Institute and later worked as an art critic for the *Pasadena Star-News* and the *Los Angeles Daily News*. Ross then served as director of the short-lived Modern Institute of Art in Beverly Hills.[61] Set up in 1947 by well-known Hollywood heavyweights, including the actors Vincent Price, Edward G. Robinson, and Fanny Brice and the agent Sam Jaffe, the private art museum exhibited the Arensbergs' famous modern-art collection of works from New York's 1913 Armory Show. Unable to manage the museum despite generous private endowments, the group of Hollywood friends closed the Modern Institute of Art in 1949 after only two years, and subsequently the Arensberg collection was given to the Philadelphia Museum of Art.[62] His position at the Modern Institute of Art allowed Ross to further his administrative experience and it also brought him in direct contact with Hollywood celebrities and with modern European art. By virtue of his stint at the Modern Institute of Art, Ross was able to bring his knowledge of modern art (and the wealthy people who bought, sold, and collected it) to the Municipal Arts Department.

Ross's embrace of modern art was at odds with the Los Angeles art clubs' traditional support of landscape painting and portraiture, and they actively tried to prevent him from expanding the city's arts programs. In a campaign to prevent Ross's appointment as the city's coordinator of art in 1949, the Painters and Sculptors Club wrote to the city council that they "were very concerned about the appointment of anyone with radical leaning as he could do a great deal of harm to the art world of our community."[63] In addition, in a similar letter, the California Art Club wrote, "we cannot recommend Kenneth Ross . . . for the position of coordinator. He is to organize art groups, lectures at clubs and schools, and children's art work . . . all of which should be kept in the conservative trend."[64] These groups and others objected to what they perceived as Ross's taste for modern art, his intention to make city art events all-inclusive, and his strong belief that art projects should be subsidized by government, rather than corporate, sponsors.

Ross articulated a decidedly populist approach to civic art, although

he was hardly the radical that the art clubs made him out to be. As an art critic for both the *Pasadena Star-News* and the *Los Angeles Daily News* prior to his involvement in city politics, Ross wrote extensively about the significance of the Federal Arts Project for creating a broader and more popular sponsorship for art in the United States. He also proposed the creation of a national art education fund that would sponsor neighborhood community art centers.[65] Ross's community art views were characteristic of veterans of the New Deal era. In November 1941, President Roosevelt announced a "National Art Week" that would be organized under the auspices of the WPA. Thousands of artists exhibited their paintings and sculptures in public libraries, hotel galleries, and private galleries, pricing their work from one to seventy-five dollars. The purpose of the federally subsidized program was to encourage the consumption of American art by making it affordable to virtually anyone who wanted to buy it.[66] At the same time, the federal art program encouraged a sort of cultural patriotism whereby artwork, in its production, reception, and purchase, served to unite Americans as the country edged toward world war. With the slogans "Dollar-Down Art," "Be Smart; Buy American Art," and "American Art in Every Home," National Art Week embodied typical New Deal rhetoric in its simultaneous patriotism and populism.[67] With thirty-two thousand artists participating nationwide, the program ensured that many of them would make a sale and that, in return, the average American could buy an original work. Just as Roosevelt advocated a national art committee that could help "communities . . . establish art centers in public buildings, schools, and other accessible locations," Ross would encourage community art programs in Los Angeles. [68] In much the same way that Roosevelt thought National Art Week might unify the nation, Ross hoped that civic art might overcome Los Angeles' sprawl by bringing together disparate neighborhoods. Ross's New Deal politics so disturbed the city council that it took the California Art Club's suggestion and blocked his appointment. The Municipal Art Commission stepped in and overrode the council's decision, naming him director of the Municipal Arts Department in December 1949.[69]

On October 12, 1951, under Ross's direction, Los Angeles opened its annual All City Outdoor Art Show, a two-week extravaganza of art expositions held throughout the city's parks and in the Greek Theater in Griffith Park. The mixed-media exhibition included abstract and traditional painting, sculpture, music, and dance. Local artists received praise, press, and prizes. There was a large participatory element (180 exhibits in total, chosen from 1,700 submissions) as well as a large spectator turnout. Within days, letters from Los Angeles citizens congratulating Kenneth Ross appeared on the desks of city councilmen.[70]

Figure 16. National Art Week, 1941, at the Los Angeles Art Association's Earl Mansion. Courtesy of Los Angeles Art Association.

Ten days later, however, it became clear that the Greek Theater exhibit in Griffith Park was not simply going to close at the end of its run. On October 22, the *Los Angeles Times* published negative letters describing the festival. One disgruntled citizen wrote that it "resembled a chamber of horrors. I have had many terrible nightmares in my lifetime but none, if put on canvas, could come up to any of those I saw today." Another wrote, "the whole show is an insult to the intelligence of the people of Los Angeles. Don't tell me I don't understand! There's nothing to understand. The crazier and the uglier the canvases are, the more prizes they win. Don't tell me these monstrosities represent contemporary life in America. Why should taxpayers' money support such trash? The public doesn't like it."[71] Other letters, from the San Fernando Valley Professional Artists' Guild and the Coordinating Committee for Traditional Art, were sent to the mayor's office voicing two main complaints:1) the modern paintings and sculptures contained Communist content, and 2) traditional artists were underrepresented.[72]

In response to the letters, city councilman Harold Harby, chairman of the Building and Safety Committee, opened an investigation of the art show in Griffith Park. He asked that Kenneth Ross, members of the Municipal Art Commission, and a select group of exhibiting artists appear in council chambers on October 24, 1951, to answer accusations that there had been a "heavy Communist infiltration" of the Greek Theater exhibit and that traditional painting had been unfairly underrepresented in favor of modern art.[73] Arthur Millier covered the hearing for *Art Digest*, in which he published a regular column covering Los Angeles art news. He reported that the four artists in question were Bernard Rosenthal, whose sculpture *Crucifixion* was deemed sacrilegious; Rex Brandt, whose painting of a boat was said to incorporate a hammer and sickle on the sail; Gerald Campbell, whose landscape painting was nonrealistic; and Bernard Zimmerman, whose sculpture was labeled "ultramodern." Councilman John Holland, chairman of the Finance Committee, and Duncan Gleason, chairman of the Coordinating Committee for Traditional Art, raised the issue of tax dollars funding public art exhibits. Gleason: "The entire show is a collection of meaningless lines and daubs with nothing that is uplifting or spiritual, only an affront to the sensibilities of normal people. . . . We understand that the annual budget for the activities of the Municipal Arts Department is $25,528 for the current year. Is it the city's province to spend this amount of money to display radical works that are not acceptable to rationally minded citizens?"[74]

With the Building and Safety Committee's concerns clearly outlined as "the expenditure of taxpayers' funds and the spread of communism in this area" but "not to enter the field of art criticism," Harby officially began the hearings.[75] Reading from *Time* magazine, Harby made statements regarding communist influence in modern art. Then, pointing to Gerald Campbell's *Landscape*, one of the first-prize winners, Harby made note that "it was distinctly of the contemporary type as compared with the traditional type of painting." He argued that "if taxpayers' money is used to maintain the Greek Theater and if Communistic propaganda of disruption and discord is evidenced by certain types of painting, their exhibition should be restricted."[76] Harby then introduced Joe Waano-Gano of the San Fernando Valley Professional Artists' Guild, Gleason of the Coordinating Committee for Traditional Art, Mrs. Lester Sessions of the Friday Morning Art Club, and E. Smith of the Highland Park Art Guild. All of these art club chairpersons testified that traditional, realist art had been unfairly excluded from the All City Outdoor Art Show, that communism had infiltrated the exhibit via modern art, and that all future city-sponsored exhibits must allow for equal participation by traditional-style painters. Gleason added that he spoke on behalf of the

Figure 17. Joe Waano-Gano of the San Fernando Valley Professional Artists'
Guild testifying before the Building and Safety Committee, October 24, 1951.
Los Angeles Herald-Examiner Collection, Los Angeles Public Library.

approximately eight thousand members of the Coordinating Committee
for Traditional Art when he stated that "trouble had occurred at the Los
Angeles County exhibit [in 1947] where definite opposition had been
registered to the exhibiting of traditional art and that exhibits [were]
becoming more radical as time passes."[77] Duncan Gleason, known for
elaborate paintings of sailing ships, had a long history in Los Angeles as
a proponent of "sanity in art," supporting Josephine Hancock Logan's
Chicago-based association of the same name. As a member of the San
Gabriel Artists' Guild in 1940, Gleason promoted "sane" representa-
tional painting rather than a modernist emphasis on abstraction and
interpretation. By 1951 he was well versed in the antimodern political
discourse of the time.

It became clear throughout the hearing that at the heart of the dis-
pute was a division between young artists (many of whom were ex-GIs)
painting in an abstract expressionist style and older artists, many of

Figure 18. Rex Brandt, *Surge of the Sea*, 1951. Los Angeles Municipal Arts
Department All City Outdoor Art Show exhibition catalog.

whom were art club members, who retained what they called "representational" or "traditional" painting styles. In fact, the two types of painting often reflected two different visions of landscape—one abstract, the other familiar and often pastoral. At the same time that public art debates were entrenched in the larger political struggles over public housing and racial segregation (in essence a struggle over control over an urban landscape), an aesthetic battle over envisioned landscapes was also being waged by artists. It was as if the struggles over public space found their way onto the canvases of urban artists. At stake was not simply who would win a ribbon at the festival but also whose view of the city's identity would prevail.

At this point in the hearing, Mayor Bowron addressed the city council, clearly supporting Ross and the artists accused of including communist content in their work, and stated that the whole incident had brought unfavorable publicity to the city. To the best of his knowledge, "not a single member of the Municipal Art Commission has Communistic leanings," and he confirmed that the insignia on the boat in the painting was one in common use to indicate a type of sailboat. Bowron's final point was that no one had complained about the art jury's selections until after the red-baiting had begun. He reminded the council to

"abate false impressions in the mind of the public" and left the council chamber.[78]

In 1951 the cold war and the Communist scare were sinking to their lowest level: the Korean War had started the year before, most of the oppressive legislation had been passed, blacklists and firings were continuing, and the Rosenberg trial, with its blaring headlines, had recently ended. The council hearing, with all of its HUAC resonance, proceeded in a theatrical manner. Several artists showed up with their artwork from the Greek Theater, displaying the paintings on easels. Lorser Feitelson, one of the Greek Theater jurors, and a victim of anti-Semitism and red-baiting in earlier years, was goaded "unmercifully [by Harby] with whispered remarks."[79] Campbell was baited by Harby, who called his painting "screwball art" because the moon depicted in it "wasn't even round." When Campbell asked, "Is the moon always round?" Harby shouted back, "The moon is *always* round!" Harby's questioning distracted Campbell to the point of tears, and while crying, Campbell blurted out, "I spent two years in the Army fighting for freedom of expression."[80] Harby offered to buy Bernard Rosenthal's sculpture so he could destroy it; he found it offensive because "it made Christ look like a frog." [81] At the end of the day, despite the turnout of artists with easels and paintings, the press, and the mayor, the only conclusions drawn by the Building and Safety Committee was that another public hearing should take place a week later, on October 31st.[82]

In the week between the hearings, debates over the virtues of traditional and modern art, public funding of the arts, freedom of expression, and communism in art raged in the press, in the mail, and on the street. The city council received hundreds of letters regarding the investigation. Many supported the Municipal Arts Department. A local artist, Byron Reynolds, wrote, "While I do not always agree with the selections, as no artist ever does, I feel the exhibition has been representative and better each year, and that Mr. Ross has personally done much to raise the stature of Los Angeles art in general."[83] However, others did not feel that the city council had gone far enough in censuring the Municipal Arts Department. The elderly schoolteacher and librarian Gertrude Mallory wrote the council that, having taken children to see a modern-art exhibit at the county museum, she was distressed at the contemporary attitude that supported "confusion . . . in our beloved country, in other forms, as well as in painting." Accusing abstract artists of being insane, Mallory commented, "since the only way one individual can understand how another's mind is working is by his words, actions, and creations, how can any person without clarity in his own mind produce anything possessing lucidity for others?"[84] In the *Los Angeles Times*, Thomas Owen sarcastically remarked, "I didn't notice—but if the Communists are so

Figure 19. Councilmen Kenneth Hahn (left) and Harold Harby hold up Gerald Campbell's first-place painting, *Landscape*, October 24, 1951. *Los Angeles Herald-Examiner Collection*, Los Angeles Public Library.

hard-pressed for propaganda outlets that they use this means of spreading their wares, we certainly don't have much to worry about," and H. B. asked, "Why do incompetent practitioners in the field of doodling . . . have the undaunted courage to hope that their slovenly and offensive smudges will receive recognition?"[85] A letter from A. S. Harvey damned the entire city: "Surely, the most infamous thing committed in the name of art was the exhibition of Christ on the Cross in the semblance of a skinned frog . . . are you not afraid that an earthquake might come to destroy a city so lewd and uncivilized?"[86]

Some of those siding with the "traditionalists" had more elaborate means of communicating their feelings about modern art. On October 25 Mr. and Mrs. Crowe set up a display in downtown Los Angeles, on Seventh and Broadway, protesting the Greek Theater exhibit. Calling themselves "grassroots Americans," the Crowes displayed papier-mâché dolls in the shapes of Abraham Lincoln and the Good Shepherd and

held picket signs emblazoned with "American Art from the Heart," a phrase echoing the federal National Art Week slogans from 1941 (for example, "American Art in Every Home" and "Be Smart; Buy American Art"). When asked by a *Times* reporter what they were doing, the Crowes replied that they were protesting what they felt was a "pinko-art display of modernistic art monstrosities" and that their "grassroots sculptures [were] a labor of love . . . for God and country, 100%. We have no gimmicks, nothing to sell."[87] The Crowes did not simply condemn the exhibit for displaying modern art with potentially subversive content; they also offered an alternative with their "American art from the heart." Unlike the abstract painting and sculpture that won awards in the All City Outdoor Art Show, their work, the Crowes claimed, was genuinely American.

Amid this atmosphere of political tension and street carnival, the city council's Building and Safety Committee, consisting of Councilmen Harby, Navarro, and Gibson, held its second inquiry into the exhibit at the Greek Theater. Kenneth Ross headed the group of proponents of modern art, who submitted two documents, the "Statement on Modern Art" and the "Greek Theater Paper." The first was a defense of the exhibit, the jury, the Municipal Arts Department, and modern art.[88] The "Greek Theater Paper" asked the council to rescind its accusations in the interest of "a constructive program of art for the City of Los Angeles." The document, signed by over a dozen prominent artists, businessmen, and professionals, including the artist Millard Sheets, the movie producer David Loew, the gallery owner Frank Perls, and Stanley Barbee, the president of Coca-Cola Co., Los Angeles, pleaded with the council that the red-baiting was ruining Los Angeles' reputation as an art center. "Many thoughtless and unnecessary things have been said . . . , some spokesmen not realizing that the words with which they describe a work reveal at once their own lack of knowledge. These statements . . . are going to be repeated nationally and unfortunately will not only make those who utter them seem ridiculous, but will make the city itself the laughing stock of rival cities in the field of art." Speaking for the authors of the "Greek Theater Paper," Kenneth Ross urged the city council to "turn this unpleasant problem into a landmark in the development of city-sponsored art in Los Angeles."[89]

A week later Councilmen Harby, Navarro, and Gibson submitted their report to the city council stating that they believed "ultra-modern art was originally fostered and encouraged as part of Communist propaganda in the field of the fine arts." Members of the Building and Safety Committee felt that while they "did not believe that any individual artist at this exhibition was a Communist; . . . [they] were equally firm in the belief that [modernists] were being unconsciously used as tools of the

Kremlin in this very effective propaganda field."[90] In equating modern art with communism at the height of the cold war, Harby and the other Building and Safety Committee members effectively dealt a deathblow to the city's public art program. The committee stipulated that Ross, as director of the Municipal Arts Department, from then on would submit his annual budgets to the council for consideration if he wished to continue the All City Outdoor Art Show in the future. In addition the committee divided all future city-sponsored exhibits into two categories, modern and traditional, with the Municipal Art Commission funding both equally.[91]

The first recommendation by the committee was criticized by artists, who believed that submitting an annual budget to a committee that had already concluded that the Greek Theater artworks were Communist-inspired would result in de facto censorship. These artists believed that the councilmen would simply cancel any exhibit showing modern art. The second recommendation generated complaints from Municipal Arts Department supporters, who argued that having two exhibits would downgrade the quality of Los Angeles' art making the city "the laughing stock of the cultural world."[92] In response, the San Fernando Valley Professional Artists' Guild wrote: "Where the 'upside-down' art supporters arrive at the absurd idea that their 'freedom of expression' will be hampered by giving them an opportunity to share one-half of the available exhibition space, or to have exhibition space entirely to themselves, is beyond normal reasoning. Throughout the world this type of argument has resulted in the monopoly of all available exhibition facilities by the ultra-screwball factions."[93]

Since the same allocation of funds previously used for one exhibit would in the future be used for two, additional funding would have to come from private sources. As a result, on November 21 the State of California incorporated the Municipal Art Patrons as a private, nonprofit foundation "in order to assist the Municipal Arts Department and to make such important events possible for people in the Los Angeles area." Jurisdiction over the All City Outdoor Art Shows switched from the public realm to a private organization with the money to sponsor art exhibitions. The division of exhibits thus also undermined Ross's authority as director of the city's main public art institution. During the discussion of the Building and Safety Committee report on the Greek Theater exhibit, unidentified members of the city council stated that they did not believe that the artists involved had any intention of planting Communist ideas in the minds of the public viewing the artwork. Others, however, said that "from their observance of the Exhibit [the artists did have such an intention] by causing confusion and uncertainty." After this discussion, the committee's two recommendations,

referred to as the "Greek Theater Resolution," were adopted by a vote of 12 to 1, Councilman Edward Roybal dissenting.[94]

The public response to the city council's adoption of the resolution was overwhelmingly negative. Denouncing the council for its decision, artists and nonartists alike sent hundreds of letters. The California Watercolor Society, instructors from the Chouinard Art Institute, UCLA professors, and many other residents of Los Angeles, who did not state their occupation, angrily wrote to the council. They demanded that a single exhibit be held, not two, and that the council retract its report equating modern art with communism. Some letters vouched for the exhibit's Americanism: "The Greek Theater Show was an honest effort, and American in every way." Others were simply embarrassed by the city's bad press, particularly at a moment when, as one letter writer put it, "Los Angeles [was] well on the way to becoming an Art Center of truly national importance, second only to New York." An impassioned letter from Theodore Heinrich of the Huntington Library argued that "every serious artist draws on vital tradition, but cannot be bound by it. Tradition in art is not a fixed thing but constantly changes to meet the needs of time."[95] Members of the Art Directors Club of Los Angeles wrote the council and clearly were fearful of what the smear campaign could do to their industry during an era of blacklisting. In their view, "the implication that modern artists are 'tools of the Kremlin' is an injustice to hundreds of loyal American citizens in this area . . . The imperious action of the city council against freedom of art can be likened only to an attempt to throttle the free press. We demand that all references to . . . communism be stricken from the record in the interest of justice."[96] Other commercial art organizations, whose members rightfully feared the detrimental political and economic effects of the Building and Safety Committee implicating their craft in a Communist-propaganda plot, pleaded with the city council to strike from the record any inferences that modern art and Communism were synonymous.[97]

Indeed, public response was so overwhelmingly negative that the city council pressured Harold Harby to rescind the Greek Theater Resolution. Led by Councilmen Ernest Debs and Edward Roybal, who had cast the sole vote against the resolution, the council reversed its stand on modern art, concluding that it had "found no evidence that the award jury at the Greek Theater art show was not qualified or did not act in good faith nor any evidence or subversion on the part of the artists." The only councilmen to vote against the reversal were Harold Henry, Harby, and John Holland.[98]

Though the Debs-Roybal motion reversed the council's report purporting that modern art was Communistic, it upheld Harby's original recommendation that the Municipal Arts Department submit its annual

departmental budget to the city council for consideration. Regarding Harby's second recommendation, that all future city-sponsored exhibits be split into one traditional and one modern, Debs and Roybal performed a delicate balancing act between Harby and Ross by suggesting that the Municipal Art Commission "investigate the advantages of the multiple jury and exhibit system, the no-jury system and all other methods currently in common practice with an eye towards realizing the widest possible democratic representation in civic art competitions."[99] Much of Debs's and Roybal's support came from Councilmen Kenneth Hahn, L. E. Timberlake, and Don Allen, all three of whom had backed Roybal's and Debs's support of public housing during the debates that took place at virtually the same time as the art show controversy. As indicated by headlines such as "Housing Row Echo Heard in Art Talk" on the front pages of the local papers, the political connections between the public housing debates and the Griffith Park art controversy were not lost on Los Angeles residents.[100]

Three months after the All City Outdoor Art Show opened in Griffith Park, the city council rescinded its official statement that the artists involved were unwittingly Communist sympathizers. The Building and Safety Committee, however, stepped up its efforts to undermine Kenneth Ross and the Municipal Arts Department. Despite Ross's compliance with the council's motion that he submit plans for the annual city-sponsored art competition thirty days prior to council consideration of the budget, Harby and the Building and Safety Committee remained unsatisfied that they had enough of a grip on the city's art program.[101] Following the 1953 municipal elections, when Fletcher Bowron was ousted in favor of Norris Poulson, the preferred candidate of Harby and other anti-public-housing supporters, the Building and Safety Committee continued to nip at Ross's heels by ordering an audit of receipts from city-sponsored art exhibits from 1952 through 1954.[102] Kenneth Ross spared few words in responding to Harby's request: "The artistic policy of the Arts [Department] can be stated in very simple terms: Los Angeles is a city of heterogeneous population and taste. This heterogeneity is part of its richness and is the fertile soil in which, through understanding, tolerance, and objectivity, a mature and significant art can flourish. [S]o long as there is a broad base of expression in the City's artistic program . . . a bigoted insistence on uniformity should not be made by anyone else in the community."[103]

Although Ross dutifully accounted for the money, an official audit was held, after which the city administrative officer exonerated the Municipal Arts Department from any blame regarding the suspected misappropriation of city art funds.[104] The damage, however, was done. In the wake of Harby's audit, members of the Municipal Art Patrons withdrew their

funding for all future exhibitions. The combined impact of the 1951 res-
olution to divide city-sponsored art exhibits in two and the withdrawal
of patrons' funding bankrupted the Municipal Arts Department and
almost destroyed Ross's All City Outdoor Art Show. Whereas the art
show ran on a budget of forty thousand dollars, the audit lowered the
budget to twelve thousand dollars for the 1956 show and a mere fifty-
four hundred dollars for the following year.[105] The mid-1950s looked
dire indeed for the Municipal Arts Department's plans to expand the
city's civic art program.

Buoyed by the success of the audit in undermining the public art pro-
grams and the publicity surrounding the abandonment of "socialistic"
public housing, Harby led a crusade against another modern artwork.
The piece in question was a second bronze sculpture by Bernard Rosen-
thal, the same artist whose *Crucifixion* had appeared sacrilegious to
Harby in the 1951 Greek Theater hearings. During the summer of 1954,
the city council was outraged to learn that the new, $6 million Los
Angeles Police Department Building in downtown was to feature the
fourteen-foot Rosenthal sculpture, *The Family*, at a cost of ten thousand
dollars, an amount included in the total cost of the building.[106] Accord-
ing to Rosenthal and the building architect, Welton Beckett, the statue
depicted a mother, a father, an adolescent male, and an infant, and sym-
bolized "the American family protected by the police."[107] It was typical
of Rosenthal's work in that he used sharp lines and rough surfaces to
portray human forms. The sculpture had been approved by the Munici-
pal Art Commission and by the Board of Public Works almost two years
earlier, in September 1952. After viewing a model of the sculpture, the
city council called a hearing to discuss the possibility of revoking Rosen-
thal's contract.[108]

Initially, the central issue was whether or not the city council could
cancel Rosenthal's contract and commission another statue. Former art
commissioner Lester Donahue denied that he had approved the statue
during his tenure, although the architect Welton Beckett's statement
demonstrated that the Municipal Art Commission had indeed approved
the artwork. With the exception of Councilman Roybal, who several
times during the hearing pleaded that the proceedings not turn into
another "art hassle," the city council unanimously attacked Rosenthal,
Beckett, and Ross for secretly moving ahead with plans, unbeknownst
to the city government or Los Angeles residents, to install a modernist
sculpture on a public building. Harby went so far as to say "this art has
been shoved down the throats of the people by a subversive clique."[109]
The strongest condemnation of the sculpture came from Councilman
Debs, who had supported rescinding the Greek Theater report in 1951.
Debs stated that the work illustrated "the artist's low opinion of the

Figure 20. Bernard Rosenthal, *The Family*, 1955. *Los Angeles Herald-Examiner* Collection. Courtesy of University of Southern California on behalf of the USC Specialized Libraries and Archival Collections.

American family—without eyes, ears, noses, and brains."[110] Despite the council's best efforts, lawyers for the Municipal Arts Department found that there was no legal basis upon which to cancel Rosenthal's contract.[111]

While in the interim, plans moved ahead for installing the statue, the city council received letters from both supporters and detractors of the Rosenthal sculpture. The California Watercolor Society and art teachers across the city wrote the Council asking them to give up their efforts to block the statue's installation. One well-known artist, June Wayne, commented, "this move to destroy [*The Family*] makes clear that neither [councilmen] Harby, Holland, or Baker are genuinely concerned about our money, but rather are crusading once again for censorship in the arts."[112] The author Irving Stone asked the city council to "hold steadfast in support of [the] excellent Rosenthal sculpture and not allow Harby and the crackpot fringe to disgrace us once again in the eyes of the cultivated world."[113] The art instructor Richard Cassady asked simply, "Why does it always have to be the Los Angeles city council [members who] make asses out of themselves?"[114]

Rosenthal's supporters reiterated a complaint similar to the one they had expressed during the 1951 Greek Theater hearings: the council's reactions embarrassed the city by attracting negative national attention to Los Angeles' cultural scene. His detractors, however, had a new complaint. Rather than red-baiting *The Family* and accusing Rosenthal of promoting Communist-influenced art, this time conservative art clubs objected to the vagueness of the statue's ethnic and racial identity. In their letters, the statue's detractors revealed a great deal about what, in fact, was disturbing to them about *The Family*. E. Nealund wrote, "we resent this hideous, abominable thing named faceless, sexless art, costing [us] the sum of $10,380. It is a brazen insult to our intelligence and to our American way of life." The Board of Directors of the Women's Club of Hollywood wished to go on record "as being unanimously opposed to this statue. [We] believe it to be an ugly representation of American life." F. A. Lydy wrote:

The Los Angeles press has quoted the sculptor as stating that his faceless and distorted creation is "designed to be seen in its 14-foot size at a distance, with faces kept in simple outline so they cannot be construed as belonging to any definite race or creed in preference to any other." It should not be forgotten that this nation was founded by members of a distinct race whose descendents represent 90% of our present citizenry. Since when, and upon what authority, is it prohibited to place statuary bearing a likeness of average citizens composing 90% majority in or upon our public buildings?[115]

These letters derided Rosenthal's *The Family* for appearing un-American, unbeautiful, unwhite, and unrepresentative of Los Angeles' public.

Lydy's letter explicitly objected to the fact that the sculpture stood for a family of any racial or ethnic background rather than a white family. In fact, many complaints focused on the "faceless" nature of the artwork, offended that it did not have the characteristics of a "distinct race" but instead, stood for anyone the viewer wanted. Harold Harby told the *Los Angeles Examiner* that "[*The Family*] is a shameless, soulless, faceless, raceless, gutless monstrosity that will live in infamy!"[116]

Why should a nonabstract representation of a subject as seemingly benign as the American family cause such a negative reaction? Rosenthal stated that the sculpture represented the family as secure and protected by the police, hardly a radical social agenda. For many Angelenos, however, the idea that a municipal bureaucracy would choose a modernist image of a racially and ethnically indeterminate family to represent them on a publicly funded civic building (the police department headquarters, no less) was an unsettling prospect at a time when the city felt unstable and fragmented and was growing increasingly diverse. During the cold-war era, the "family" reflected shared ideologies of domestic and national security lived through postwar prosperity and the suburban experience. Exemplified in Los Angeles, the suburban domesticity characteristic of postwar life for many Americans functioned as a buffer against fears of communism, foreign intrusion, bureaucratic collectivism, and modernization. The American nuclear family, figuratively at least, even served as protection against nuclear war.[117] For an artist to claim that a *modernist* sculpture represented the American family transgressed the necessary boundaries of cold-war domestic ideology by conflating the interpretative, immigrant, and urban qualities of modernism with hermetically sealed visions of suburban homogeneity. Rosenthal may have intended his sculpture to be uncontroversial, but by not depicting an obviously, and specifically, white family, the sculpture undermined racialized assumptions about who was represented in Los Angeles' civic imagination.

On January 20, 1955, under the watchful gaze of security guards, the Los Angeles Board of Public Works installed *The Family* in front of the new downtown police department building. Fears that anti-modern-art and patriotic protest groups would steal or vandalize the publicly funded artwork prompted the irony of hiring private guards to oversee municipal police property. Reporters were admitted to the construction grounds only with special permits. Once the piece was installed, the National Sculpture Society and the Christian Nationalists joined others in picketing the sculpture, proclaiming that "the statue is not representative of our culture" and that *The Family* is "a metallic monstrosity . . . an outrageous violation of the Fine Arts" that would "surely prove dele-

terious to morality."[118] Despite earlier threats of destruction, *The Family* still stands outside the same building.

While the 1951 Greek Theater controversy resulted in tighter control of the Municipal Arts Department's budget and, in effect, censured city-sponsored artwork, by 1955 Harby was less effective and did not achieve his ultimate goal of passing "an ordinance outlawing modernistic or futuristic art from all public buildings."[119] Harby was probably less effective because by 1955 Kenneth Ross, the Municipal Arts Department, and the Municipal Art Commission had adequate support from prominent members of Los Angeles' business and art establishment. In addition, by 1955 the worst of the Red Scare was over, undermining a key source of Harby's political prowess. To prevent the removal of the sculpture, a group of prominent Angelenos including the architect John Rex; the banker Victor Carter; Frederick Hard, president of Scripps College; the author Irving Stone; the museum director Joseph Fulton; and University of Southern California art professor Edward Peck formed the Los Angeles Art Committee. Members of this Committee helped lend legitimacy to the Rosenthal sculpture by lending their names, official positions, and cultural authority to the pro-*Family* faction.

Additionally, the old art clubs were, for the most part, out of commission by the mid-1950s. They may have been effective red-baiters but even a few years later they seemed terribly out of date with little of the elite backing they had once enjoyed decades earlier. By 1955 modern art had become the main art form in both city and county art venues. A perusal of catalogs from both the municipal All City Outdoor Art Shows and the county's annual Artists of Los Angeles and Vicinity exhibitions demonstrate that contemporary abstract expressionist painting and sculpture dominated and that traditional landscape painting, when it did appear, seemed archaic in comparison. In a 1956 overview of Los Angeles art, Arthur Millier wrote, "there was no return to the ascendancy of comfortable landscape painting. The American Scene, replete with gas stations, coal mines, and soft-drink signs stemmed from the depression art projects gradually giving way to two other types of painting—the superrealistic and the abstract."[120] The era of the art clubs was officially over. Traditional landscape painting was replaced by the American expressionist work characteristic of the era and later developed by 1960s pop artists such as Jasper Johns, Andy Warhol, and Los Angeles' own Ferus Gallery artists.

The immediate postwar years transformed Los Angeles' civic culture from private art clubs representing the tastes and privilege of a segment of the urban elite to a program of public art and cultural activities directed toward a broader swath of the Los Angeles population. With roots in the New Deal's WPA programs, this art was seen by Kenneth Ross as capable of forging a civic culture in a city increasingly frag-

mented and decentralized by the dual forces of suburbanization and segregation. He did not imagine a uniform representation of Los Angeles; that was impossible in a city that would reach 2.5 million residents by 1960 (the same year that California would become the most populous state in the country). Instead, Ross included multiple representations of Los Angeles, and the world around Los Angeles, in his art festivals.

It is significant that one of the most controversial aspects of Ross's art festivals was the inclusion of new forms of landscape imagery. Gerald Campbell's expressionist *Landscape* was the most obvious example, but a glance through the All City Outdoor Art Show catalogs from 1951 through the 1960s reveal "landscapes" in multiple images of Los Angeles, Japanese-influenced pen-and-ink drawings of local beaches, abstract paintings simply called "Landscape," and even billboards, advertising motifs, and experimental photography. All of these art forms drew attention to emergent views of Los Angeles as the city grew and changed. As the physical geography of the city morphed after the war, and new freeways, suburbs, urban advertising, and hundreds of thousands more automobiles created a new postwar landscape, landscape painting actually changed as well. The turn-of-the-century images of Los Angeles had all been landscapes, even if they were commercially produced and glued to packing crates. The art clubs replaced this imagery with highbrow landscapes of pastoral scenes and allegorical themes that were tied closely to efforts to Europeanize the city. In the 1950s this civic art was replaced again, this time by abstract expressionism, which, while still considered landscape art by some, was certainly darker and more introspective.

One of the many ironies of the struggle over art and civic identity in the postwar period is that the efforts to push avant-garde, experimental, and modern art out of the public realm resulted in alternative art communities that, though initially marginalized, would eventually in the 1960s put the city on the international art map. Los Angeles' Beat and bohemian artists self-consciously undermined the postwar culture of domestic suburban life at the same time that they celebrated the opportunities offered by prosperity: cheap cars, low rent, voluminous urban detritus, and ample space. They literally participated in Los Angeles' civic culture by taking part in the All City Outdoor Art Shows but also created their own urban culture of imagery through posters, postcards, and installation pieces that forged a new landscape for Los Angeles, albeit an underground one. These artists, primarily men, eschewed the consumer trappings of postwar America, and preferred to build and repair objects themselves, often turning found objects such as old cars or tossed-out refrigerators into art pieces. Other artists reveled in the

new materials and paints of postwar industrial manufacturing and produced shimmering homages to custom-car culture and pop art, attracting collectors and museums from all over the world. Los Angeles' civic imagination would change once again as national attention, at long last, focused on the city, but the commercial possibilities of art in Los Angeles would quickly overcome Ross's democratic views of publicly funded art for the people. In the wake of the 1950s municipal art controversies, Ross's hard fought-for public art programs were overshadowed by the emergence of the new commercial gallery scene, and civic culture, as fraught as it had been, slipped away from the public domain and took shape as an increasingly private enterprise of downtown revitalization and architectural might.

Bohemia in *Vogue*

In the 1960s the *New York Times*, *Art News*, *Art in America*, *Vogue*, and *Time* magazine covered the Los Angeles art scene and, for the first time, brought young local artists to the forefront of national media attention.[1] *Vogue*'s November 1967 issue featured a six-page promotional article by *Artforum* founder and contributing editor John Coplans on the most prominent of Los Angeles' artists, including Edward Kienholz, Ken Price, Craig Kauffman, Billy Al Bengston, Larry Bell, and Robert Irwin. Los Angeles, the city notorious for a lack of civic culture and a hostility toward modernism, suddenly hosted the most exciting trends in contemporary American art, including "junk," "assemblage," "finish-fetish," and the city's own "L.A. Look." Coplans wrote, "As few as ten years ago southern California was an intellectual desert. No institution in Los Angeles had enough insight, determination or vitality to bring to bear the kind of pressure needed to create an environment in which art could flourish as a living and vital entity. Given this background, the blossoming of the Los Angeles area as a center of modern art during the past decade seems nothing short of miraculous."[2] According to Coplans, Los Angeles had spent the past decades in a creative vacuum only to produce a new generation of brash male artists whose hipness was only overshadowed by their genius. He argued that Los Angeles' artists "were driven by a compulsive search for quality in their own work" and "by an insistent demand to see firsthand the important art of their time."[3]

Despite the city government's internal battles over art and modernism, these artists best known as members of the Ferus Gallery group or, less generously, the "Venice Beach mafia," had indeed emerged as significant Los Angeles-based artists. Examples of Kienholz's politically and sexually explicit assemblages can be found in most major modern-art museums; Robert Irwin designed the gardens of the new Getty Museum and Research Institute, and, along with John Altoon, Ed Ruscha, Craig Kauffman, Ken Price, Larry Bell, Ed Moses, and Billy Al Bengston, is a mainstay of the postwar southern California modernist canon. Ferus's prevailing dominance within postwar Los Angeles art history is so pervasive that modern-day critics feel compelled to point out that the genesis

of Los Angeles art was not the Ferus Gallery when discussing anyone out-side this specific group of artists.[4]

Both the Ferus Gallery and Venice Beach have become mythic spaces in Los Angeles cultural lore as sites where a handful of ragtag bohemi-ans produced their artwork on the margins of the city. Even as munici-pal and county authorities clamped down on artistic expression and made civic participation in the arts extremely difficult, these artists overcame local provincialism to emerge as stars of the post-abstract-expressionism, pop art world. Reiterating Coplans' themes, and going so far as to claim the new art scene as emblematic of the city, in an article entitled, "Place in the Sun," *Time* magazine pointed out: "In the South-ern California landscape, there have sprung up like desert flowers a new variety of artists. They vary widely but are united by a common dedica-tion to 'cool' materials far divorced from the conventions of oil paint and bronze—plastics, neon, acrylics, Plexiglass, aluminum. They also share a preoccupation with a visual illusionism that plays with space and color to make the eye see beyond the surface of the work, perhaps inspired by the clear, bright light of Southern California (on its non-smoggy days)."[5] Not only were the artists themselves cool, but the mate-rials they used also reflected the qualities of Los Angeles' new art scene: young, aloof, and distinct from New York. By drawing attention to the artists' use of postwar urban industrial materials, evidence of Los Angeles' economic affluence, *Time* reaffirmed the youthful freshness of the artists whose "cool" materials also suggested an inherent connec-tion with the contemporary regional economy. The emphasis on the "new" also implied separation from any previous historical context, including the city's fraught relationship with modern art. The press cov-erage depicted the art scene in stark isolation from the city's broader history.

In contrast to the perspective of *Vogue* and *Time* magazines, Los Angeles' new prominence in the 1960s as an important art center was not because of a sudden burst of creativity that took usually astute art observers by storm. This mythology of the postwar southern California art culture grew out of self-conscious efforts on the part of Los Angeles' young artists to market their work and their creative uses of the urban spaces afforded them. Venice coffeehouses, vacant theaters, back rooms of antique stores, underground journals, and merry-go-rounds proved the only sites available in an era of strict municipal surveillance of public art space. The county museum's decades of resistance to modern and contemporary art and the city's paroxysm of antimodern sentiment in the early 1950s left young, innovative artists with few options other than to retreat to the art schools or forge their own art spaces and communi-ties. Fortunately, rents were cheap, and Los Angeles' notorious sprawl

left enough space unoccupied for artists to spread out and experiment with what would frequently become large sculptures and light-catching installations. Traditional public exhibition spaces such as the Municipal Art Gallery in Barnsdall Park or at the county museum, however, were unavailable. Self-promotion, inventive uses of alternative spaces such as the Venice coffeehouses, and no small amount of hustle challenged the conservative cultural restraints in Los Angeles and produced the "cool" scene.

Ed Kienholz and Wallace Berman used found objects, garbage, discarded wood, print media, and rusted hulks of cars to build installations and assemblages critiquing postwar materialist culture.[6] With the dark imagery of dismembered dolls and heavy meaning of Kabbalah texts, they represented the countercultural, Beat, and jazz-infused art considered "serious" art by their contemporaries. John Altoon worked mostly with pen, color, and paint. Others, including Billy Al Bengston, Craig Kauffman, Larry Bell, Ken Price, and Ed Ruscha, took great interest in the southern California popular culture surrounding them. Car paint, light bulbs and new materials such as fiberglass, acrylics, and Plexiglas allowed the artists to form light-filled glittery finishes, gleaming sheens, and glossy topcoats labeled "finish-fetish" or "L.A. Look" by contemporary critics and friendly observers. Almost all of these artists crafted images of themselves as both Los Angeles artists and as young men with machismo to spare. Echoing reviews of Jackson Pollock a decade earlier, the critic Jules Langsner described Altoon's October 1958 Ferus exhibition as "Abstract Expressionist oils [that] are vigorous, forceful, masculine."[7] The artwork reflected this masculinist self-identification as did print advertisements for their shows that depicted them on surfboards, in cars, on motorcycles, and in bed with multiple women. By taking a look at the national fascination with Venice and the art and advertising produced at Ferus, one observes the conscious formation of a postwar Los Angeles artistic identity.

Beyond the creation of cool artistic personae, the city's new reputation as an art center had its roots in the very struggles that had obscured it from serious consideration as anything but a cultural backwater. The conservative assault on the arts during the postwar period had further isolated the city from the growing postwar art market and the accelerating cultural dominance of New York while undermining the development of a local art scene. The major art press was located on the East Coast, including the *Times* and *Art News*, and Los Angeles' art world appeared in its pages by turns either quaintly obsolete or obscenely reactionary. Langsner, the artist and art critic for *Art News* and *Art International*, as well as the associate editor of *Arts and Architecture*, covered Los Angeles throughout the 1950s and 1960s and tirelessly promoted the

Figure 21. Ken Price, Ferus Gallery announcement, 1961. Courtesy of Ken Price Studios.

city's artists and galleries when no one else would. Yet, even he feared that "a tub-thumper might well . . . twist popular prejudices to set himself up as the town's art commissioner" and that "the temper of the art community, somewhat scorched by politicians and amateur pundits, is still a bit on the waspish side."[8] While investors, philanthropists, and critics helped drive the New York-based artists Pollock, Gorky, de Kooning, Rauschenberg, and Johns to international prominence, Los Angeles seemed to fall off the nation's creative radar. In addition, if municipal officials alone did not damage the city's reputation, perhaps it was embedded in Los Angeles' physical form to be the dowdy cousin of the world's art centers. In 1956 the gallery owner and painter Herman Cherry pessimistically pointed out that urban sprawl left artists isolated and vulnerable to the city's assaults: "Los Angeles is a community where artists live under the strangest conditions of any of our major cities. To visit an artist or a gallery one has to brave the nerve-wracking traffic . . . It makes it exceedingly difficult for artists to get together. There is nothing like . . . a Greenwich Village, or the Left Bank. Efforts in the past to find a meeting place have always failed and were doomed to fail from the nature of the place."[9]

While there was a community of serious professional artists acclaimed locally and abroad that included Lorser Feitelson, Helen Lundeberg, Karl Benjamin, Emil Kosa, Hans Burkhardt, Knud Merrild, Rico Lebrun, Howard Warshaw, and William Brice, there was little institutional support beyond teaching in the art schools.[10] June Wayne, founder of the Tamarind Lithography Workshop, made clear in a 1970 interview that the lack of either supportive civic interest in the creative arts or a dynamic gallery life such as existed in New York or Chicago kept Los Angeles lagging well behind:

There was very little "scene" here. The first galleries were just starting up, like Landau. Walter Arensberg and his collection were here . . . Stendahl was here with his great Pre-Columbian [art]. Vincent Price [founder of the Modern Institute of Art] was wandering around but wasn't a big deal except that he was a movie star; same thing of Edward G. Robinson . . . The Los Angeles County Museum was stodgy and mixed in with dinosaur bones and natural history. There were pockets of artists but L.A. lacked the *density* of New York and therefore seemed countryish and too "laid back."[11]

Like other professional artists and gallery owners, Wayne believed that Los Angeles' geography prevented the formation of concentrated artists' communities. The city's sheer size and spatial decentralization prevented the type of artist clusters found in other art centers, and the lack of focused market interest meant that there was little economic base in sales, with artists' primary incomes coming from teaching or working for

the film industry.[12] Unlike in New York, there were few lofts and Los Angeles lacked the institutional support that San Francisco had in the San Francisco Museum of Art and the DeYoung Museum. Instead of a cultural center with an institutional infrastructure, the Los Angeles art world was remarkably diffused throughout the city.

Not surprisingly, the city's 1950s campaign of public hearings, police surveillance, and a calculated lack of municipal funding either forced its avant-garde to retreat underground or pushed promising talent out of the city. In 1955 and 1956, Ferus founder Walter Hopps found that the city simply would not reserve or lease him any municipal exhibition space. In 1957 Wallace Berman left Los Angeles for San Francisco after being arrested on obscenity charges at the Ferus Gallery's opening show, and by 1959 the Los Angeles County Sheriff's Department was systematically raiding and closing Venice Beach coffeehouses. Yet, Venice and Ferus defied Los Angeles' cultural conservatism and staked claims to a civic imagery of youthful bohemianism and commercial machismo. The evidence suggests that clues to their survival lay in the artists' efforts to overcome urban sprawl and disparate art communities to form concentrated scenes.

One critical factor in the survival of 1950s artist communities was the 1944 Servicemen's Readjustment Act. The act, or the GI Bill, as it was more commonly known, caused an enormous increase in the number of college students in the United States as veterans flocked to subsidized university educations. Between 1945 and 1956, 2.25 million veterans attended college, the vast majority men who chose liberal arts specialties over science or business training.[13] Veterans, such as John Altoon, Robert Irwin, Noah Purifoy, Karl Benjamin, and Lee Mullican all attended the city's art schools on federal subsidies. With galleries such as the Los Angeles Art Association purposefully promoting the artwork of locally trained war vets, forming a type of clearinghouse whereby artists and buyers could find one another, young, newly-trained artists were primed to build an energetic community.[14]

Another reason that Ferus and Venice emerged so prominently was the appropriation of their bohemian, Beat identity by cultural entrepreneurs who harnessed popular support and publicity for the new Los Angeles art scene. Eclipsing an earlier generation of serious painters with a distinctive and celebrated hard-edge abstractionist style, the new bohemians caught national public attention, in effect, because the city council's efforts to eradicate modern art backfired by pushing young artists out of mainstream art forums and into alternative and underground scenes at precisely the moment that a local and national audience was prepared to receive both the scene and the hype. It was in the coffeehouses of Venice that the Beats took hold in the early 1950s and it was

in commercial coffeehouses in other parts of Los Angeles that entrepreneurs took hold of the Beats, creating a hugely popular and profitable alternative fashion for teenagers and tourists. The more Los Angeles pushed to close down the coffeehouses, the more popular coffeehouses became.

The fact that Ferus was conveniently located on the gallery strip in West Hollywood generated a market of avant-garde collectors and a loyal audience for Los Angeles' pop art and 3-D installations of found materials. Prior to Ferus's opening, art critics had already identified La Cienega Boulevard as the site of the local avant-garde because of the short strip of modern and contemporary art galleries found there. When the Los Angeles Art Association moved from its temporary digs on Beverly Boulevard to La Cienega in 1960, the association's executive director Helen Wurdemann conscientiously promoted the strip as "Gallery Row," the highlight being weekly talks and directed tours through all the La Cienega galleries. Starting in 1962 and running through 1969, the Monday night "art strolls" attracted large numbers of passersby and an increasingly well-informed clientele.[15] Together with Walter Hopps's art classes for collectors at UCLA, the Los Angeles Art Association went a long way toward creating a cadre of patrons and collectors. This circle of entrepreneurs and customers helped solidify a disparate cultural scene and helped overcome the sprawl that left artists isolated and vulnerable to the city's assaults. By the time *Vogue* and *Time* focused their gaze on Los Angeles' up-and-coming artists, the private gallery strip had already achieved a certain degree of polish.

Thus it was that a young cohort of artists managed to completely eclipse an earlier generation of serious painters with a distinctive and celebrated style. Helen Lundeberg (1908–99), for example, had emerged in the 1930s and 1940s as one of the most prominent of American surrealists, while her husband, Lorser Feitelson (1898–1978), was recognized for his late-1940s paintings of abstracted spatial forms. The two continued to be prolific painters throughout the 1960s and were actively involved with the Los Angeles Art Association and the promotion of art in the city. Between 1956 and 1963 Feitelson hosted his own show, the Los Angeles Art Association–sponsored *Feitelson on Art*, which ran on the local NBC affiliate KRCA (Channel 4) every Saturday evening at 5:30. The show featured weekly discussions with local and nationally acclaimed artists and analyzed specific artworks and painting techniques. With few public spaces in which to sponsor public art, television served as a medium where one's own living room became the access to local civic culture.[16] Together, Lundeberg and Feitelson led other painters including John McLaughlin and Karl Benjamin, to form a loosely associated school of Los Angeles artists working in hard-edge geometri-

Figure 22. Los Angeles Art Association, 825 La Cienega Blvd., ca. 1965. Courtesy of Los Angeles Art Association.

cal abstractions. Feitelson, McLaughlin, and Benjamin together with Frederick Hammersley were featured in a 1959 county museum exhibit, "Four Abstract Classicists," that received critical acclaim, traveled to Europe, and according to Peter Plagens, "provided Los Angeles with its first claim to international success as a modern art center."[17] This might have been so, but the exhibition took place at precisely the same time that Ferus and Venice began attracting national attention as the center of the new bohemian and Beat-associated scene. Though the hard-edge abstract painters achieved respectful notoriety in the art press, they represented older trends in modern American art. They were not popularly competitive with the bright colors, car paint, and stud personae of finish-fetish and the L.A. Look.

Against an eclectic backdrop of repressive cultural politics, dislocated urban geography, youthful machismo, and pop culture, Los Angeles attracted artists to live under the southern California sun. Predominantly men, many of whom were of working-class and rural backgrounds, they arrived on the coast because of the availability of cheap housing, the expanding and reputable art schools, and the pursuit of

the good life. Many would not stay, finding the scene wanting, unable to find a market, fearing the city's oppressive art politics, or simply disliking the proximity to Hollywood. However others did stay building lives and careers for themselves.

Born in 1927, Edward Kienholz grew up on a farm and lived through the lean years of the Depression in rural Washington. Kienholz understood poverty and learned to make use of whatever materials were on hand. After an academic career of fitful attendance at various schools and odd jobs, he moved to Los Angeles in 1953, traded one of his own paintings for a tooth extraction, and decided to make a living as an artist.[18] When asked why he chose Los Angeles, Kienholz responded that "it was so big that you could be completely anonymous. . . . And I liked that. I liked that feeling. It wasn't a small town; [there weren't] people looking over your shoulder."[19] In contrast to June Wayne, Kienholz preferred Los Angeles' decentralization. He felt that it provided artists with more creative freedom because they could work alone, unaffected by the demands of a trendy art market. Kienholz intensely disliked the abstract expressionist art produced in Los Angeles in the early 1950s and felt that the urban sprawl allowed enough room for young artists experimenting in new forms to create a new audience.

Kienholz may have seen the creative benefits of Los Angeles' dislocated art world, but soon he was nevertheless at the forefront of efforts to build a closer-knit arts community in the heart of West Hollywood. Shortly after his arrival in Los Angeles, he met the printer Robert Alexander, who would later found the Temple of Man in Venice Beach. Kienholz recalled that Alexander took him to his first viewing of a commercial art gallery.[20] In the Felix Landau Gallery, "everything was white and clean and pretty [and I thought] that's the way it should be."[21] Kienholz asked to exhibit there, but Landau refused. Not easily discouraged, he visited two more respected Los Angeles galleries, the Frank Perls and the Paul Kantor. Laughed out of both, Kienholz realized that he would have to open his own gallery if he had any chance of selling his artwork.

A decade younger than Kienholz, Ed Ruscha moved to Los Angeles from Oklahoma in 1956 with the intention of becoming a commercial artist. Filled to capacity with Korean War veterans pursuing arts degrees, there was no room for Ruscha in the Art Center School in Pasadena, the region's main institution for commercial art. Instead he attended Chouinard, "the Bohemian school . . . beards and sandals and fine arts."[22] Art friends Jerry McMillan and Joe Goode followed Ruscha from Oklahoma and together studied at Chouinard under Robert Irwin, Emerson Woelffer, and John Altoon.[23] Young and attracted to the popular culture of hot rods, custom cars, and Disney animation, Ruscha set-

tled into what would become an extraordinary art career. His early internships were with Plantin Press, where he focused on book printing and design. After art school, however, influenced by Los Angeles' culture industry and the stirrings of pop art, Ruscha began work on his common objects and words paintings. These would find their way into galleries and museums early in Ruscha's career and are now exhibited in modern art museums around the world, fetching enormous prices at auction. While many artists experiencing gallery and museum success on the West Coast made the move to New York, Ruscha, like Kienholz, chose to stay in Los Angeles.

Craig Kauffman, born in 1932, was a Los Angeles native. He said that it was "under a double challenge from both San Francisco and New York" that artists in his hometown met with the L.A. Look. [24] As reaction to the abstract expressionism so prevalent in the Bay Area and on the East Coast, young Los Angeles artists worked with new industrial materials and made slick surfaces to match. They created colorful, often three-dimensional confections such as "a brightly colored ceramic egg coyly oozing glossy purple refried beans by Ken Price [, . . .]a plexiglass-encased painting of a painting of a sheet blowing in the wind by Joe Goode [, and] a vacuum-formed violet bulge by Craig Kauffman." [25] Los Angeles artists were making what Kauffman called "clean things," in contrast to the heavy painterly style prevalent in other cities. Active in the new art scene from early on, and returning to Los Angeles after a couple of years in San Francisco, he did not seem to experience the cultural isolation that other local artists described. In addition, rather than provincial, the most frequent criticism leveled against the city, Kauffman described the scene as professional. The greatest difference between San Francisco and Los Angeles, according to Kauffman, was the commercial orientation of southern California artists. [26]

Another of the artists who chose to stay in L.A. was Billy Al Bengston, who was born in 1934 at Dodge City, Kansas. From 1953 to 1957 he studied at different colleges in Los Angeles and San Francisco, finishing at the Los Angeles County Art Institute (now Otis College of Art and Design). He went on to teach classes at Chouinard. His first exhibition was held at the Six Gallery in San Francisco, and he had his first one-man show at the Ferus in 1958. Bengston became most famous for his motorcycle-parts paintings. A motorcycle racer and part-time employee in a bike shop, he often painted gas tanks, trim, and other parts. Noting how quickly traditional oil paints could crack, Bengston experimented with the surfaces produced by industrial spray paint. Described by some critics as pre-pop, he distinguished himself by incorporating everyday objects as both subject and surface into his artwork before Warhol and other stars of the American pop-art world did so. He would take a paint-

ing such as *Sonny 1961,* which featured his iconographic military stripes, and wax it to give the picture the sheen of well-tended car. With his dark sunglasses, jeans, and tough talk, Bengston stood out among the Ferus group. Together with Ken Price and Robert Irwin, Bengston was a surfer who designed and painted coveted boards benefiting from the technological revolution in industrial materials. *Life* featured Irwin with a Bengston-painted board in a 1962 article entitled "A Painting Surfboarder," which emphasized the fusion of art and beach cultures.[27] Bengston's artwork and personae melded together into a specific Los Angeles lifestyle that sold the postwar promise of speed, leisurely prosperity, and freedom from responsibility. As the art historian Andrew Perchuk pointed out, "Bengston is one of a number of West Coast artists, including Robert Irwin and Ken Price, who were instrumental in redefining the terms of artistic identity in the early '60s by insisting that subcultural affinities and leisure-time activities (surfing, car customizing) were at the foundation of their artistic personas."[28] A specific urban lifestyle was part of the artwork and a significant reason for its popular appeal. This was certainly true of Venice Beach, the bohemian art community and surf scene that formed the backdrop for the emergent west-side gallery culture, providing both collegial and creative support while addressing troubling concerns of its own.

Considered by critics to be the runt sibling of the better-known bohemian art circles of the Beat generation, New York City's Greenwich Village and San Francisco's North Beach, mid-1950s Venice nevertheless had a vibrant scene of poets, novelists, painters, and other colorful characters. Venice, the early twentieth-century urban-bourgeois fantasy of the developer Abbot Kinney, who had hoped to bring genteel culture to Los Angeles, was by the postwar period a decaying wreck of peeling paint, ostentatious archways, crumbling stucco, and stinking sewers. Its proximity to the beach, however, and its cheap rents made it attractive to every type of alternative lifestyle follower, including artists, writers, musicians, student dropouts, dope smokers, Zen masters, vegetarians, lesbians, and gay men. The Gas House coffeehouse and the Venice West Café functioned as town hall, watering hole, and crash pad for the authors and painters who lived in or visited the area. Both coffeehouses exhibited and sold artwork produced in the community and hosted live music and poetry readings, creating an alternative civic art center for Venice residents.

The most famous resident of "Venice West" was the writer and Beat guru Lawrence Lipton. Lipton surrounded himself with lesser-known painters and writers of the era, such as Arthur Richer, Stuart Perkoff, Alexander Trocchi, and Charles Newman, but also occasionally hosted famous guests such as Allen Ginsberg, Jack Kerouac, Lawrence Ferlingh-

Figure 23. Billy Al Bengston, *Sonny 1961*. Courtesy of Billy Al Bengston.

etti, and Kenneth Rexroth. Frustrated by his lack of writing success, and feeling put out by his friend Rexroth's lack of attention to the Venice scene, Lipton set out to show the world that Los Angeles did have a Beat art culture as good as anything one could find in other cities. The result was his best-selling 1959 tome, *The Holy Barbarians*. Meant as a sociological history of southern California Beat culture, it was interpreted by reviewers and Americans across the country as a guidebook to coolness, a veritable how-to guide to becoming a beatnik.[29] With John Altoon on the cover, shirtless and sitting with friends on a mattress in a dingy apartment, abstract oil on the wall behind him, the dust jacket promised "the first complete story of the BEAT GENERATION." It was both tourist guide and a call to arms:

Our barbarians come bearded and sandaled, and they speak and write in a language that is not the language of conventional usage. This is not, as it was at the turn of the century, the expatriates in flight from New England gentility and bluenose censorship. It is not the anti-Babbit caper of the twenties. Nor the politically oriented alienation of the thirties. The present generation has taken note of all these and passed on beyond them to a total rejection of the whole society, and that, in present-day America, means the business civilization. The alienation of the hipsters from the squares is now complete.[30]

Whatever Lipton's personal motives in writing the book, the result was a remarkably successful advertisement for the neighborhood. Complete with photographs of "real" Beats and a glossary of Beat jargon, *The Holy Barbarians* attracted thousands of tourists and reporters to Venice Beach throughout the summers of 1959 and 1960. The influx of cultural voyeurs in shorts and suntan lotion ended what local "old-timers" felt was the genuine Venice experience of bohemian community and anonymity. Lipton's clever encapsulation of the Beat experience also attracted unwanted attention from the Los Angeles Police Department, which hoped to track down the narcotics users described in *The Holy Barbarians* in the hopes of a headline-grabbing bust. Even more damaging, however, the media attention armed "square" homeowners with sensationalist ammunition about the freaks in their midst. Organized into groups such as the Venice Civic Union and the Women's Civic Club of Venice, homeowners took the opportunity created by the publication of *The Holy Barbarians* to rid themselves of their neighborhood's bohemian element. In the *Los Angeles Times*, Alfred S. Roberts, president of the Venice Civic Union, complained that since the publication of Lipton's best-seller, "beatniks have been pouring into Venice from everywhere. We've got to get on our feet and scream and get these people out of here."[31] One distressed Venice poet retorted in the papers, "These property owners are trying to kill the arts in America."[32]

Figure 24. Cover of Lawrence Lipton's *The Holy Barbarians,* featuring John Altoon and friends. Photograph by William Claxton. Courtesy of Demont Photo Management.

While homeowners flipped their collective wigs and wrote angry let-
ters to the papers and the city government, cultural entrepreneurs capi-
talized on the public interest in hanging out with the Beats. In 1959
alone more than fifty coffeehouses (eateries that did not serve alcohol)
opened in the broader Los Angeles area, from Malibu to the Sunset
Strip and Pasadena to as far south as Laguna Beach. With cover charges
and seventy-five cent cups of coffee, these cafés were serious business
enterprises with an eye for fashion. Herb Cohen, who opened Cosmo
Alley and the Unicorn, required his wait staff to dress in "beatnik style
to provide atmosphere for the 'square' eager to glimpse the Beat
world."[33] The *Los Angeles Mirror News* published a series of tourist guides
to the Beat generation that listed the new cafés along with descriptions
of the artwork and the art scene found inside:

Café Frankenstein, Laguna Beach. Covered inside and out with murals by Burt
Schoenburg. Dark atmosphere, several folk singers, a biographer who will write
one's life story for 30 cents. Mostly college types; Cat's Pajamas, Arcadia. Walls
adorned with ceramics, oils, watercolors, ink drawings by Bill Garner. Mostly San
Gabriel customers in teens and early 20s; Club Renaissance, Sunset Boulevard.
Has a membership gimmick. Very commercial. Sells records, sandals, books, pot-
tery, ceramics. [Features] experimental films, low budget operas and dramas,
pantomime, poetry, small jazz groups. Mostly Hollywood crowd; Dragonwyck,
Pasadena. Entire place painted black. Paintings on the walls but one can't see
them. Predominantly Negro.[34]

Stories of the economic threat to bar and nightclub owners and tales of
thousands of teenagers flocking to late-night and possibly racially inte-
grated dens of iniquity made the newspapers frequently enough to pres-
sure both city and county authorities to look into the "coffeehouse
problem."[35] Nightclub owners' concern about the popularity of the cof-
feehouses encroaching on their business went so far as a one-hundred-
thousand-dollar damage suit lodged against Herb Cohen for purpose-
fully turning a nightclub into a "beatnik hang-out."[36] With nightclub
owners lobbying hard, soon the Los Angeles City Council required all
coffeehouses to have entertainment licenses.[37] Requiring the licenses
did not simply create an inconvenience and an expense for their own-
ers; it gave the police department the power and cultural authority to
grant the permits at its own discretion. As a result, the police had the
power to control sites of cultural activity, usually by making arrests,
orchestrating drug searches, planting spies, and through general surveil-
lance. Like San Francisco's North Beach and New York's Greenwich Vil-
lage, Venice's emergent art scene was targeted as a center of "cool" and
the police worked hard to infiltrate it. An undercover officer in San
Francisco reported that for five months he "faked marijuana dreams,
played the harmonica, and even wrote beatnik poetry nobody liked."[38]

Figure 25. The Venice West Café, 1959. Photograph by Austin Anton from Lawrence Lipton's *The Holy Barbarians*.

In Los Angeles, though, artwork itself contributed to the suspicious nature of the bohemian community. Coffeehouses displaying paintings and sculptures attracted the most attention from the Los Angeles Police Department and the county sheriff's office. An anonymous coffeehouse owner reported in the *Times* that "the average cop thinks there is something subversive about any place with paintings on its wall. He thinks an artist is a suspicious character partly because of the way he may dress and partly because the officer holds art itself suspect."[39] The police concern with art bore a striking resemblance to the warnings about young people with guitars and long hair issued in Leon Charles's 1951 widely circulated propaganda piece *How to Spot a Communist, or "Psychological Warfare": A True Story of the Communist Plot to Destroy America; Will You Help?*[40] In the tradition of *Red Channels*, *How to Spot a Communist* attempted to pinpoint with precision the physical and cultural traits of those espousing suspected left-wing ideologies.

With artwork already historically proving politically problematic in Los Angeles, the concentration of an art scene in Venice focused municipal authorities' attention on the subversive nature of artists themselves. Another series of public hearings began in August 1959 when Eric "Big Daddy" Nord, owner of the Gas House, requested an entertainment

license from the city government. (The Gas House was named for the impending execution of Caryl Chessman.) Venice civic groups stalled the possibility of Nord receiving his license by demanding an investigative public hearing into the subversive goings-on at his popular coffeehouse. The Gas House hearings were held at the Los Angeles Police Department Building in the new Civic Center, where in 1955 conservative art groups and Councilman Harold Harby had attempted to stop the installation of Bernard Rosenthal's sculpture *The Family*. According to the papers, Big Daddy Nord took a look at the notorious Rosenthal sculpture and said: "Man, I thought the fuzz were strictly squaresville but dig that chopwork. We're home!"[41]

The first opponent of an entertainment license was A. S. Roberts, representing the five-hundred-member Venice Civic Union. His objections to the Venice Beats were that "they drink, make a lot of noise, and act in ways unbecoming normal citizens. I went to the Gas House and saw a bathtub in the middle of it with a man just sitting in it. Just sitting in it!" Roberts's testimony was followed by that of Miss Edgar Hersford, president of the Women's Civic Club of Venice. Upon visiting the Gas House on the Fourth of July, Hersford was horrified to find that the Beats were "standing around smoking, drinking coffee, and acting nonchalant." Lawrence Lipton responded, "The lady is quite right, of course. It's sinful to be nonchalant. We shall endeavor to be more *chalant* in the future."[42]

Yet, it was the idea of an art community, indeed, an artistic civic body, that formed the basis of the Gas House proprietors' arguments in favor of an entertainment license. When the hearings continued on September 2, Lipton, Nord, the singer Julie Meredith, and other representatives of the Venice art community showed their support for the Gas House by displaying paintings and sculptures as evidence that they were indeed artists invested in their community and not the drug-addled troublemakers the police made them out to be. As further evidence of their dedication to civic spirit, they brought along brightly painted garbage cans to place along the beach.[43]

After months of hearings testimony, Police Commissioner Mulherin refused Big Daddy Nord the entertainment license on the grounds "that some of the so-called beatniks are of bad moral character . . . and that issuance of an entertainment license would increase the problems of the Police Department."[44] Nord kept the coffeehouse open anyway and was arrested, charged, and convicted of operating without the license. Shortly thereafter, in 1960, the Los Angeles City Council's Building and Safety Committee condemned and destroyed the building.[45] Six years later the Venice West Café closed in the wake of city council hearings to ban bongo drumming at the beach.[46]

The coffeehouse closures only added to the publicity generated by Lipton's *The Holy Barbarians*, turning Venice into a national phenomenon. *Life* magazine picked up the story of the Gas House and ran a piece called "Squaresville, U.S.A. vs. Beatsville" comparing the life of a "square" family living in Kansas to the Beats living in Venice.[47] Roger Corman's 1959 low-budget horror parody *A Bucket of Blood* brought to the screen the sordid tale of Walter, the slow but endearing busboy who, while working in a Venice coffeehouse, came to covet the acclaim of the Beat poets and abstract artists in his midst because they always got the pretty girls and free drinks. Walter becomes an artist when a dead cat he unintentionally embalmed in cement is revered as a piece of art brut, spontaneous, untrained, but brilliant. Craving more and more attention, he begins to embalm people, tricking the hip Venice scene until one day the plaster chips, revealing the pale bluish flesh beneath. The art in Venice was not just empty of meaning and hollow; it was dead. By 1959 Venice was so famous, it was camp. By encouraging the arrival of more young people, which, in turn, provoked greater crackdowns on the coffeehouses, the national media attention did little to benefit the Venice art scene, which was losing all of its long-standing cultural institutions.

While the "holy barbarians" struggled to hold onto Venice, Walter Hopps was hard at work building a broader audience for the avant-garde in Los Angeles. Hopps, a native of Glendale, was born in 1932 and attended Eagle Rock High School. In the eleventh grade he was introduced to art through a humanities enrichment program that led him on field trips to the Huntington Library and the home of modern art collectors Walter and Louise Arensberg. In an era when modern art was under assault, considered either a joke or a potential Communist threat, Hopps was lucky to meet such modernist aficionados and even luckier to spend time with them beyond the parameters of his high school curriculum. The Arensbergs let Hopps use their library to teach himself the field and, through their extensive personal holdings, introduced him to works by Brancusi, Magritte, and Duchamp (in the case of Marcel Duchamp, Hopps even met the artist when he dined at the Arensberg house). The existence of such an impressive collection in a city whose civic institutions generally ignored the modern must have fueled Hopps' interest and later challenged him to develop a local audience for the avant-garde. He left the city to attend Stanford but, in 1951, transferred to UCLA in 1951 where he studied microbiology and art history.[48]

Hopps's return to Los Angeles coincided with the Griffith Park red-baiting hearings and the censure of abstract and avant-garde artwork in the city's public spaces. Concerned by the effect a blacklist would have on young artists, many of whom were personal friends, he decided to

open his own gallery. In 1954, together with the poet Ben Bartosh and his wife Betty, Hopps opened the Syndell Studio on Gorham Boulevard in Brentwood. The gallery's name had inauspicious roots. Maurice Syndell was a suicidal Nebraska farmer who killed himself by jumping in front of a car traveling through an empty stretch of heartland highway.[49] Syndell Studio was a ghoulish inside joke and possibly a self-denigrating reference to committing professional suicide. Syndell showed local artists' work and also imported examples of contemporary San Francisco art to L.A. While at Stanford, Hopps had encountered the work of James Dixon, Frank Lobdell, Jay DeFeo, and Sonia Getchtoff, who together with Joan Brown, Clyfford Still, Douglas MacAgy, Clay Spohn, and Hassel Smith at the California School of Fine Arts, created gritty abstract expressionism influenced by the Bay Area's Beat and jazz culture.

Artists and critics credit Hopps with bringing the San Francisco and Los Angeles scenes together in creative ways no one had previously tried. Specifically, he promoted San Francisco action painting, a style derived from Pollock's method of getting inside a painting through the physical means of distributing paint across a canvas in wild, energetic, and occasionally random streaks, splatters, and drips. While seemingly careless, the desired effect depended on great control over the paint and deliberate body movements. Although the form was dominated by men in New York's postwar art world, San Francisco distinguished itself with several prominent women action painters. Jay DeFeo was perhaps the most famous of the San Francisco women Beat artists and her obsessive masterpiece *The Rose* captured abstract expressionist physicality in the extreme. The painting took seven years to complete (1958–65) and, by the time it was finished, was so layered in paint and miscellaneous objects that it weighed over nine hundred pounds, was over a foot thick in places, and seemed to quiver when one looked at it. Getting it out of her San Francisco studio required a large hole to be cut out of the wall. After he left Los Angeles for the Bay Area in 1957, Wallace Berman spent time with DeFeo, photographing her in front of the painting.[50] These photographs made her look very young, extremely beautiful, and, with cigarette in hand, the quintessential Beat girl painter. No such female artist persona emerged publicly in 1950s Los Angeles, though DeFeo and Getchtoff would find a loyal audience in southern California and frequently exhibited at the Ferus.

Not a lucrative commercial enterprise, Syndell Studio's success lay in its generative efforts to push through the dull conservatism of Los Angeles' traditional art culture: "If someone sold a work, so much the better, but the main purpose was to get new ideas and breakthroughs out where they could be seen."[51] To achieve this, in 1955 Hopps conceived of a large exhibition that would focus on the two major trends in

contemporary West Coast art, San Francisco abstract expressionism and Los Angeles assemblage, which had not yet developed into the large-scale installation form it would take in the 1960s. With the conceived exhibition too large for the Syndell Studio, Hopps tried to reserve space at the Frank Lloyd Wright Pavilion in Barnsdall Park but found his request promptly rejected. Hopps also tried the Greek Theater in Griffith Park but learned quickly that any municipally owned property was unavailable.[52] Given the ongoing audits of Kenneth Ross's public arts program and the embarrassing civic controversy caused by Rosenthal's *The Family*, it could not have surprised Walter that the city was uncooperative. This was precisely why artists needed his Syndell Studio in the first place.

Unfazed, Hopps rented the merry-go-round at the Santa Monica pier and launched a show, ACTION I, which has subsequently become a curatorial legend. ACTION I consisted of a tarp stretched around the merry-go-round horses and mounted with about twenty-four paintings, lithographs, and collages. The entire show turned around slowly and played music by John Cage and Dave Brubeck. Folks from Venice Beach, tourists, and patrons from a nearby transvestite bar made up the bulk of the audience, but Hopps did get Allen Ginsberg, Neal Cassady, and Jack Kerouac to attend.[53] He pressed on.

In the spring of 1956 Hopps met Ed Kienholz, who had been using a vacant theater with a double proscenium as the Now Gallery. In exchange for converting the Turnabout into a commercial movie theater, the management gave Kienholz the unused stage. After three months at the Turnabout, Kienholz was invited by Kenneth Ross to be the city's contractor for the annual festival. The 1951 Greek Theater had divided future city-sponsored art exhibits into two types but with the same allocation of public funds, forcing the Municipal Arts Department to turn to private sources for money. Harold Harby's year-long audit of the department's expenditures prompted the withdrawal of private funding. By 1956 the All City Outdoor Art Show's budget had tumbled to fifty-four hundred dollars, significantly less than the forty thousand dollars allotted in previous years.[54] Near bankruptcy, the Municipal Arts Department needed a contractor who would work for cheap and Kienholz fit the bill. Backed by an army of artists-cum-laborers and paid one thousand dollars plus expenses, he organized, built, and promoted the show.[55]

Hopps received a Syndell booth in exchange for helping Kienholz set up the festival and took the opportunity to provoke the municipal authorities who were circulating through the festival hoping to prevent more embarrassing public art controversies.[56] He displayed a downward-facing curved piece of plywood that was painted white and adorned with

Figure 26. All City Outdoor Art Show in Barnsdall Park, 1956. Photograph by
Seymour Rosen. Courtesy of Kristine McKenna.

a tar-dipped ball of steel wool. Kienholz has described the piece as look-
ing decidedly like female pubic hair, and apparently the city agreed,
requesting that Hopps remove it immediately from his festival display.[57]
He did, and the 1956 All City Outdoor Art Show continued without fur-
ther incident. In fact, it was a banner success, lauded by the mayor's
office as the largest municipally sponsored art show in the country. In
two and a half days the festival attracted over eighteen thousand people
who viewed more than a thousand pieces by local artists.[58]

Following the festival's success, Kienholz and Hopps began a produc-
tive partnership. First they reorganized ACTION I as ACTION II and set up
the show at Kienholz's Now Gallery. This time Hopps got the serious
press he had hoped to receive for the merry-go-round show. In his
monthly *Art News* column, Jules Langsner referred to La Cienega as the
"Los Angeles Left Bank" and the Now Gallery as hosting our "local
avant-garde."[59] Langsner's enthusiasm never waned as he encouraged
Angelenos to see works by Craig Kauffman and San Francisco painters
Jay DeFeo and Sonia Getchtoff. Particularly smitten with Getchtoff, Lan-
gsner described her work as "untitled paintings [that] take advantage of
accidents, yet she impresses order upon her emerging forms, and some-

times ends by suggesting palpable landscapes seen through the glass of the imagination."[60]

With the ACTION II exhibit under their belts, Kienholz and Hopps collaborated on their second significant project: opening the Ferus Gallery. The new project was intended for the Now space at 716 North La Cienega, but the proprietor of the theater defaulted on his mortgage payments and lost the theater, and Kienholz ended up on the street. Streeter and Camille Blair, a couple who owned an antique store further down the street, offered the back of their store as a gallery space. Kienholz and Hopps thought that it would work.[61]

Meanwhile, an increase in the number of commercial art galleries in the West Hollywood area, including La Cienega, Melrose Avenue, and Sunset Boulevard, exposed the new influx of private money into Los Angeles art, the growing concentration of an art scene, and an entrepreneurial savvy on the part of a young generation of artists and collectors.[62] Whereas the first decades of the century saw few commercial galleries established in the city, the late 1950s and early 1960s witnessed the opening of over one hundred in a few short years and within a couple of square miles. The new gallery district was based on La Cienega in West Hollywood, one-half mile east of Beverly Hills. Building on a 1940s neighborhood tradition established by the Frank Perls Gallery, where Man Ray showed in 1941, and the Felix Landau Gallery, which opened in 1948, young artist-entrepreneurs began opening their own galleries and displaying contemporary work, among them Esther Robles, David Stuart, Rex Evans, Jack Soles, and Irving Blum.[63] The major La Cienega galleries included Ferus, Primus, Massa, Ceeje Gallery, the Galleria Gianni, and the Los Angeles Art Association, later named Gallery 825. Galleries off La Cienega on Melrose Avenue and Beverly Boulevard included the Comara and the Galerie de Ville. Going west on Sunset one found the Everett Ellin and the Dwan.[64] The Beverly Hills galleries included the Paul Kantor, the Silvan Simone, the Charles Feingarten, and the Michael Thomas. Advertised as the new urban bohemia, La Cienega Boulevard, like Venice Beach, became a tourist destination. In addition, like the coverage of the Beat coffeehouses, newspapers listed weekly tours and special events taking place in the galleries.[65] Most popular were the Monday night "art-walks," when the galleries stayed open late and people could browse from one gallery to the next.[66] These self-guided tours helped collectors find new talent and price the current market. Many, such as Betty Asher, Donald and Monte Factor, and Frederick and Marcia Weisman, became serious contemporary art collectors after learning what to look for in UCLA art-appreciation courses taught by Walter and Shirley Hopps.[67] Langsner became the loudest voice of support for Los Angeles' new status as the second-best city for art in the

United States: "In the space of half-a-dozen years the status of Los Angeles in the art community has changed from the home of the nuts who diet on nutburgers to a lively and vital center of increasing importance on the international art map, having become in the interim the country's second city with regard to caliber and number of galleries, collectors, museum activities, and creatively prodigal painters, sculptors, and printmakers."[68]

This was remarkable praise since a few years earlier he had described Los Angeles art as hovering "at this outermost rim of the continent."[69] Echoing Langsner, *Studio International* reported, "it is estimated that today more original art is sold here than in any city in the United States, including New York."[70] No longer having to exert so much energy locating overlooked or abandoned urban spaces to use as galleries and studios, artists could focus on building a market for their work and exploring new media, and they honed their talents on found materials and the plastic colorful by-products of the postwar military-industrial economy.

Ferus, which opened on March 15, 1957, became the best known of the era's galleries. Unlike others, which either closed quickly or slowly rose to respectable prominence, Ferus lived on far beyond its actual nine-year life span. Kienholz and Hopps organized its shows from 1957 to 1958, featuring the work of more than thirty-five artists who lived, worked, or hung out in Venice, West Hollywood, the canyons, or even the Bay Area. Bought out by the suave entrepreneur Irving Blum and moved across the street in 1958, the gallery flourished until 1966, when Blum pulled out and moved back to New York. With *Artforum*'s office located above the gallery from 1964 to 1967, Ferus was beautifully located at the nexus of Gallery Row and the art press to become the darling of modernist critics and collectors alike.

The gallery's first exhibition was "Objects on the New Landscape Demanding of the Eye" and included, among others, Altoon, Bengston, DeFeo, Richard Diebenkorn, Getchtoff, Kauffman, Kienholz, Ed Moses, Hassel Smith, and Clyfford Still. Essentially a showcase for Bay Area abstract expressionism, the show featured artists whom Hopps would continue to promote for much of his Los Angeles career. In addition, unlike the more commercial Ferus, this early incarnation included women. The name Ferus, proposed by Hopps, captured the essence of an edgy, youthful vanguard and its adaptability to a hostile or, at the very least, an indifferent environment. Hopps took the name from the Latin *Ferus hominis*, meaning "fierce, savage, violent, and irascible." For Hopps, the term "seemed to describe . . . the kind of people we were and the kind of people we were dealing with."[71]

Given the gallery's ferocious name, its most notorious exhibition

might seem an unlikely choice: the work of the poet and gentle visionary Wallace Berman. Lauded by friends, family, and fellow artists as having reconciled the "contradiction between ambition and ideals," Berman came to represent, for a generation of California artists, an authentic voice and genuine dedication to art. Born in 1926 in Staten Island, New York, Berman moved to Los Angeles with his family during the Depression, growing up in the Jewish Fairfax district and in Boyle Heights, two neighborhoods that deeply influenced his art. In the Fairfax, Hebrew lettering was prominently displayed in shop windows and ethnic newspapers while in Boyle Heights, a diverse multilingual neighborhood, Spanish, Japanese, and Hebrew lettering appeared in all over the walls of commercial establishments. Berman's collages, Verifax prints, and assemblages would foreground Hebrew lettering, a feature much noted by art critics and historians.[72] More than the Hebrew, the fact that Berman often layered paper and left sections to peel revealing the print below brings to mind old store signage, beat-up poster boards, newsprint, and other cheap urban street advertising. Unlike the pop works of other Ferus artists that highlight a shiny newness obscuring any references to history or ethnicity, Berman's art is dependent on a heavy sense of the past. His work is in stark contrast to the L.A. Look, and yet it nevertheless speaks to a distinct Los Angeles sensibility. The city was made up not only of suburbs and beach bums but also of complicated multiethnic neighborhoods full of immigrants and refugees laden with the history and concerns of an old world found across the Atlantic, the Pacific, or south of the United States-Mexico border. Of the artists active during this period of creative revitalization, Berman alone offered a serious examination of the spiritual and historical weight of life in his city.

A private and family-oriented man, Berman spent ten years experimenting with painting, drawing, and assemblage before deciding to hold a public exhibit. His wife Shirley has described his prior shows as wine-and-cheese parties held in their living room in Topanga Canyon.[73] While he limited his own exhibitions, Berman promoted his friends' work throughout Los Angeles and San Francisco. From 1955 to 1964 he collected the writings, poetry, photographs, and drawings from the underground art scenes in these two cities and printed them in the handmade periodical *Semina*.[74] Works by Allen Ginsberg, George Herms, Bruce Conner, Bob Kauffman, and David Meltzer all appeared in issues of the journal. *Semina* served as a textual means of holding together a scattered artists' community and a creative response to a repressive political environment. *Semina* literally stitched together two cities and created a sense of unity cherished by those who participated. For artists in southern California, *Semina* served an even more significant purpose. At the height of Los Angeles' cultural censorship, *Semina* represented a

Figure 27. Wallace Berman, *Untitled*, 1956–57. Los Angeles County Museum of Art. The Kleiner Foundation Gift of Contemporary Art through the Modern and Contemporary Art Council. Photograph © 2006 Museum Associates/LACMA.

gathering place for an art scene that had little geographical space to inhabit—just a textual one. Shy and unassuming, but also self-confident, Berman was convinced by Kienholz and Hopps to exhibit publicly in their new gallery on La Cienega Boulevard.

On June 7, 1957, Berman set up a display of collages and assemblages, the centerpiece of which was a sequence of four large wooden pieces, *Homage to Herman Hesse*, *Veritas Panel*, *Cross*, and *Temple*. Each piece resembled heavy, old-fashioned furniture and represented religious,

sexual, and domestic themes familiar to everyone who knew him. Outside the intimate *Semina* group, however, Berman's work was open to harsher scrutiny and criticism. An unidentified visitor took offense at a tiny photograph of two people engaged in sexual intercourse suspended from *Cross* and reported to the Los Angeles Police Department that Berman had exhibited "lewd and lascivious pornographic art."[75] The police phoned the gallery to give advance notice of their inspection and advised Berman that he could remove objectionable material before they arrived. Berman left the artworks intact. When the Hollywood vice squad arrived, dressed as tourists in Hawaiian shirts, they asked, "Where's the art?"[76] The police walked past the offending photograph of sexual intercourse and arrested Berman for an ink drawing of mythical creatures having sex, which was not even by Berman but by the poetess Cameron. Nevertheless, Berman was brought before Judge Halliday (the same judge who had found Henry Miller guilty of producing pornography earlier in the decade). Halliday also found Berman guilty and sentenced him to either thirty days in jail or a $150 fine. The actor Dean Stockwell paid the fine, and shortly thereafter Berman and his family left for San Francisco, damning Los Angeles as the "city of degenerate angels."[77]

In contrast to scholars who have described Berman's arrest as an especially egregious event in Los Angeles' history of artistic repression, Kienholz described Berman's arrest quite differently. In a 1976 interview, he referred to the incident as a "big farce." Berman and the other artists hoped that there would be some "hue and cry over the intrusion of police in the arts, which [they] expected. It didn't work."[78] Berman had planned to carry the American flag as he marched off to jail, but by paying the fine, Stockwell ended the incident. The exhibit closed for a few days in anticipation of other police visitors, but since the offensive drawing had been removed, Kienholz simply reopened the show. There were no other complaints.[79] In a 2003 public discussion at the Getty Research Institute, Charles Brittin remembered that Kienholz had, in fact, waved Cameron's drawing at the police and asked, "is *this* what you're looking for?"[80] From this perspective, two interpretations are possible—one, an overly oppressive police intrusion on a peaceful creative haven, and the other, a purposefully provocative encounter on the part of the artists meant to draw public attention to themselves. Perhaps both are true. The fact is that Brittin and his camera were ready when the police arrived, and he created a photo-documentary of the arrest, photographs lovingly displayed forty years later by Craig Krull.[81] Rather than passive martyrs to the cause of free artistic expression in Los Angeles, Berman and the Ferus group seem to have been reasonably self-confident and several steps ahead of local authorities. The point is less that the city had

improved its position vis-à-vis the avant-garde (which clearly it had not) but that by occupying more space and forging a visible community, artists were actively negotiating with municipal authorities over cultural turf, and art was gaining ground. Berman would stay in San Francisco for several years, appearing in George Leonard's 1958 *Look* pictorial "The Bored, the Bearded, and the Beat," in which Berman and his wife Shirley were pictured in their furnitureless apartment with their young son Tosh looking desolate, rumpled, and stoned. Berman's credo "ART IS LOVE IS GOD" was misquoted by Leonard as "Man, art is cool and cool is everything."[82] Berman would end his self-imposed exile in 1961 and return with his family to Los Angeles, settling permanently in Beverly Glen. He lived there until he was killed by a drunk driver in 1976.[83]

Berman stands out among the Ferus artists for the type of artwork he was producing and for the *Semina* scene he cultivated, which, in turn, surrounded and protected him. Apart from George Herms, he did not look like the other artists. His bearded hippie-prophet appearance distinguished him from the biker or athletic surfer look characterizing other Los Angeles artists of this period, and he showed at the Ferus only once. Other artists on the Ferus roster tended to rotate in and out of shows each year, with Altoon, for example, showing at least nine times between 1957 and 1959 and fifteen times before the gallery closed. Bengston, to cite another example, was included in a dozen exhibitions, including several one-man shows.[84]

Like Berman's work, Ed Kienholz's artwork marked a sharp distinction from the finish-fetish and L.A. Look that would later characterize the gallery. Kienholz's sculptures and freestanding installations were made of garbage, found objects, and layers of varnish that embalmed political and pop cultural ephemera such as campaign buttons and comic books. Kienholz was not a pop artist, as he rejected the fetishism of new consumer durables, preferring sexually and politically charged critiques of materialism and ill-gained prosperity. His elaborate constructions were dubbed "junk" by critics for their materials but not their meaning. It is not surprising that Kienholz's work would evolve from abstract expressionism to three-dimensional collage to freestanding room-sized structures built of car parts, televisions, and broken store mannequins. Postwar Los Angeles was covered in the detritus of wasteful consumption, and Kienholz, like Berman, was from a working-class background without the resources to invest in paint, canvas, or bronze. Even if he had had the resources, Kienholz was so well trained in auto repairs and construction that the sheer amount of junked materials in Los Angeles must have seemed to him to be begging to be restored or rebuilt into something new. Berman originally worked with large wooden pieces since he worked for years in a local furniture factory. There he

could get material cheap and learn to put it together. The art historian Thomas Crow points out too that southern California artists were so marginalized from the national art market that they did not expect to sell anything so works made out of cheap and disposable materials were particularly attractive.[85] Artists recycled secondhand consumer durables into new forms, making use of material goods but paying little or nothing for them and using them in ways unintended by the manufacturers.

In the fall of 1958 Irving Blum moved to Los Angeles from New York, where he worked for the Knoll International Showroom, an expensive furnishings house. He arrived in Los Angeles in order to find artists with marketable potential and build a profitable art gallery. Wanting to make the move from furniture showroom designer to gallery owner, Blum felt that the Los Angeles art scene seemed easier to infiltrate than that of New York and held the promise of dynamic young artists moving beyond the abstract expressionism still dominating East Coast galleries. The gallery with the most interesting art was Ferus.[86] Ferus had great promise but was in financial trouble. Kienholz's preference for bartering rather than selling artwork did not pay the rent, and the gallery could not survive much longer on Hopps's salary as a UCLA art instructor.[87] Unhappy with the inevitable commercialization of his gallery space, Kienholz sold his share in Ferus to Blum for about $600.[88] Needing financial backing, Blum brought in a third partner, the wealthy philanthropist Sayde Moss, who bought a one-third interest in the gallery. According to Hopps, Blum contributed the proceeds from his voice-over work in a porn film, *The Immoral Mr. Teas.*[89]

Blum moved the gallery across the street and gave it a swank new interior, which Kienholz described as "a slick posh look compared with the old because [he] . . . could afford to buy carpets and things. I felt it [lost] some of the *esprit de corps* that the old gallery had."[90] Blum added three new artists, Ed Ruscha, Larry Bell, and Ken Price to the roster while scaling down the original thirty-five artists to around seven. He emphasized the L.A. Look and finish-fetish styles and brought in major New York names such as Andy Warhol and Roy Lichtenstein. Warhol's July 1962 appearance in Blum's gallery marked his first formal exhibition and his first of two Ferus shows, the second of which ("Liz-Elvis") brought Warhol into the young Hollywood scene, got him excited about using movie cameras, and led him to declare, "for a while there in the early sixties, it looked like a real solid art scene was developing in California. . . . But there weren't enough dealers there and the museums weren't active enough, and the people just weren't buying art—they were satisfied looking at the scenery, I guess."[91] Blum increased publicity for the gallery through *Artforum*'s glossy but hip advertising pages. Images of Ferus artists, all male, depicted them as "enjoying their hip,

California youth, surfing, riding motorcycles, reveling in L.A.'s car culture, and smoking a few cigars."[92] Blum was not the only one to entice haute modernists to the city. By 1961 Hopps had left to run the Pasadena Art Museum where he became famous for staging a chess match between surrealism's überdaddy Marcel Duchamp and the writer Eve Babitz, who played Duchamp in the nude. Hopps would help build the museum into an important center for modern and contemporary art and establish a public place for the exhibition of local art. Most members of the Ferus group had shows there in the 1960s.

If Wallace Berman's art can be seen, to some extent, as a treatment of city, referencing its diverse neighborhoods, recognizing its history, and playing with its cultural layering, the later Ferus artists seem to have rejected L.A.'s history and diversity and instead relished a lifestyle of surface imagery and leisure time. The colors of suburban kitchens and new cars permeated the L.A. Look, but this work spoke not of family or home but of surf, beach, and freeway fliers. Influenced by Hollywood, TV shows, and car culture, the new Ferus embraced the decadence of postwar materialism and featured work that helped define an image of Los Angeles as a newly developed frontier—optimistic, youthful, and prosperous.

Ed Ruscha, who did not appear on the gallery's roster until 1963, literally explored Los Angeles far more than his peers did. His painted landscaped wordplay inscribed the city with the language of the culture industry. Artworks with the brightly painted words "HOLLYWOOD" or "20TH CENTURY FOX" reinforced and reflected Los Angeles' reputation as large, brash, and commercial. His photography reveals an obsessive inventory of the city. *Twentysix Gasoline Stations* (1962) (which documented a trip from L.A. to his home in Oklahoma), *Some Los Angeles Apartments* (1965), *Every Building on the Sunset Strip* (1966), and *Thirty-Four Parking Lots in Los Angeles* (1967) offer on-the-ground as well as bird's-eye-view perspectives of the city, finding formal patterns in the banal and grim homogeneity in the sprawl. The film historian David E. James has commented on the cinematographic quality of Ruscha's 1960s photographs: "the Los Angeles they documented was banal but essential—and anything but glamorous. With no people and few cars, the city appears a ghost town of repetitive, suburban sprawl, without narrative or hierarchy, as if everywhere were the scene of a crime—or a film noir."[93] James argues that Ruscha's work produced during the late 1960s, when he was exhibiting regularly at Ferus, avoids connections to larger cultural resonances in the city or in California and seems severe and detached. This is perhaps true of the photographs, but there is no question that Ruscha's work is of Los Angeles, if more distanced perhaps than Berman's work, which embodies an ethnic geography, or Bengs-

ton's, which directly reflects vernacular pop culture. Ruscha's later Ferus work and the pop landscapes that made him internationally famous are intriguing and innovative, and they existed comfortably alongside and within commercial promotion. His art is smart but not especially challenging—there is little sexual, violent, political, or abrasive about it. It is witty and thoughtful, yet flat. His work, despite its filmic nature, emphasizes the two-dimensional, a quality picked up by other artists depicting Los Angeles—David Hockney, in particular, whose suburban lawns, sprinklers, and swimming pools offer a view of the city as if seen through a barbiturate-enhanced stupor. In this mid-1960s period the three-dimensional depth of Kienholz and Berman was obscured by pop's caprices. Yet to this day Ruscha deploys text to great end in his paintings and prints, consciously part of a legacy of Los Angeles artists who historically dealt in newsprint, postcards, and other cheap, distributable forms.

From the beginning, Ferus highlighted the artists more than any specific style of artwork. Wallace Berman's 1957 exhibition poster featured him bearded, turned thoughtfully to the camera, and holding his son. His philosophy "ART IS LOVE IS GOD," handwritten in the bottom right-hand corner, is initialed W. B., as if Berman signed off on his own image. Ken Price's 1961 poster boasted of his known surfing prowess: arms extended in a relaxed pose, in as full control of the wave as he was of his medium. Billy Al Bengston played with his image. In a series of advertisements from 1961 and 1962, Bengston appeared by turns on the motorcycles he raced and superimposed on Buster Keaton film stills. In 1962 John Altoon's one-man-show poster featured a full headshot, eyes cast downward in modesty or perhaps in focused concentration on a task at hand. Celebrity artists also appeared in Ferus announcements. Frank Stella's showed him in a trench coat, spread-eagle in the window frame of an industrial building, supporting it with his body as would Columbo-cum-superhero. Roy Lichtenstein's announcement featured him sitting casually in a sweater and Chuck Taylor sneakers in front of one of his large cartoon canvases, ever the preppy. Ed Ruscha's poster showed him bedded down with two girls, the caption reading "Say Good-Bye to College Joys." The 1964 retrospective of works by Moses, Irwin, Price, and Bengston was titled "The Studs," while a 1963 group show's announcement featured late 1950s photographs by Patricia Faure of the early Ferus artists, including Kienholz and Altoon, roughhousing and posturing.

The ethnic makeup of the Ferus stable did not go unnoticed. At Henry Hopkins's Huysman Gallery, set up across the street from Ferus in 1961, young students coming out of Chouinard (and trained by Altoon and Irwin) staged a counterexhibit, "War Babies," featuring abstract expressionist and assemblage pieces by Joe Goode, Ed Bereal,

Figure 28. Billy Al Bengston, Ferus exhibition poster, ca. 1961. Courtesy of Billy Al Bengston.

Larry Bell, and Ron Miyashiro. More startling than their artwork was the exhibition poster, which featured them in racially stereotyped postures: Goode, a Catholic, eating a fish; Bereal, an African American, eating watermelon; Bell, a Jew with a bagel; and Miyashiro using chopsticks. The staged meal was eaten on an American-flag tablecloth.[94] This

exhibit was remembered for being Hopkins's last gallery show before he became the longtime curator and director of the new Los Angeles County Museum of Art, and the pointed reference to the posturing Ferus promotional imagery is hard to ignore.[95]

The Ferus announcements, placed mostly in *Artforum*, were effective in generating press and attention for the Los Angeles art scene. As hard as the art clubs had worked to promote Los Angeles as an art center and cosmopolitan metropole, it was these young men rejecting the formal parameters of postwar American modernism and tapping a civic identity of beach, sex, and movies that put the city on the national art map. Increasingly there was support from Hollywood. Dennis Hopper and Dean Stockwell were longtime members of the scene. The starlets Teri Garr and Toni Basil partied with the Ferus artists; and the Velvet Underground paid a visit while performing on the Sunset Strip. By 1965 Phil Leider, editor of *Artforum*, "had a Ferus Gallery guy on the cover and every month the stuff we were writing was on the Ferus Gallery."[96] The imagery commodified the artists and helped lay a foundation for the commercial success of Los Angeles' contemporary art.

In emphasizing the artists more than their artwork, the Ferus exhibition announcements revealed undergirding assumptions about the intended audience and market—the attraction of Los Angeles art was its youth, its decadence, and its men. Caroline Jones's study of postwar constructions of the American artist traces the articulation of the art space, predominantly among New York artists, as male, isolated, and dependent on a late nineteenth-century notion of the studio—the site of genius, modernism, and protected and depoliticized thought. By the 1960s the camera, Jones's "machine in the studio," had fully projected the American artist outward, as consumable as the newly minted art pieces of the pop generation.[97] The marketing of the Ferus artists suggests a literal process of incorporating the artists' bodies into the consumable artwork just as the artworks incorporated the materials of the city.

The paring down of the gallery created bitterness for artists. Matsumi Kanemitsu, a successful New York–based artist who worked at Tamarind, Chouinard, and Otis in the 1960s and 1970s, referred to the Ferus as the "Venice Mafia" for its insularity and marketing exclusivity.[98] In reference to *Artforum*'s narrow focus on the new Ferus, John Baldessari recalled that he felt "shut out as I'm sure many artists did."[99] In fact, under Blum's leadership, the Ferus was reshaped from a dark, hidden artists' studio located off an alley into a bright, highly visible commercial gallery with easy street access off La Cienega, while the artwork exhibited within it changed from deeply personal junk sculpture and assemblage to pop, a commercially successful art movement that both

celebrated and critiqued the very consumer culture that the original Ferus artists tried to circumvent. What made many of the Ferus artists successful, ultimately, was the fact that much of their art did precisely what the boosters of yore hoped art would do earlier in the century—promote Los Angeles as a city of leisure and new wealth.

Edward Kienholz, who remained angry about Blum's involvement in the gallery and the changes his involvement would bring, nevertheless kept his ties to Ferus and held a one-man show there in 1962. His exhibit "Edward Kienholz Presents a Tableau at the Ferus Gallery" included the freestanding installation of a brothel named Roxy's. Despite its overtly sexual nature (one of the prostitutes would gyrate when a spectator pressed a foot pedal), the exhibit survived scrutiny by city authorities. In an interview Blum explained why the exhibit could remain open: "there were several attorney friends of the [Ferus] gallery by that time, and anytime that possibility [of censorship] surfaced, I think they were able to use their good offices and their influence to persuade people of the legitimacy of what the gallery was up to."[100] When one considers the response to Wallace Berman's more innocuous exhibit five years earlier, it is clear the gallery had experienced significant change. With broadening commercial appeal, the Ferus Gallery could, by 1962, attract powerful friends whose influence served as a buffer against Los Angeles' provincial attitudes.

Yet, when Kienholz's work appeared in the newly opened Los Angeles County Museum of Art in 1966, the Los Angeles City Council and County Board of Supervisors reacted violently against the exhibit. Los Angeles municipal and county authorities did not appreciate Kienholz's vision of a brothel (*Roxy's*) nor his tableau of an adolescent sex romp in the backseat of a used car (*Back Seat Dodge '38*) in a publicly funded civic space. In a letter to the Edward Carter, president of the Los Angeles County Museum Board of Governors, county supervisor Warren M. Dorn wrote that it was "tragic to me that with so much talent available we should have this kind of depressing, nauseating and revolting expression displayed in our magnificent new public facility."[101] In response, the County Board of Supervisors voted to close down the show. This decision was partially supported by the city council, which split down the middle over a resolution to support the board "in their efforts to uphold high moral standards by publicly objecting to the Kienholz exhibit . . . which is partly supported by public funds."[102] While the county and city officials argued over the exhibit, record numbers of visitors lined up to visit the exhibit in the new museum. Henry Hopkins told the *Los Angeles Times* that he expected over three hundred thousand visitors. The museum's director Kenneth Donahue refused to close the exhibit without a direct order from the museum's board, which was not forthcoming.[103]

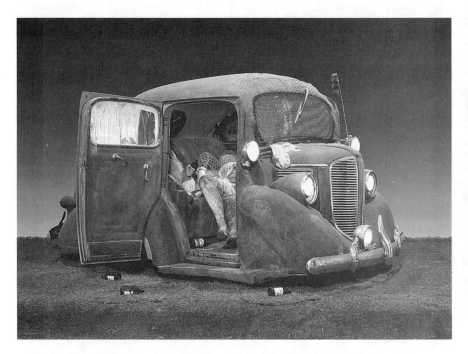

Figure 29. Edward Kienholz, *Back Seat Dodge '38*, 1964. Los Angeles County Museum of Art, purchased with funds provided by the Art Museum Council Fund. Photograph © 2006 Museum Associates/LACMA.

The exhibit remained open. In an effort to save face, the County Board of Supervisors took a vote of confidence. With Supervisor Frank Bonelli dissenting, the vote was 4 to 1 in favor of the museum. Bonelli wished the county to unload the museum entirely and introduced a motion calling for the leasing of the Los Angeles County Museum of Art to the Museum Associates, the private, nonprofit corporation that had built the facility. Though supported by Supervisor Kenneth Hahn, Bonelli's motion was defeated by the remaining three county supervisors on the basis that the contract under which the Museum Associates paid for the land and the building stated explicitly that the museum must stay under public control. To turn the museum over to a private corporation violated the county's contract.[104]

The Kienholz show at the Los Angeles County Museum of Art signified the arrival of Ferus artists in the mainstream of the Los Angeles, and indeed the American, art world. The controversy over the content of the show illustrated that public space was still vulnerable to censure in Los Angeles but that enough money and influence supported the avant-

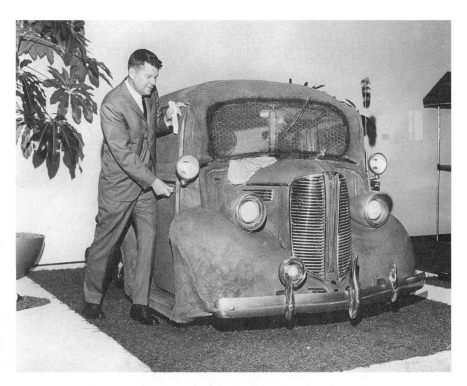

Figure 30. Supervisor Dorn closing the door on *Back Seat Dodge '38*, March 26, 1966. *Los Angeles Herald-Examiner* Collection, Los Angeles Public Library.

garde from the private sector to prevent the type of censorship that had occurred in the early 1950s. The Kienholz exhibit at the Los Angeles County Museum of Art also coincided with the closure of the Ferus Gallery. In 1966 Craig Kauffman was the only original Ferus member and, according to Kienholz, had been "buffed down into a real saleable jewel."[105] Not only had the original artists left, but most had left because of financial disputes and petty jealousies that erupted within the once closely knit community. Blum admitted that "the influx of large sums [and] the unequal distribution of that money began to erode the early camaraderie and real affections that these people had for each other."[106] By the end of the year Blum merged, in name and finances, with the prestigious Pace Gallery in New York, and the Ferus was closed for good in 1967.

Irving Blum's Ferus and *Artforum* did not only promote a group of male artists who, increasingly, made Los Angeles the center for pop; these promotional forces also created a widely recognized artistic iden-

tity for southern California and the United States as new, cool, and in sharp relief to the formality of the New York and Chicago art worlds. That this identity would be white and male was a sore point for women artists struggling to push through the historically sexist American art scene. Judy Chicago, one of the most famous feminist artists in the 1970s and 1980s, and best known for the installation *The Dinner Party,* began her career in Los Angeles at precisely the same time as the Ferus and Venice group. Starting art school at UCLA in 1957, Chicago was influenced by the work produced at Ferus, particularly the perfectly smooth surfaces and light-reflective materials used by Billy Al Bengston and Craig Kauffman. Her early works, *Car Hood* (1964) and *Trinity* (1965), reflect these finish-fetish qualities. Pleased to get a seat alongside the boys at the Barney's Beanery table, if not invited to show at the gallery, Chicago cultivated a tough persona that was reflected in her own *Artforum* ads.[107] Her announcement for a December 1970 show at California State University, Fullerton depicted the artist dressed in sweats and gloves in a boxing ring waiting for a fight.

America's postwar macho modernism allowed few women to partake of the increasing publicity and commercial opportunities that the 1960s scene would open up, and Los Angeles was no exception. Chicago described her experience in this Ferus world: "When I was a young artist in the burgeoning Los Angeles scene, I wanted, above all, to be taken seriously in an art world that had no conception of or no room for feminine sensibility. In an effort to fit in, I accommodated my aesthetic impulses to the prevailing aesthetic style."[108] As much space as there was to work in Los Angeles, there was not much room for women in the 1960s, and this was perhaps ironically reflected in Chicago's taste for huge spatial installations. The best example was 1972's *Womanhouse,* when Chicago and Miriam Schapiro built fantasy rooms in a dilapidated Hollywood house, creating an environment that commented on the horrors and possibilities of middle-class domestic life.[109] If there was room only for Chicago at the Barney's table, she would claim much bigger space to work in 1970s Los Angeles, exhibiting in as many rooms as she wanted.

The artists Joan Brown and Jay DeFeo did not share Chicago's feelings of exclusion, having shown in Ferus group shows, but the general sentiment by the 1970s was irritation with the overt machismo of the Los Angeles scene.[110] The best example of a woman emulating Ferus promotional bravado while simultaneously laying bare (literally) its sexist problematic is Lynda Benglis's November 1974 *Artforum* announcement that appeared alongside a feature article by Robert Pincus-Witten, "Lynda Benglis: The Frozen Gesture." In her ad Benglis appeared nude, oiled, and holding a giant dildo, a gesture that earned her wide notoriety and

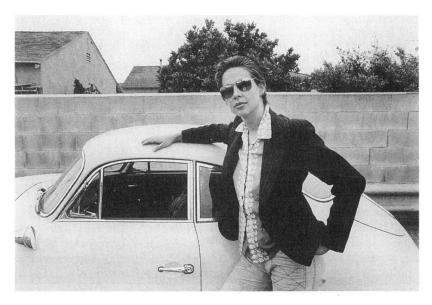

Figure 31. Lynda Benglis, *Artforum*, April 1974. Art © Lynda Benglis/licensed by VAGA, New York, N.Y.

rendered that *Artforum* issue forever vandalized in university libraries as students still tear out the souvenir. Less sexually aggressive but even more immediately suggestive of the Ferus ads was an earlier announcement (*Artforum*, April 1974) with Benglis in jeans and sunglasses and photographed in front of her car. For readers familiar with the Ferus scene, the angle and size of the shot evoked Joe Goode's 1969 pinup calendar project, "L.A. Artists in Their Cars," with Ruscha, Bengston, Price, Goode, and eight other male L.A. artists in dark glasses and either smoking, drinking, or goofing around in their most important tools for urban freeway survival. Benglis's ad implied that there must have been room for at least one calendar girl as women artists drove too.

By building communities, challenging municipal and county authorities, and playing off Los Angeles' complex and contradictory cultural politics, local artists built the city into the country's second art center, and their scene held a place in the international art world of the 1960s. The more Los Angeles municipal and county officials tried to close the new art spaces down, the more the Ferus and Venice artists provoked the interactions that promoted their work. Quite frankly, by inventing modern advertising and visual promotional tools, Los Angeles taught its postwar artists how to sell themselves. Even the *New York Times* was forced to admit that Los Angeles "has come to deserve its title of the Second

Scene," pointing out that "the sensuous colors and 'object' quality of Los Angeles art mirrors perfectly the affluence of California life."[111]

While art-scene aficionados basked in the attention of the national press, the acrid smoke of the 1965 Watts riot singed buildings in south central Los Angeles and wafted into the sky. Watts Towers Art Center directors Noah Purifoy and Judson Powell addressed the impact of social inequity and troubled race relations on the city in sculptures also created from urban industrial materials but in a different context from that of the Venice and Ferus artists. Purifoy and Powell gathered the melted neon, broken glass, and burned plastic debris from burned stores, homes, and cars and built stark, yet beautiful objects. Their exhibit, "66 Signs of Neon," traveled across the country to Washington, D.C., and was presented in Europe as well. Unlike the pieces that Los Angeles junk and pop artists built from the detritus of affluence or the by-products of a growing high-tech industry, Purifoy and Powell's work emerged from the debris of want and frustration. And, unlike cultural promoters who had once proclaimed Los Angeles "the Athens of America," with artwork the key to international cosmopolitan status, "66 Signs of Neon" pointed toward the ill effects of urban growth, affluence, and a civic culture that benefited the wealthy at the expense of poor and minority neighborhoods.

With Los Angeles' heralded arrival on the national art scene in the late 1960s, a perceptible tension developed between the pop art that seemed to bolster Los Angeles' sunshine image and the artful criticism that commented on the city's enduring social crises. Though the artwork produced by Venice and Ferus artists had originally proven a counterpoint to Los Angeles's booster images, the impact of cultural commodification, media attention, and a new art market rendered it without a historical context or an obviously critical perspective. In fact, the acclaimed 1960s art scene that rose up alongside revitalized civic cultural projects "worked" because—in celebrating Los Angeles, in drawing aesthetic connections between industrial materials, cars, and leisure culture—pop, the L.A. Look, and finish-fetish performed the very booster functions that civic promoters had hoped art would perform earlier in the century. The same modernism that people feared would undermine Edenic, sentimental images of Los Angeles evolved into its own form of celebratory urban art, reinforcing a deeply flawed and exclusionary civic identity of prosperity, leisure, and promise.

Imagining the Watts Towers

In 1959, while the Venice Beach Gas House hearings raged in the press, the Los Angeles City's Council's Building and Safety Committee reissued an old order to demolish the Watts Towers. Far from the civic art battles and the excitement of La Cienega's new gallery scene, an unassimilated and self-educated Italian laborer had worked alone in his backyard, building the city its most famous artwork. On his awkwardly shaped triangular lot on East 107 Street in Watts, Sabato Rodia lived from 1921 to 1954, when he deeded his property to a neighbor and abruptly moved to Martinez, in northern California.[1] During his thirty-three years in the historically multiracial neighborhood notorious for its ghetto and its race riot, he handbuilt a fantasy city of seven towers, a gazebo, two fountains, two cactus gardens, a boat, and a surrounding fence. Embedded in tile on one of the towers is *Nuestro Pueblo,* Spanish for "Our Town," but the structures are best known as the Watts Towers. Just shy of one hundred feet tall at their highest point, they have received international acclaim as a masterpiece of engineering, folk art, junk sculpture, and mosaic tiling. When a grassroots preservationist organization applied for a building permit as part of a bid to repair and maintain the towers the city, not knowing or appreciating what the towers were, refused and instead ordered them destroyed. An impressive public outcry prevented the destruction but in its wake left a unique and fragile, if enormous, personal creation to serve as the inspiration for new and innovative public art programs, a lightning rod for increasing racial tension in an economically declining neighborhood, and a politically charged civic symbol.

In part because Rodia never specified what the towers meant (or explained and was misunderstood) and in part because their sheer size and eccentricity lend them to the imagination (civic or otherwise), the Watts Towers have become a public artwork laden with shifting cultural and political meanings. Whether portrayed in newspapers as a public safety hazard or in art journals as an important international artwork, appearing as a metaphor for African-American community in movies and music videos, adorning the cover of municipal financial reports as

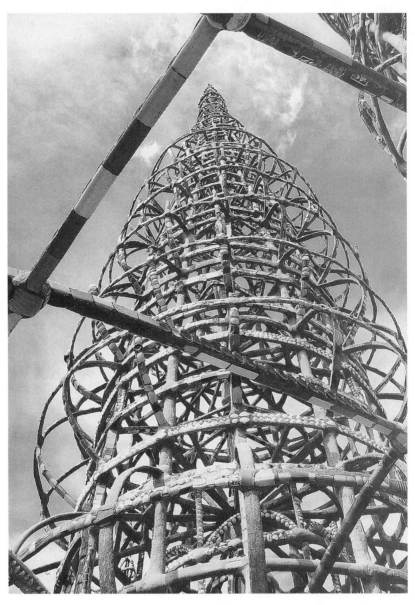

Figure 32. Sabato Rodia, *Nuestro Pueblo* (Watts Towers), 1921–54. Photograph by the author.

a symbol of urban redevelopment, or showing up in guidebooks as a tourist destination, the towers exist as an ever-increasing collection of images.[2] Because the Watts Towers are irrevocably linked to the racial politics of Los Angeles, the meanings of these images slip and change depending on the prominence of Watts, or matters of race in general, in the American popular imagination. This point is underscored by the fact that while some Angelenos know of the towers, most people who visit them are not from Los Angeles or even California at all.

Nuestro Pueblo's geographical location in south central Los Angeles has proven a deterrent for local visitors. The towers' fame as an artwork juxtaposed with their physical presence in Watts have led them to become a convenient stand-in for Los Angeles and an emblematic symbol of postwar American blackness; they have served as cultural place markers in hundreds of literary pieces, movies, music videos, and television shows, from Don DeLillo's *Underworld* to HBO's *Six Feet Under.* As such, political efforts to claim, preserve, and celebrate the towers have been tightly connected to the postwar struggles for space and power in the city. This representational layering of an urban-based idiom is certainly visual, but it also emerges from the language surrounding Rodia's creation. He called it *Nuestro Pueblo* but few know the work by this name, a provocative take on Los Angeles' original name, El Pueblo de Nuestra Señora la Reina de los Angeles de Porciúncula. By inscribing his towers in Spanish, Rodia honored his Mexican neighbors and the pre-American history of Los Angeles, and he claimed the towers and the city for others than himself alone. The Italian origins of Rodia's inspiration and his conscientious effort to incorporate the language of his Mexican neighbors have largely been obscured by the name "Watts Towers" which stuck during the 1959 Building and Safety Committee hearings involving their imminent demolition. The municipal government's unsuccessful efforts to obliterate the towers with a wrecking ball tie Watts to Los Angeles' long history of destroying artworks unfitting a specific political moment and the city's resistance to innovative, alternative, and modernist projects. Yet, in Los Angeles, a city that long sought recognition as a reputed artistic center on par with New York and other world cities, the Watts Towers have proved to be a political challenge and a cultural irony. While the towers are symbolic of the city's failure to ensure social equality they have also served as a testament to Los Angeles' indigenous creative merits. The city of Los Angeles has always had a conflicted relationship with the towers, working almost as hard to destroy them as to harness their cultural value.

In the early 1900s Watts, originally a Mexican land grant named "Tajuata," grew into a multiethnic, working-class transportation hub known as the "crossroads of Los Angeles" as Mexican, African Ameri-

can, and Asian Americans joined Anglos working on the railroad tracks. Processes of segregation combined with the large black migration of the World War II era made Watts, and the surrounding area now known as South Central Los Angeles, a largely African American, and now Latino, neighborhood. Known for its high rates of black home ownership and solid middle class, Watts would, by the late 1950s, suffer the effects of white and middle-class black flight, the early erosion of a heavy manufacturing base, and the dissolution of public housing. Restrictive housing covenants and Federal Housing Authority redlining policies meant that black residents were limited by where they could go in Los Angeles, and Watts residents who found access to new suburban areas left as quickly as they could. A once stable community, Watts in 1959 was an early example of what Los Angeles' ghettos would look like later in the century as regional, national, and global economic restructuring widened class disparities among African Americans and between African Americans and other ethnic groups. Growing unemployment, decreased rates of home ownership, and the loss of a once superb public transportation system in favor of private automobiles and freeways that cut across the residential area were signs that Rodia's old neighborhood was in rapid decline. These social changes encouraged many of South Central's remaining white residents to move out, while middle-class black families fled to whichever suburban alternatives were available.[3]

Watts was not the only community in postwar Los Angeles to struggle with urban restructuring; nor were redlining and freeways the only factors contributing to increased racial segregation. George Sánchez argued that the 1950s represented a difficult time for multiethnic communities such as Watts as right-wing politics pressured Jews, among other white ethnic groups, to leave peacefully integrated neighborhoods for white suburbs. Even when dedicated to civil rights, the combination of racialized housing policies, increasing economic pressures, and fears of voicing political opposition in the censorious early 1950s pushed even progressive Angelenos out of their communities, leaving behind the more impoverished and less assimilated.[4]

As many scholars have demonstrated, the postwar period in Los Angeles is best characterized as one of urban relocation, rarely at the behest of city residents.[5] In one of its most egregious examples, the Los Angeles City Council gave its final approval to the Bunker Hill Renewal Project in March 1959. The 136-acre downtown project razed nineteenth-century mansions that were home to pensioners and the poor and replaced them with financial and civic buildings that became Los Angeles' downtown civic center. The "substandard rooming houses and cheap hotels" were removed by city authorities because of their "inevitable earmarks of crime, disease, fire, and excessive public housing

costs."[6] This was followed by the eviction of the last residents of Chavez Ravine, the Arechiga family, to make way for the building of Dodger Stadium. As Angelenos ate lunch and watched the action on television, the family members were led (or carried) to waiting police cars.[7]

Los Angeles also enacted the slum clearance policies trumpeted by New York's chairman of the Committee on Slum Clearance, Robert Moses, whereby "blighted" areas, often hosting thousands of private residences, were razed. Rather than new and affordable housing units, commercial districts or sometimes nothing at all replaced long-established working-class neighborhoods. Watts was one such target of postwar slum clearance. In the fall of 1959, at precisely the same time that Los Angeles' Building and Safety Committee reissued the order to demolish the Watts Towers, the *Los Angeles Examiner* reported that the area east of Central Avenue on 103rd Street was the subject of municipal "housing rehabilitation." About two blocks from where *Nuestro Pueblo* stood, almost three thousand properties, mostly African American residences, were to be cleared away as part of the committee's bid "to clean up slum and blight conditions."[8]

A critical part of urban renewal was the freeway system that allowed suburbanites rapid access to and from commercial and leisure districts. As part of postwar urban renewal programs instituted in Los Angeles, freeway construction was symptomatic of nationwide federal support of white suburbs at the expense of minority neighborhoods. The freeways built under the auspices of the 1956 Interstate Highway Act (many of which were begun earlier as WPA projects) often cut through poor areas, destroying limited low-income housing, obliterating public space, and forcing property values to plummet.[9] Los Angeles' Harbor Freeway (the 110) and the Santa Monica/San Bernardino (the 10) were especially damaging to minority communities in Los Angeles by creating a geography of ethnic invisibility as commuters drove over and past neighborhoods such as Compton, Watts, and East L.A. without ever seeing the segregated consequences of southern California's suburban growth. With loss of the Red Cars (Henry Huntington's electric trolley line) that followed the embracing of freeways, Watts, the former transportation hub, had grown obsolete. Rodia's towers, which for thirty years had been seen by thousands of daily passengers on their way to work, were no longer a prominent feature of the Los Angeles landscape. Like so many minority residents, the towers too disappeared in the shadow of the freeway system. Bud and Arloa Goldstone have astutely pointed out that "this sudden lack of an audience and the increasing urbanization of his neighborhood probably influenced [Rodia's] decision to leave."[10] Like Bunker Hill's residents and Chavez Ravine's Arechiga family, the Watts Towers were simply in the way.

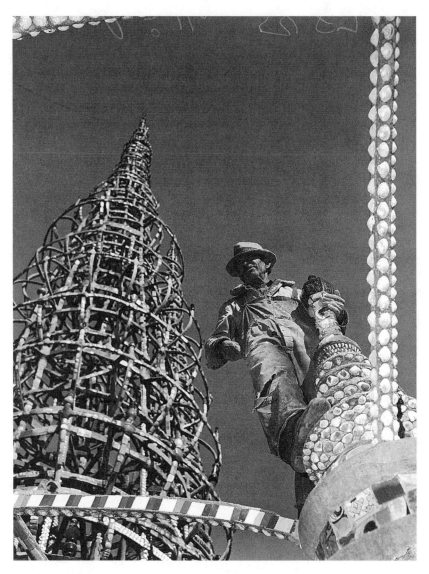

Figure 33. Sabato Rodia standing on the towers, ca. 1953. Department of
Special Collections, Charles E. Young Research Library, UCLA.

The towers, and the surrounding smaller structures, are built from steel rebar that Rodia bent into his desired shapes by placing it under the nearby railroad tracks and bending it with the weight of his body.[11] The shaped rebar was overlapped with heavy wire and wrapped with another layer of chicken wire to secure the joint. Rodia then created his own unique mixture of durable cement (currently unmatched by preservationists), with which he encased the wire-wrapped joint. He then pressed broken glass, dishes, tiles, shells, found objects, and tools into the mortar. Most of the objects were left to stick permanently, while others, such as tools and household objects including faucet knobs, fire screens, and baking tins, were used to create imprints and removed, leaving Rodia's signature heart and floral designs in the 140-foot wall and along the cement floor.

The physical feat of Rodia's accomplishment is usually the first quality to impress the novice viewer. Not only did he bend steel with his body, but Rodia also built his towers without scaffolding, blowtorch, or power tools. Instead he used a window washer's belt and devised a system of pulleys that he used to haul himself, and thousands of pounds of cement, up and down the metal towers as he wrapped the joints and stabilized each level before moving on to the next. Rodia also built ladders into the towers' form to facilitate his movement, possibly foreshadowing the maintenance that the structures would constantly require. When Rodia was not working on *Nuestro Pueblo* he labored for a tile company. He collected the leftovers of expensive tile used in homes in more affluent parts of the city, and gathered broken glass, 7 Up bottles, shells, and miscellaneous objects from the neighborhood and the beach. To have envisioned the project at all is remarkable, but that Rodia tenaciously stuck to it for over thirty years truly makes the Watts Towers so impressive. Having completed his project, Rodia gave the property away and left Los Angeles, never to see his handiwork again. Located by art history students from the University of California in 1961, Rodia granted interviews and made a warmly received appearance at a discussion of his work at Berkeley.[12] At the age of eighty-six, he died on July 16, 1965, less than a month before Watts would erupt in violent civil protest.[13]

Why Rodia built *Nuestro Pueblo* has been a source of great speculation ever since he began work on it in 1921. A native of Ribottoli, a village twenty miles east of Naples, who came to the United States in the 1890s to work in the Pennsylvania coal mines, Rodia kept most details of his personal history vague.[14] Why he might have dedicated his adult life to such a solitary endeavor also remains obscure. Local newspapers interpreted the towers as an immigrant's homage to his adopted homeland, a gift to America.[15] A 1939 *Los Angeles Times* piece reported that the project helped Rodia through his alcoholism; in his new sobriety he no

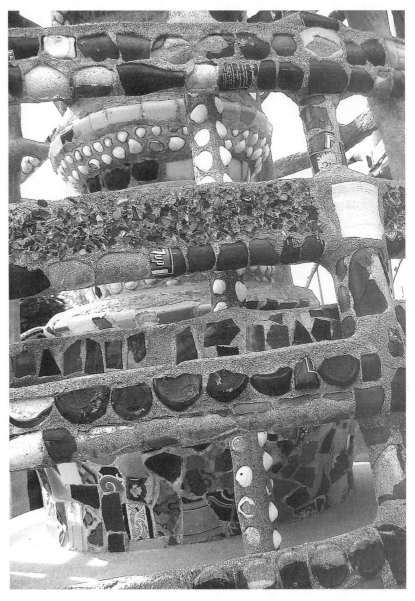

Figure 34. Sabato Rodia, *Nuestro Pueblo* (Watts Towers), 1921–54. Photograph by the author.

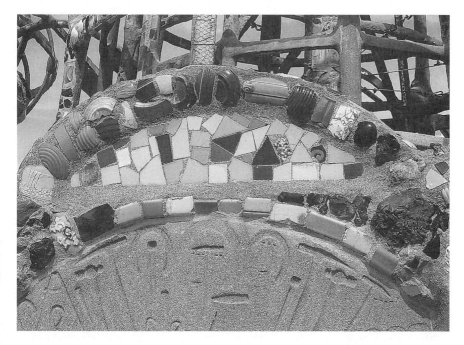

Figure 35. Sabato Rodia, *Nuestro Pueblo* (Watts Towers), 1921–54. Photograph by the author.

longer used his own bottles but those of other drinkers.[16] In 1952 the papers reported that neighbors who once found the towers eccentric now took pride in their local landmark.[17] Those who lived with the towers as part of their daily urban experience speculated that Rodia had built a radio tower, possibly one transmitting the war-time propaganda messages of Ikuko Toguri (Tokyo Rose), who grew up in Watts. The student filmmaker William Hale, who documented Rodia working in 1953, argued that "inner necessity" caused the craftsman to obsessively "build toward the sun."[18] Art critics have deemed Rodia an outsider artist, spontaneously spinning his steel and cement like a spider, arms encrusted, like the very sculpture he was building, with broken glass.[19] In 1971 Reyner Banham declared the Watts Towers "almost too well known to need description" and Rodia as "very much at one with the surfers, hot-rodders, sky-divers, and scuba-divers who personify the tradition of private, mechanistic *satori*-seeking in California."[20] Rodia was recorded as saying, "I wanted to do something big."[21]

There is another compelling possible explanation. In 1985 two folklore scholars, I. Sheldon Posen and Daniel Franklin Ward, published the

findings of a lengthy investigation into the Feast of Saint Paulinas, an Italian-American festival that took place each June in Brooklyn, New York. The highlight of the festivities was the carrying of a three-ton, six-story tower called a *giglio* through the streets on the shoulders of over one hundred men. Other festival participants carried a giant galleon. Atop both the tower and the boat stood a statue of Saint Paulinas. Posen learned while conducting his research that the festival originated in Nola, near Naples in southern Italy. Paulinas had been a fifth-century bishop of Nola captured by invading Vandal marauders and taken to north Africa. There he was made a slave but through divine gifts was able to interpret the future for the Vandal king. As a reward, the king set Paulinas and his fellow captives free. They returned to Italy by ship and were greeted by villagers bearing mounds of lilies (or *gigli*). The contemporary annual festival celebrated the miraculous return of Paulinas to his village. Ward realized that Los Angeles' Watts Towers, the topic of his own doctoral research, bore a startling resemblance to these *gigli* ceremonial towers.[22] Adding together Rodia's own origins in a town not far from Nola and his inclusion of a large boat in his complex of structures lends credibility to their argument that he was re-creating the *gigli* of his youth in his backyard. The Committee for Simon Rodia's Towers in Watts has argued that this plausible explanation was long overlooked because a reporter misunderstood Rodia as pointing to his boat and saying "Ship of Marco Polo," obscuring any obvious connection to Nola or Saint Paulinas. Given the strength of the *gigli* festival evidence, the committee believes Rodia actually told the reporter that the sculpture was "il barca di Paolo" or "Paulie's boat."[23] A 1937 *Los Angeles Times* article did state that the structures were "modeled after quaint towers which Rodilla [*sic*] remembered from his native Italy," but does not elaborate on what those "quaint towers" might be.[24] Someone early in the towers' construction had part of the story, but years of reinterpretation and misunderstandings have rendered the towers' meanings elusive, infinite, and deeply personal to those engaged with them.

No one is certain why Rodia left Los Angeles, although surviving interviews imply that he left because of aging and his deteriorating relationship with the neighborhood, as teenagers tossed garbage over the fence or threw rocks, breaking his carefully placed tiles and bottles.[25] After he moved north, Rodia's next-door neighbors tried to turn *Nuestro Pueblo* into a taco stand (Tower Tacos) but the city refused to grant them the building permit. The towers stood in vandalized disrepair until the Committee for Simon Rodia's Towers in Watts, composed mainly of white, middle-class art students, artists, architects, and engineers, fought to protect them from the city's demolition order, beginning work to permanently conserve and exhibit them to the public.[26]

The goal of the Committee for Simon Rodia's Tower in Watts, which was formed in 1958 by the film student William Cartwright and the actor Nicholas King, was to ensure effective and permanent guardianship of Rodia's work. Having found the neglected property, Cartwright and King sought out the towers' owner, Rodia's former neighbor, Joseph Montoya, and bought the property for about three thousand dollars.[27] It quickly became clear that caring for the towers would be more complicated than any of the students involved had thought. When the committee applied for a permit to construct a caretaker's cottage on the site, its request was refused.[28] Unsure about what the towers were and finding no building permit, the Building and Safety Department in 1957 had issued the first demolition order for their removal. Because of the vandalism occurring after Rodia's departure from Los Angeles, the department also declared the property unsafe and a public hazard. Neighbors reported to investigating students that local teens made sport of throwing rocks and chipping away at the bottles and tiles pressed into the towers' mortar, probably searching for the treasure rumored to be hidden within. At the subsequent July 1959 public hearing regarding the towers' future, Deputy City Attorney W. E. Wilder argued that their "workmanship was of poor quality [and that] the towers have begun to deteriorate rapidly in recent years," adding "the structures are broken in places and in danger of collapsing."[29] Assured of the towers' strength, the committee challenged the city to test them. The committee's engineer, Bud Goldstone, whose expertise in aeronautical structures convinced him that Rodia's skilled craftsmanship would withstand a 10,000-pound-pull stress test, persuaded the committee's attorney Jack Levine to put forth the stress-test challenge. The city accepted, agreeing that if the towers survived, the Building and Safety Department would withdraw the demolition order. On October 10, 1959, the widely publicized test was held and with one thousand people watching, the towers survived a truck's ten thousand-pound pull intact.[30] The next day H. L. Manley, chief of the Building and Safety Department, announced that the city would drop its efforts to have the towers torn down. For the moment the towers were saved.[31]

In preparation for the demolition hearings, the Committee for Simon Rodia's Towers in Watts launched an international campaign of letters and petitions to define the towers as a significant artwork rather than an eccentric local curiosity. The committee members hoped that if the towers could be understood as art, rather than as a capricious novelty, then perhaps the city of Los Angeles would grant them civic landmark status, ensuring their long-term protection. This was a risky strategy, given the city's history of destroying public artworks and restricting private ones. As the committee phrased it later in 1966, "in spite of dra-

matic changes during the last decades, there is still a strong backlog of sentiment against the arts as useless if not outright corrupting."[32] In Los Angeles this was an especially dubious legacy as the postwar period had been so terribly marked by nasty public art controversies such as those over the 1951 Griffith Park hearings, Bernard Rosenthal's *The Family* in 1955, Wallace Berman's arrest in 1957, and the 1959 Venice coffeehouse closures. The Watts Towers thus came under municipal scrutiny in the midst of a decade-long campaign, led by the Building and Safety Department, members of the Los Angeles City Council, and supported by the Los Angeles Police Department, to shut down art spaces in other parts of the city.

With Los Angeles' policy toward the arts one of restrictive ordinances and censorship, championing the towers as artwork was perhaps not the best strategy for attracting municipal support. This strategy did, however, reframe the towers as part of a modern art discourse, an effort welcomed by local artists, studios, publishers, architects, gallery owners, and museum curators who wrote letters of support. Louis Stoumer of Camera Eye Pictures wrote, "the towers are a most strange, amazing and important manifestation of folk art in our time of mass production and cultural conformity."[33] One Frank Waters sent a letter stating that the towers "are an eloquent commentary on our modern machine-made civilization to which we of the Atomic age here in smog-ridden Los Angeles have need to listen."[34] Richard Neutra described them as "architectural jewelry."[35] The Los Angeles Art Association wrote Mayor Norris Poulson that "a city as important as Los Angeles is but as lacking in cultural points of interest simply cannot afford to lose the Watts Towers."[36] In a critique of the plethora of Spanish colonial revival architecture in southern California, Tri-Arts, Advertising Art and Design wrote Poulson that the towers "are precious examples of folk art, far more genuine and worthy of preservation than many of the spurious 'Spanish' landmarks given so much attention locally."[37] Support also came from outside Los Angeles. James Johnson Sweeney, director of the Guggenheim and president of the International Art Critics Association, called for "every effort to preserve these inspiring structures," pointing out the great artistic interest that Europeans had showed in the towers since the 1940s.[38] Carl Sandburg wrote of the irrevocability of destroying the towers, while the Museum of Modern Art in New York signed the committee's petition and hosted an exhibition of Watts Towers photographs.[39]

The emphasis on the towers' folksy artfulness and modernist commentary on the contemporary human condition emerged hand in hand with the success of junk art and assemblage best exemplified by the work of Berman and Kienholz. As Los Angeles' abstract expressionism crawled out of paintings and off the walls and became rearticulated as

three-dimensional sculptures assembled from discarded objects, the accompanying art criticism framed a discourse into which the Watts Towers could fit nicely.[40] By the late 1950s junk art and the L.A. Look made it possible to see in a radically new way what in the 1930s journalists and art critics had interpreted as a bizarre local curiosity.[41] As Susan Sontag put it in her classic 1977 collection *On Photography*: "We now make a history out of our detritus. And some virtue, of a civic kind appropriate to a democratic society, is attached to the practice. The true modernism is not austerity but a garbage-strewn plenitude."[42]

Much emphasis was placed on the towers' aesthetics, whether modernist, folk, or fantasy, but as critic Lawrence Alloway has pointed out, "junk art is city art."[43] Richard Cándida Smith has argued that while the towers offer elements of the fantastic, Rodia emphatically re-created an urban environment: "the setting . . . offered no escape from urban reality. Nuestro Pueblo confronts its visitors with images of the jumble of urban life: the towers reflect both church spire and the modern skyscraper and the stalagmites, both a cactus garden and apartment buildings rising up from the ground; the arbor with its incised design speaks interchangeably of parks, the industrial worlds of automobile parts and construction tools, agricultural products, and pure purposeless beauty."[44] Despite the delicacy and inherent playfulness of Rodia's work, there is nothing soft or gentle about it. Many of the featured textures are jagged, and kiln-treated broken glass is a main decorating motif. *Nuestro Pueblo* represents less a warm alternative to the surrounding urban area than a cool reconfiguring of the neighborhood's debris into a possessively (and obsessively) patterned space.

Once the Building and Safety Department declared the towers safe to stand, the city cautiously (and briefly) tried to parlay the towers into a tourist attraction. Following a 1960 fund-raiser by Kenneth Ross and the Municipal Arts Department, entitled "The Significance of the Watts Towers in the Community Landscape," articles appeared in the *Los Angeles Times* arguing the towers as a site to be included in guidebooks along with the Rose Bowl, Forest Lawn, Grauman's Chinese Theater and the recently opened attraction Disneyland. As one piece put it, "Watts Towers is the one local landmark guaranteed to raise a few eyebrows, whether in approval, awe, or amazement."[45] Professional claims that the Watts Towers were indeed art, combined with Ross's support, were successful in achieving some municipal recognition. In March 1963 the city of Los Angeles recognized the site as a cultural heritage monument.[46]

The troubled relationship between Watts and broader Los Angeles led the towers' protectors to try to separate them symbolically, if not physically, from the surrounding neighborhood. Images promoting the towers' artfulness were usually shot from the ground up, obliterating

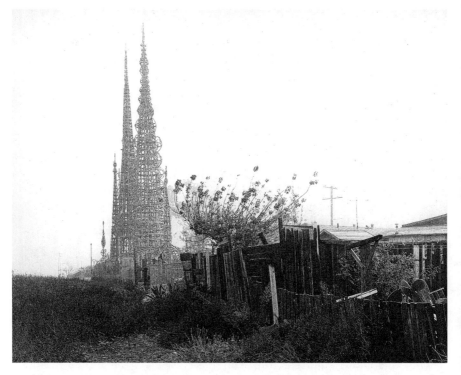

Figure 36. Sabato Rodia, Watts Towers. Photograph © Seymour Rosen, 1962. Courtesy of SPACES (Saving & Preserving Arts & Cultural Environments).

their surrounding urban environment. Photographs exhibited by the Museum of Modern Art (1961) and the Los Angeles County Museum of Art (1962) show the towers in a rural setting with barely a hint of the city that has always surrounded them.[47] Photographed from peculiar angles, the towers were shorn from Watts and recontextualized in the discourse of postwar modernism. Conversely, neighborhood activists and community leaders historically have tightly linked the neighborhood to the towers. Once saved from the municipal wrecking ball, the towers have served as an uneasy liaison between white liberals invested in the towers' artistic merits and predominantly black community activists hoping to parlay the towers into federal and state funding for local cultural and commercial facilities. The Watts Towers Art Center (WTAC), a separate building originally established by the Committee for Simon Rodia's Towers in Watts in 1959 and serving community youth as a space for free arts and music education since 1961, has competed with preservation efforts for state funding. The quality of this codependent

relationship between the towers' preservationists and the community center has ebbed and flowed through the decades, depending greatly on the broader political and socioeconomic context.

Neither the push to make the towers a tourist attraction nor their granting of official monument status was done with much municipal enthusiasm, and the city made no move to support the WTAC. The second part of the committee's preservation campaign, in fact, was the creation and maintenance of this community center. Committee member Eve Echelman recruited the African American artists Noah Purifoy and Judson Powell and the teacher Sue Welsh to set up and run it. Purifoy, who had a background in social work, ran the WTAC with a sense of community activism. While much of the towers' publicity had focused on preservation and aesthetics, he insisted that the WTAC function as a material connection between the towers and the community of Watts, with art the medium through which a child could learn that "he is part of the community of man, and that he is no more and no less than any other."[48] Judson Powell emphasized the philosophy of education through the arts. If children learned to interpret their world in creative ways with paint and paper, their public education would become more important to them and their curriculum easier to grasp. With two full-time teachers on staff, Debbie Brewer and Lucille Krasne, the center offered drawing and painting classes everyday for children ages four to eighteen. The community role of the WTAC would attract significantly more state and municipal attention after the Watts riot, but in the years prior there was little support beyond 1964's Teen Post, a program funded through Lyndon Johnson's "War on Poverty."[49] Some federal funding also came through a research project entitled "The Aesthetic Eye" to study black youth and the connections between the learning process and art education.[50]

As early as 1963 the committee proposed an ambitious expansion of the WTAC. The new cultural facility would be better staffed, offer a broader range of classes, and host a social services office. Hoping that the unification of art attraction and community-at-large would help build much-needed cultural facilities in Watts, the committee thought that the state of California would be instrumental in offering the support to enact such a project. This strategy was articulated in a committee publication stating "After removing the demolition danger, [the committee] has turned its attention to larger purposes—long-range preservation of the towers as a cultural monument; development as a community facility."[51] In the spring of 1965 the architectural firm of Kahn, Farrel, and Associates, on behalf of the committee, submitted to the California Department of Parks and Recreation a proposal to build the "Simon Rodia Community Arts Center," which included a teen cen-

ter, a social services office, a food facility, exhibition spaces, an outdoor amphitheater, dance studios, a theater seating two hundred, and a parking lot for four hundred cars. The plan essentially overhauled one square block of Watts, building on vacant land owned by the committee.

The expansion was overly ambitious, and some committee members had voiced doubts whether it was appropriate for "a small, self constituted committee to have control of something like the towers," let alone create and run an entire arts and culture center.[52] The facility's new name, Simon Rodia Community Arts Center, dropped any immediate association with Watts, and its size and scope spoke to some committee members' loss of perspective in their preservationist zeal. Noah Purifoy, the original director of the WTAC, stated in interviews that the planned expansion was a mistake. Purifoy felt that an expanded art center designed to draw people from outside Watts to what would, it was hoped, eventually become a credential-granting art school was an art program too sophisticated for the focused goals of the WTAC.[53] Purifoy feared that such a project would alienate Watts residents and defeat the original intent of the WTAC, which was to provide a safe place for black youths to learn about the creative process. In addition, he disliked the proposed new name because he had always been reluctant to identify the art facility as a community center, recognizing that neighbors would see one more government agency making an intrusion akin to urban renewal and redevelopment.

Judson Powell shared Purifoy's concern that they not pose as an agency. He recalled that Watts residents often came to the WTAC asking for money, bail bonds, medical assistance, and other aid far beyond the abilities of a community art facility. The WTAC and the committee found themselves in the situation of offering a cultural site useful to an impoverished urban neighborhood but neither equipped nor prepared to provide the facilities and infrastructure that residents needed. Powell felt that the role of the WTAC was to tie art to public education by creating outreach programs with the Los Angeles Unified School Board. The Watts community felt that it ought to play a greater role in the administration of the WTAC, creating further tension between the art center and the neighborhood.[54] The anxiety over the expansion was for naught as the state rejected the plan outright and refused the towers both state park and landmark status. The California Department of Parks and Recreation concluded that "the Simon Rodia towers are definitely a sort of bizarre art form. . . . However, their preservation is not a matter of statewide concern."[55] In its report, the State encouraged private ownership and maintenance of the towers and helpfully recommended "that the proper local agency enlarge and develop the area into a Community Art Center," thereby kicking financial responsibility back to the committee,

which was barely surviving from grant to grant without any secure fiscal base.[56]

The same summer that California rejected the Watts Towers as a state park and crushed hopes of a permanent source of funding, Los Angeles hosted what became known as the Watts riot, one of the largest civil uprisings in U.S. history. It began on Wednesday, August 11, 1965, during a scuffle between police and onlookers after twenty-one-year-old Marquette Frye's arrest for drunk driving at 116 Street and Avalon, several blocks south of Watts. Violence escalated after Marquette was bloodily struck in the head by a cop's nightstick and rocks were thrown at the departing police car. As remaining police called for backup, growing numbers of young men took to the streets lighting fires and throwing stones, and moving on to overturn cars and break windows of white-owned shops and businesses. By Thursday the Los Angeles Police Department and the county sheriff were out numbered, and on Friday, August 13, Gov. Pat Brown called in the National Guard. On Friday the uprising moved into Watts, resulting in the burning of two full blocks of 103rd Street near Central Avenue. Throughout the day Noah Purifoy maintained considerable calm over the WTAC as crowds of kids gathered for their regularly scheduled art classes. The phone rang continuously as worried Watts Towers fans from all over the world called to find out if they were surviving the violence outside. Purifoy stationed children at the phones so that callers would hear their voices, saying that all was well but also reminding the callers that there were people there too who might be cause for concern.[57]

At 3:00 on Saturday morning, 3,356 National Guardsmen were in the streets of south central Los Angeles. At 8:00 P.M., Governor Brown instituted a curfew, and by midnight on Saturday there were over ten thousand National Guardsmen on active duty in Los Angeles. The curfew was finally lifted on Tuesday, August 17. A frustrated response to high unemployment, a dire education system, a lack of social services, a history of police violence, and a dearth of public transportation in a neighborhood where less than 14 percent of residents owned cars, the riot left 34 people dead, 1,032 injured, and approximately 4,000 arrested, 500 of whom were under eighteen years of age. The McCone Commission estimated damage to stores and automobiles to be over $40 million.[58] As shocking as the televised images were to Americans all over the country, black Los Angelenos knew that trouble had been brewing for a long time. As the novelist Chester Himes puts it, "the only thing that surprised me about the race riots in Watts in 1965 was that they waited so long to happen. We are a very patient people."[59]

The Watts riot forever changed national perceptions of American urban race relations, dulled Los Angeles' sunshine booster image, and

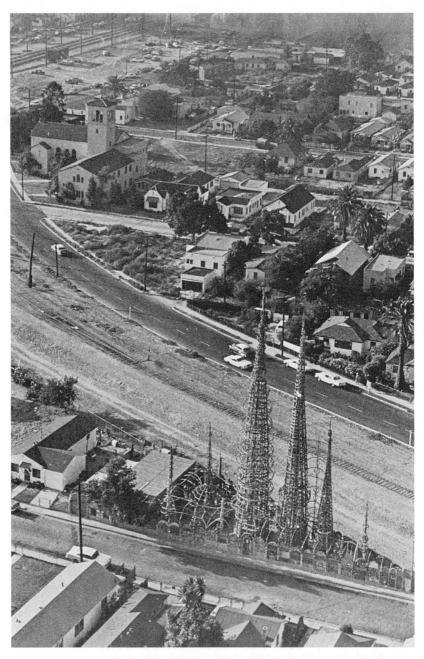

Figure 37. *Nuestro Pueblo* during the 1965 Watts uprising. The very top of the frame is marked by smoke and fire. Photograph by Roger Coar.

reoriented how Rodia's towers would be publicly represented as the city was catapulted into the American popular consciousness as an emblem of urban blight and black revolution. With the national spotlight on Los Angeles, Watts, and anything associated with it, was too charged for lighthearted editorials about an eccentric Italian tile setter and too dangerous to attract art-loving tourists. Rodia's grateful-immigrant gift to America seemed more appropriate as an emblem of urban failure. In a radical contrast to the art discourse surrounding the towers prior to 1965, post-riot mentions of the towers were in direct conversation with recent events, emphasizing their unavoidable geography. The year 1966 proved a pivotal one for the city of Los Angeles' renewed interest in Watts, art production in the community, and publicity for the city and the towers.

Purifoy's fears that outside interests in Watts could do more damage than good were realized when less than six months after the riot, in January 1966, headlines splashed across the *Los Angeles Times* promising that "Visions Point to Park-Like Future for Watts."[60] While residents voiced anxiety that the burning of south central Los Angeles facilitated urban renewal (or "Negro removal"), city planners began work to transform the neighborhood into "the concrete and trees of pedestrian malls, sparkling new commercial structures and even garden apartments."[61] The city's Community Redevelopment Agency (CRA) proposed long-term plans for new housing but suggested that commercial development was the most important strategy in rebuilding the area.[62] The most dramatic component of the CRA plan for Watts was its appropriation of the committee's 1964 plan for an expanded community center. In this new, post-riot rendition, the burned out 103rd Street business district was transformed "into a tree-lined pedestrian mall with a park corridor connecting it to the Watts Towers as a cultural monument."[63] The CRA plan kept the originally proposed name Simon Rodia Community Arts Center," removing direct associations with Watts, black Los Angeles, or the original goal of the center to create a safe cultural space for black and Latino youth.[64] In fact, CRA drawings of the center show a safe cultural space for *white* middle-class Angelenos. Appalled, the committee insisted that the WTAC be black-run, arguing that "federal or local support cannot be expected unless greater Negro participation is achieved."[65] As a result, it has consistently had African American directors.

CRA money did not come through for the new WTAC and it is unclear what happened to $3 million earmarked for Watts's redevelopment. Instead, the committee regrouped and launched a campaign to raise $75,000 for a new building. Jack Levine, the attorney for the committee since the 1959 Building and Safety Department hearings, stated at a press conference that members wanted only to sponsor an expanded art

center and leave its operation to the community.[66] Despite millions of federal dollars being pumped into the neighborhood through the U.S. Department of Housing and Urban Development (HUD), the War on Poverty, and other offices such as the Economic Youth Opportunity Agency, Teen Post, and Job Corps, the committee was unable to raise the necessary funds. Almost a year later, the committee staged a "dig-in" whereby two hundred people, mostly Watts residents, worked in shifts to dig the twelve-inch-deep trench needed to lay the building foundation. Unable to afford the necessary heavy equipment, neighbors and committee members put in the concrete foundation by hand. Plans for the new center were donated by sympathetic architects in the Los Angeles area. Though the committee hoped to open the center in August 1967, the new building was not dedicated until March 1, 1970.[67] By surviving almost fifty years, the WTAC may be the oldest nonprofit community art space in the country. It is certainly the model for the radical Los Angeles arts centers of the 1960s and 1970s, such as the Studio Watts workshop, Watts Happening House, the Performing Arts Society of Los Angeles, and the Compton Communicative Arts Academy, as well as Chicano centers found mostly on the other side of town: Mechecona Arts Center, the Mexican American Center for the Creative Arts, and Plaza de la Raza.[68]

If flawed commercial redevelopment plans represented Los Angeles' approach to addressing the "Watts problem," a focus on the arts represented that of the neighborhood. In the spring of 1966 Powell and Purifoy of the WTAC worked with the Los Angeles Unified School Board to plan the "Watts Festival of Arts" to be held at Markham Junior High. The festival included theatrical productions, a parade, and various workshops on painting, dance, music, and sculpture. The big draw, however, was Powell and Purifoy's exhibit "66 Signs of Neon." In 1964 the artists had thought about creating a sculpture garden around the towers made of found objects from the neighborhood. The Watts revolt produced unlimited quantities of burned and trashed materials that those with a creative eye could gather and mold into sculpture. Thus, the exhibition was born. "The riot," explained Powell to the newspapers, "was the first thing this community ever did together."[69] After collecting three tons of charred riot detritus, the artists invited four friends to join them in their project named for the drippings and casings from broken neon signs.[70] The artworks also included assemblages of shattered windshields, torn sheet metal and ghoulish montages of children's shoes and broken dolls. The exhibit at Markham Junior High attracted an enormous amount of attention, traveling to Washington, D.C., and onward to Germany in an ironic twist as bloody American ruins were shipped abroad.[71] In the accompanying catalog, *Junk*, Purifoy tied the exhibit, the riot, and his goals as the director of the WTAC together. Basically agreeing with

Figure 38. Noah Purifoy, with a piece from "66 Signs of Neon," 1966.
Photograph © Harry Drinkwater.

the findings of the McCone Commission, the governor's report that blamed unemployment and a lack of educational resources for the revolt, Purifoy felt that art and culture should also have been emphasized. By having few outlets for artistic creativity, education in south central was further failing its youth. "66 Signs of Neon" was shown again at the 1967 and 1968 Watts arts festivals but by 1969 it had been dismantled, with the individual pieces scattered and lost. The Watts arts festival was aggressively taken over by radical young black activists to become the Watts Summer Festival, a music-based event attracting upward of ten thousand each year in tribute to the thirty-four killed in 1965. Unpleasant encounters between Purifoy and Watts Summer Festival organizers eventually led to both his and Powell's departures from the WTAC. Powell went on to found the Compton Communicative Arts Academy and Purifoy to work further in arts education and policy, including the California Arts Council.

Purifoy's dark view was echoed in a widely read account of post-revolt Watts, "A Journey into the Mind of Watts," Thomas Pynchon's 1966 exposé for the *New York Times*. Pynchon brilliantly described a neighborhood that went from national obscurity to national obsession and yet remained virtually unchanged as an impoverished black neighborhood in which government intervention was resented, the police feared, and communication between black activists and white liberals poor. It was a place ("Raceriotland," a perverse play on Disneyland) that America wanted to forget: "Somehow it occurs to very few of them [white Americans] to leave at the Imperial Highway exit for a change, go east instead of west only a few blocks, and take a look at Watts. A quick look. The simplest kind of beginning. But Watts is country which lies, psychologically, uncounted miles further than most whites seem at present willing to travel."[72] Pynchon knew that the one thing that *has* historically drawn white visitors to black Los Angeles is Rodia's backyard fantasy. However Pynchon was not willing to let a curious public off so easily. No pat on the head for *Times* readers on June 12, 1966. Instead, Pynchon foregrounded Rodia and the Watts Towers as more evidence of Los Angeles' urban decay. Pynchon respected Rodia, admiring his "dream of how things should have been: a fantasy of fountains, boats, tall openwork spires," but also saw the mortared broken glass as a specter of failure: "A kid could come along in his bare feet and step on this glass—not that they'd ever know. These kids are so tough you can pull slivers of it out of them and never get a whimper. It's part of their landscape, both the real and the emotional one: busted glass, busted crockery, nails, tin cans, all kinds of scrap and waste. Traditionally Watts. Next to the Towers, along the old Pacific Electric tracks, kids are busy every day busting more bottles on the street rails. But Simon Rodia is dead, and now the junk

just accumulates."[73] Little publicity for the towers followed the Pynchon article or the Purifoy and Powell exhibition of 1966, with a few exceptions. One was a children's book written in 1968 by Jon Madian. *Beautiful Junk* depicts a kindly old gent schooling a black child on the artistic value of garbage. Distributed to elementary schools around the United States, Madian's picture book shows an actor playing Rodia (the real Rodia had been dead three years) in a romanticism of the relationship between an elderly white man and a racially charged neighborhood. A second public image of the towers in the post-riot years was their appearance on the cover of *Time* in 1969 in celebration of California's population explosion. Two years later Reyner Banham celebrated the architectural landscape of Los Angeles, featuring the towers as among the few orienting emblematics in his maps of the city.

With a general lack of publicity and the stigma of 1965 preventing the fund-raising campaigns possible in 1959, the committee could no longer afford to keep the towers or the WTAC. After sixteen years of maintaining the towers on private donations, in 1975 the committee turned them over to the municipal government. The city promised to maintain them and repair weather damage and hired a contractor to do so. Untrained in the skilled work needed to reinforce Rodia's unique structure, the contractor and his associates badly damaged the towers, performing what is known as a "savage restoration," whereby a work of art or historical landmark is "preserved" in such a way as to purposely destroy or irreparably damage the original work. What the ten-thousand-pound-stress test could not do in 1959 was achieved sixteen years later by chipping away the mosaics, ripping apart the foundation, attempting to pour plastic onto the face of the towers, and leaving flammable waste in barrels within the towers' base. Fortunately, the towers did not explode, and the Center for Law in the Public Interest sued the city, on behalf of the committee, to stop the damage and force the city to pay reparations. In a complex lawsuit that would finally end in 1985, the committee donated the Watts Towers to the state of California with the stipulation that $207,000 of state funds would go to the city for their preservation and upkeep. As part of the settlement, Watts Towers was proclaimed a California Historic Park, while responsibility for restoration was assigned to the Los Angeles Cultural Affairs Department.[74]

The municipal government's neglect of the towers reflected the national attitude toward the inner city in the 1970s—a lack of empathy combined with diminished financial support. The conservative backlash against the social upheaval of the 1960s was pronounced in California as exemplified by the passage of Proposition 13. In 1978 the landlord-lobbyist Howard Jarvis gathered over a million signatures to put the proposition on the state ballot. Proposition 13 limited property taxes for

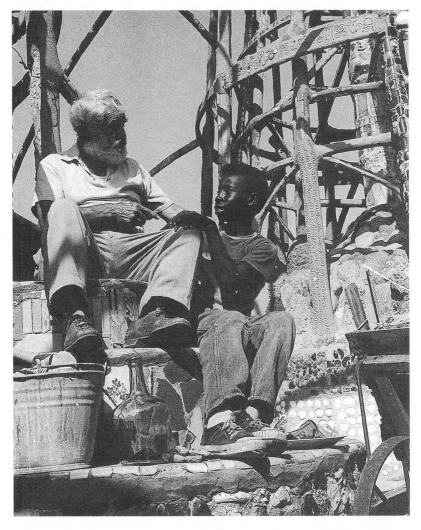

Figure 39. Fictional Rodia (on the left). From Jon Madian's children's book
Beautiful Junk. Photograph © Lou Jacobs, Jr., 1968.

suburban homeowners, which, in turn, severely limited the funding of
schools, public services, and urban infrastructure in inner-city neighbor-
hoods.[75] Proposition 13 had an immediate effect on the Watts Towers.
In a letter to a concerned resident of Watts, the office of the mayor
wrote: "all of us [in the city government] share your concerns regarding
the safety of the Watts Towers. However we cannot give any assurances

for 24 hour security. . . . With the passage of Proposition 13 it may be necessary for the city to have fewer security officers than we had before to guard all of our public facilities."[76]

The 1970s and 1980s represented a shift in the political infrastructure of the city. Conservative mayor Sam Yorty lost in 1973 to the first (and to date only) African American mayor of Los Angeles, Tom Bradley. He would win four consecutive terms before his retirement in 1993. Properly criticized for copping to corporate land grabs, susceptibility to foreign payoffs, and not supporting affordable housing, Bradley was also responsible for putting Los Angeles on the international map as a financial center, with the 1984 Summer Olympics his career's major coup. As Roger Keil argues in his work on Los Angeles as a global city, downtown Los Angeles would undergo an immense civic transformation during the Bradley years, becoming dominated by skyscrapers and the symbols of global capitalism: "Bradley's ability to smooth out the waves of social unrest in Los Angeles during [the 1970s and 1980s] enabled new concepts of an urban future to surface, and opened the space of the city to the fantasies of developers who had their eyes on the downtown prize."[77]

Bradley's vision of a rejuvenated Los Angeles, with racial and economic distress things of the past, included an emphasis on the arts as part of a new, invigorated civic identity. In anticipation of the 1984 Olympics, Bradley commissioned forty-seven murals, painted along major stretches of the 110, 101, and 10 freeways. Often showing runners or other sports participants, the murals "officially" resurrected an art form that the city of Los Angeles had destroyed in the 1930s as Communistic, anti-imperialist, and overly critical of racial and class inequities. By the 1960s and 1970s, of course, murals had become a major visual component of the Chicano movement and of radical social movements in Los Angeles and other cities throughout the United States. The irony of Los Angeles Cultural Affairs Department adopting a highly politicized and historically marginalized art form to represent the new global Los Angeles as a seat of international financial prowess was not lost on local artists. To this day, the Bradley-era murals are a favorite target of graffiti artists and taggers who see these freeway wall paintings as the unwelcome marks of "official" cultural authority.[78]

This strange separation of art and history in the name of a new civic identity continued through the 1980s when the Los Angeles papers, the *Herald Examiner* in particular, sponsored a fund-raising campaign in support of the towers. Pulling together an impressive roster that included representatives from the Committee for Simon Rodia's Towers in Watts, local art critics and commentators, museum curators, newspaper editors, state assemblymen, prominent American architects, and a couple

of Watts activists, the *Herald Examiner* hosted "The International Forum for the Future of Sam Rodia's Towers in Watts," which ran for three days in June 1985 at the Davidson Conference Center at the University of Southern California. Avoiding emphasis on the 1965 revolt and the social history of Watts, the press instead used the towers to obscure racist power relations that defined living conditions in south central Los Angeles and promote Bradley's civic campaign of "community affirmation." The *Herald Examiner* adopted the old language of the 1950s preservation campaign writing: "No symbol in Los Angeles carries more meaning than these sparkling spires. A testimony to immigrants' dreams. . . . Today that vision towers over Watts, high above the railroad tracks, the little houses and the human struggle—a tribute to a community's inner strength."[79] This commentary, combined with photographs that rarely showed the neighborhood, served to separate the "towers as community" symbol from the history of Watts. Moreover, the romantic mythology surrounding an immigrant building such a monument obscured from view Watts' new immigrants from Mexico and Central America. Even with all the trappings of an official and possibly productive meeting, little came of it other than plans to host an international design competition to redevelop the area surrounding the towers commercially. Mike Davis has pointed out that at the very time that Los Angeles came into its own as a global city, with the trappings of shiny buildings and plans for new museums, "such vital generators of community self-definition as the Watts Towers Art Center . . . had to make drastic cutbacks to survive the 'age of arts affluence.' "[80]

While Los Angeles' municipal government and the newspapers deployed the towers as a deracialized, deracinated, and depoliticized symbol of community, popular culture increasingly adopted the towers as a symbol of American blackness in the 1980s and 1990s. Pop-cultural appropriations of the towers were not new. Musicians who lived or performed in postwar Watts, for example, often had close affiliation and nostalgia for *Nuestro Pueblo*. Charles Mingus and Johnny Otis, jazz and rhythm and blues greats respectively, have commented in their autobiographies on the towers' significance as a neighborhood landmark and a testament to artistic endeavor. Mingus, who spent his childhood in Watts, describes them in improvisational jazz metaphors in his 1971 autobiography *Beneath the Underdog*: "[Rodia] was always changing his ideas while he worked and tearing down what he wasn't satisfied with and starting over again, so pinnacles tall as a two-story building would rise up and disappear and rise again. What was there yesterday mightn't be there next time you looked, but then another lacy-looking tower would spring up in its place."[81] Visual artists have been captivated too; Jann Haworth and Peter Blake featured Sabato Rodia amid the crowd of

faces assembled on the Beatles' 1967 *Sgt Pepper* album cover (see top right-hand corner, one left of Bob Dylan). In 1965, the art department of California State University, Long Beach, organized the International Sculpture Symposium, inviting eight renowned sculptors to create site-specific sculptures constituting a "museum without walls." Included in the permanent collection was a large installation of reinforced concrete blocks by the Dutch artist Joop Beljon. Etching the sculpture on one side with a heart, Beljon entitled his own outdoor urban sculpture *Homage to Sam Rodia.*[82]

With the 1980s came the infusion of hip-hop into mainstream American popular culture, with its graffiti, urban dance moves, and rap music; it has been described by Tricia Rose as "a black cultural expression that prioritizes black voices from the margins of urban America."[83] The social effects of neglecting the inner city increasingly played out in movies, with Los Angeles emerging as the filmic trope of black urban unrest in the late twentieth century in much the same way that New York served as the symbol of American ethnic conflict and urban blight in 1970s films such as *Taxi Driver, Mean Streets, Serpico,* and *Saturday Night Fever.* With the Watts Towers physically located at ground zero for gang warfare, a historical touchstone for popular conceptions of Los Angeles' "South Central," Rodia's lifework became a common spatial reference for Hollywood. In *Colors* (1988), the film's director, Dennis Hopper deploys the towers to show metaphorically how a black neighborhood is torn apart by gang warfare, police violence, and drugs.[84] *Ricochet* (1991), starring Denzel Washington and John Lithgow, encodes the towers as symbols of "blackness," black community, and Black Power when a white predatory pedophile is impaled on them.[85] In the 1992 buddy film *White Men Can't Jump* the towers signal a white man's arrival in the ghetto, while the 1996 *Courage under Fire* deploys the towers to new effect. Displayed in a black-and-white print hanging on a bedroom wall, the towers ambiguously serve, for a middle-class black family functioning in the upper echelon of white Washington, D.C. political culture, as a marker of black authenticity, one's roots in the 'hood, or perhaps a sign of a finely tuned aesthetic sensibility.

The towers have increasing resonance in hip-hop. Since the Los Angeles gang wars of the 1980s (and possibly before), the hand sign for Watts is three fingers of the right hand pointed down, symbolizing Rodia's three main towers. In recent years, the towers have been featured in advertisements, music videos, and computer games. The singer Tyrese featured Rodia's work on the cover of his 2001 CD release, commenting in the liner notes, "I use the Watts Towers as a symbol of freedom, history, struggle, independence, strength and a high level of confidence."[86] L.A. hip-hop artist The Game prominently featured the towers in several

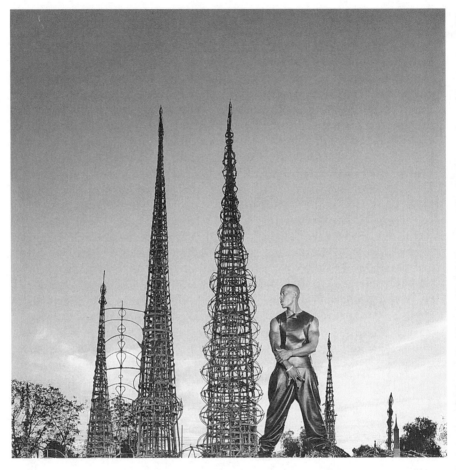

Figure 40. Tyrese, *Watts 2000* album cover artwork. Photograph © Dan Winters.

of his videos. In 1999 the towers appeared in a Levi's print ad in which a young hipster sat on a stool in the lot behind the towers holding a sign that said "Restoration, Rejuvenation."[87] Their appropriation by Levi's helps render the Watts Towers as an icon of popular culture while a multinational corporation profits by cashing in on the struggles of real social and political history. Removed from their urban context in high art discourse, popular representations of the towers in the hyper-violent video game *Grand Theft Auto-San Andreas* and Boost Mobile's briefly ubiquitous "Where you at?" advertising campaign exploit the towers for their authenticating street credentials. As hip-hop has mainstreamed through global popular culture, representational icons such as the towers have

become increasingly part of an urban vernacular landscape whose meanings are loosely tied to pop notions of black cultural identity and tightly secured to commercial products. Far beyond any intention of Sabato Rodia, the Watts Towers increasingly embody the globalized process by which an urban space's commercial value makes a profit for those well outside the reach of the social ills that originally gave that space its "authenticity" and, in turn, its consumer marketability.

The political climate of the 1990s helped formulate new uses for the towers. In 1990 Arloa Paquin Goldstone, wife of the engineer for the Committee for Simon Rodia's Towers in Watts, successfully applied for National Landmark status for the towers. On the heels of this new achievement, Los Angeles' Watts Redevelopment Project used the towers to decorate the cover of its November 1991 report.[88] The towers stood for all that Watts could be: economically viable, politically connected. The historian William Fulton has pointed out, however, that many African Americans did not support this 1991 Community Redevelopment Agency (CRA) project because they saw it as one more urban renewal program causing damage in Los Angeles.[89] It is yet another ironic twist that proponents of urban renewal would use the towers as a symbol of a rejuvenated black neighborhood when so much more energy has gone into preserving the towers than rectifying social and economic inequities. This irony is especially pronounced since urban renewal helped destroy Watts as an economically viable neighborhood and led to the early efforts to tear down the towers in the first place.

The 1991 CRA project evaporated first with the brutal beating of Rodney King by officers of the Los Angeles Police Department and then with the "not guilty" verdict that sparked looting and violence across a wide band of southern Los Angeles. With riots focusing national attention again on Los Angeles' poor neighborhoods, the failure of programs, grants, and contracts that followed the aftermath of 1965 was shown in stark relief. James Woods, founder of the Studio Watts Workshop, another community arts program in South Central, has said, "If funding had concentrated on establishing institutions rather than temporary programs, we could have accomplished much more."[90] Short-term funding of community art could not maintain such programs any more than fixing Watts Towers could fix Watts.

Since the summer of 1999, Watts and the towers have become state-recognized tourist attractions. Through the nonprofit Watts Labor Community Action Committee and the California Council for the Humanities, local activists have organized bus tours of Watts with an extended stop at Rodia's towers. Tour organizers hope that educating outsiders on the cultural merits of Watts will attract commercial interests to the area. In July 1999 President Clinton visited the neighborhood as part of a

national tour of economically depressed areas. Work on the large Watts Towers community art center, proposed and rejected by the state in 1965, began in 1998, but the project is still riddled with design problems and is moving slowly. Moreover, Watts faces new challenges as its Latino population has overtaken the African American population. The new residents of Watts are also poor, and the social services that exist in the area are ill-equipped to handle Spanish-speaking clients.[91] In 2001 the Cultural Affairs Department's eight-year, $2 million renovation of the towers was completed, with help from the Getty Conservation Institute, and the scaffolding was removed to great fanfare in the local media.[92] In 2006 the Committee for Simon Rodia's Towers in Watts began a campaign to get either the city or the state to issue a stop-work order to end another bout of damaging restoration practices that have inalterably erased unique examples of Rodia's handiwork.

Representations of the Watts Towers in artwork, advertising, municipal reports, art journals, and popular culture are inscribed with the contrasts between high art and community art, black public space and white safe space, art removed from its urban context and art made of urban debris, towers of power and towers of poverty. Underlying much of the language of cultural authority surrounding the towers is an inarticulate but obvious discomfort with the evolution of the towers into a nationally recognized civic landmark in a city with a long history of painting over, literally and figuratively, representations of nonwhite and poor people. Though efforts were made to symbolically separate the towers from the multiracial, working-class space from which they emerged, the Watts Towers Art Center, and certainly the 1965 Watts riot, underlined the relationship between the neighborhood and the spatialized racial politics of Los Angeles; the towers might have represented modernist artwork, but they also represented black Los Angeles, and it would become impossible to separate the two. It is certainly one of the greatest ironies of Los Angeles' art history that a city with such a long and intensive investment in its own self-image as a white bourgeois Eden should become well known for the Watts Towers: a fantasy city built of urban detritus by an Italian immigrant in a struggling black and Latino neighborhood.

Conclusion

New social movements and political identities took hold of a generation of artists in the 1970s. Modern and contemporary art became an "art of engagement," art that was irrefutably political, offering trenchant social critiques of racism, sexism, the Vietnam War, and colonialism.[1] Struggles for racial and gender equality produced exciting art reflecting new political identities and heated claims to social and cultural turf. Cities across the country, from San Diego to New York, saw freeway and subway murals that spoke of neighborhood pride and youthful artist celebrity. Los Angeles was no different in that the black and Chicano arts movements, generative of community and identity formation, drove the founding of neighborhood arts centers such as the Brockman Gallery, Compton Communicative Arts Academy, Los Angeles Contemporary Exhibitions (LACE), Self-Help Graphics, Plaza de la Raza, Studio Watts Workshop, and the Social and Public Art Resource Center (SPARC). Judson Powell, James Woods, Harry Gamboa, Jr., Gronk, and Judith Baca, along with hundreds of colleagues, students, and mentors, created both artwork and an artistic infrastructure that stood in opposition to the commercial galleries, museums, and the civic institutional mainstream.

In Los Angeles this political positioning was especially charged because of the city's history of deploying art, and the discourse surrounding it, as a tool by which to control and contain cultural expression and public space and mark the socially acceptable parameters of civic inclusion. Los Angeles' artists not only turned their backs on civic cultural authority but also worked to subvert it. Perhaps the most trenchant and immediate example was performed in 1972, when Gronk, Willie Herrón, and Gamboa spray-painted the entrances to LACMA after a curator refused even to entertain the idea of a Chicano art show within its walls. The next day Gamboa photographed Patssi Valdez near their signature tags, documenting both a Chicano art stereotype ("gang" graffiti) and a swipe at Los Angeles' racist exclusivity.[2] When Judith Baca inscribed the walls of *Danzas Indigenas* with anticolonialist writings in 1993, she recalled this 1970s challenge to civic cultural authority thereby infuriating the nativist group, Save Our State, which led to the protests

Figure 41. Estrada Courts murals, 1973–78. Photograph © 2003 Megan Hoetger.

twelve years later. Baca's sculpture, a Metrolink commission that swiped at civic culture, also hinted at her ambivalence about her acceptance into the artistic mainstream.

Such ambivalence about the uncomfortable relationship between official civic culture and social protest art was experienced by Chicano artists in the 1970s as murals became municipal and state-sanctioned art forms thought to prevent gang violence and dissuade graffiti practices. Estrada Courts, a public housing project built in east Los Angeles in the 1940s, grew famous for its eighty-two murals painted between 1973 and 1978. Led by invited Chicano artists, the youth of Estrada Courts, many of whom were members of the Varrio Nuevo Estrada (VNE) street gang, painted the huge and colorful murals. Public perception of the Estrada Courts murals, which seemed to transform a beat-up housing project into a proud show of self-worth, was overwhelmingly positive—so much so that in 1976 President Ford wrote the mural program director, Cat Felix, to commend him for the fine labor and to honor it by choosing Estrada Courts as one of several hundred sites in the national program "Horizons on Display." Soon many of the same kids who had painted the murals were again tagging the walls with the VNE *placas* that the

Figure 42. Estrada Courts murals, 1973–78. Photograph © 2003 Megan
Hoetger.

murals were meant to cover. Marcos Sanchez-Tranquilino suggests that
rather than vandalism, the tagging of one's own mural points toward
a complex sense of wall ownership and a social tension created by the
uncomfortable yet approving attentions of official cultural authority.
This tension, both political and aesthetic, fostered splits within the Chi-
cano arts community as many younger artists saw greater power in rene-
gade muralism and barrio calligraphy than in state-sanctioned pieces.[3]
As much as the message of Estrada Courts represented an inversion of
dominant visions of place in Los Angeles, its achievement of acceptabil-
ity within academic discourses of modernism and agencies of urban
renewal rendered the murals complicated participants in the city's con-
struction of civic identity. It is remarkable to see, thirty years later, that
the murals still survive. Many are free of tagging, but even those that are
heavily tagged were done so in ways that remind the viewer of the vision
and the labor that produced the murals in the first place. The effect
created together by the murals and the tags, whether interpreted as
authorial signatures or kids claiming turf, is one of a powerful sense of
civic identity honoring local history and a collective memory of social
activism.

While the ideologies of radical social politics characterized new art movements in Los Angeles, the 1970s also marked the era of civic renewal, with millions of private and public dollars earmarked for the restructuring of downtown Los Angeles. Once Mayor Tom Bradley took office in 1973, the city was on its way to its place on the international stage as a global metropolis replete with high-finance skyscrapers, new civic cultural institutions, and big plans for further redevelopment. By the 1980s design plans for the Los Angeles Music Center and Walt Disney Concert Hall were in play, and the opening of the Museum of Contemporary Art testified to the arts affluence of the period. Yet, even with two hundred thousand people at work in the buildings everyday and millions of dollars spent on civic arts, downtown Los Angeles and its brand-new cultural center remained unwelcoming and not easily accessible, a foreign destination for most Angelenos. Downtown's designers created a sharply segregated urban space divided between the affluent financial and cultural sector at the top of Bunker Hill and the Latino and Asian shops, arcades, and vegetable markets at the bottom. While Bradley's civic imagination had been realized, that of a diverse Los Angeles public was still relegated to a space outside the civic mainstream. This outcome was no surprise; for years large numbers of Angelenos had opposed bond issuances to break ground on Bunker Hill or raise money to build the Los Angeles Music Center because these projects ignored the needs of smaller communities and neighborhoods, providing glittering displays of corporate power with cultural facilities that contributed to the enjoyment of the few. As civic culture evolved into a corporate and highly centralized feature of Los Angeles' political economy in the 1990s and 2000s, art in the city changed too. While the crème de la crème of the new gallery scene on La Cienega Boulevard expanded to include the chic west end of Melrose Avenue and newly gentrified parts of Culver City, the works of Los Angeles–based artists became cornerstones of national and international modern art collections. In 2006 a new milestone was reached when the chic arbiter of taste, Paris's Centre Pompidou, curated the critically acclaimed exhibition "Los Angeles 1955–1985," a veritable catalog of L.A. cool.[4]

Museums often have proved to be heavy with immovable aesthetic choices that underscore hegemonic visions of the city. David Harvey warns us that today's "cultural institutions seem to have as their aim the cultivation of nostalgia, the production of sanitized collective memories, the nurturing of uncritical aesthetic sensibilities, and the absorption of future possibilities into a non-conflictual arena that is eternally present."[5] To the credit of its curators and staff, in 2004 the Natural History Museum of Los Angeles County tried to prevent the embalming effect of false collective memory by organizing a self-critical exhibition sensi-

tive to its own history of civic exclusivity. The show, "L.A: light/motion/ dreams" underscored the multiculturalism attempted by the museum's flashier counterparts by attracting a remarkably diverse audience to an elaborate light show-cum-art exhibit examining the relationship between the city's cultural and natural environments. By emphasizing the visitor's shared place in the city, the show made one feel infused with a sense of civic belonging. Fantastic and energetic in its execution, with ambient electronica mesmerizing listeners and kaleidoscopic images implicating the viewer in rapid-motion video clips of the city, the exhibit offered tantalizing fragments of the urban environment. Included were an installation of a taxidermied coyote, cat in jaws, standing on a diving board of a swank Topanga Canyon home and an L.A. river piece that seamlessly included the graffiti prevalent on the banks of the flood channel. In a darkened room, projections of the Watts Towers swept over visitors as voice-overs pronounced fears of urban violence and loss of home ownership for Angelenos of color. Unfortunately, however, unless one bought the helpful companion DVD to view at home, the social histories that make Los Angeles so at odds with its natural environment are difficult to find. Though thankfully lacking the pretensions of other civic cultural attractions, this exhibit too seemed to lose Los Angeles amid the lights, tongue-in-cheek display cases, and darkened corridors.

In twentieth-century Los Angeles, civic identity was formulated and contested through visual culture, with artistic modernism the lightning rod by which the political stakes of the city's cultural turf wars were illuminated. Los Angeles still strives to make an art-based civic identity stick but with little success. In a 2007 RAND research study entitled "A Vision for the Arts in Los Angeles," Elizabeth H. Ondaatje and Kevin F. McCarthy reported that the city was "poised on the threshold of an exciting new era" where it could be recognized at last as a world-class center for arts and culture.[6] While not yet achieving such recognition, Los Angeles could get there if only its civic and cultural leaders would "think regionally"; "consider the entire arts, culture, and entertainment sector, not just the nonprofit 'high arts' or commercial industries"; and "align the arts sectors and its goals with broader community goals."[7] Unknowingly the authors eerily echoed progressive reformers' 1910s calls to civic pride; the movie studio magnates' 1930s campaign to wed the fine arts to the film industry and undo artificial divisions between high and low culture; Kenneth Ross's longtime struggles to decentralize public art; and Noah Purifoy's and Judson Powell's efforts to entrench the arts in local schools and community centers in black Los Angeles. Unlike these people, however, Ondaatje and McCarthy seem unable to recognize the power dynamics at work when projecting a civic strategy of art development ("A Vision for the Arts") onto a city, especially one the size of Los

Angeles and with such a contentious art history. The singular vision of a
coherent civic identity is inherently a practice in dominance and, as the
historical record reveals, impossible to implement given art's flexible
interpretations and Los Angeles' long struggles with the arbiters of cul-
tural authority.

Notes

Introduction

1. *SPARC/Social Public Art Resource Center Newsletter,* June 25, 2005; "The State of Public Art in the Face of Fanatical Neo-Conservative Agendas," *SPARC/Social Public Art Resource Center Newsletter,* May 14, 2005; Judith Baca, Baldwin Park Press Release, May 12, 2005; www.saveourstate.org, accessed August 8, 2006.

2. Though posed somewhat differently, this question of the relationship between social stratification, ethnic marginality, and urban form has been addressed in works by the historians William Deverell and Phoebe Kropp, both of whom examine the political implications of the Spanish fantasy past, a concept coined by the early twentieth-century writer and critic Carey McWilliams to mean the Anglo-American celebration (in fiestas, architecture, and civic culture) of Spanish colonialism, mission life, and early Mexico. Greg Hise and William McClung too have shown how malleable civic imagery has been in Los Angeles, with competing representations of Arcadia and utopia, Eden and industrial urbanity, all fitting within a dominant Anglo culture's concerns for building an ideal society. See William Deverell, *Whitewashed Adobe: The Rise of Los Angeles and the Remaking of Its Mexican Past* (Berkeley: University of California Press, 2004); Phoebe Kropp, *California Vieja: Culture and Memory in an American Place* (Berkeley and Los Angeles: University of California Press, 2006); Greg Hise, *Magnetic Los Angeles: Planning the Twentieth Century Metropolis* (Baltimore: Johns Hopkins University Press, 1997); and William Alexander McClung, *Landscapes of Desire: Anglo Mythologies of Los Angeles* (Berkeley and Los Angeles: University of California Press, 2000).

3. Famous celebratory tours of Los Angeles include Reyner Banham, *Los Angeles: The Architecture of Four Ecologies* (New York: Harper and Row, 1971); and Edward Soja, *Postmodern Geographies: The Reassertion of Space in Critical Social Theory* (London: Verso, 1989). The literature on Los Angeles' disturbing self-erasure continues to grow, but key works include Carey McWilliams, *Southern California: An Island on the Land* (1946; Salt Lake City: Peregrine Smith, 1973); Mike Davis, *City of Quartz: Excavating the Future in Los Angeles* (London: Verso, 1990); Norman M. Klein, *The History of Forgetting: Los Angeles and the Erasure of Memory* (London: Verso, 1997); Deverell's *Whitewashed Adobe* and Phoebe Kropp's *California Vieja.*

4. Coined the "Spanish fantasy past" by Carey McWilliams, the celebration of "Spanish-ness" while denigrating the history of Mexican California has been the subject of critical cultural work on Los Angeles. See Deverell's *Whitewashed Adobe* and Phoebe Kropp, "Citizens of the Past? Olvera Street and the Construction of Race and Memory in 1930s Los Angeles," *Radical History Review* 81 (Fall 2001): 35–60.

5. Dolores Hayden, *The Power of Place: Urban Landscapes as Public History* (Cambridge, Mass.: MIT Press, 1995), 9–10.

6. Jo-Anne Berelowitz, "Protecting High Culture in Los Angeles: MOCA and the Ideology of Urban Redevelopment," *Oxford Art Journal* 16, no. 1 (1993): 149.

7. Walt Disney Concert Hall Upcoming Events 2004 season, www.musiccenter.org, accessed October 10, 2004.

8. There is an enormous literature debating the genesis, politics and evolution of artistic modernism in the United States, but the key works of the last two decades include T. J. Clark, *Farewell to an Idea: Episodes in a History of Modernism* (New Haven, Conn.: Yale University Press, 2001); Thomas Crow, *Modern Art in the Common Culture* (New Haven, Conn.: Yale University Press, 1996; Francis Frascina, ed., *Pollock and After: The Critical Debate*, 2nd ed. (London and New York: Routledge, 2000); and Serge Guilbaut, *How New York Stole the Idea of Modern Art: Abstract Expressionism, Freedom, and the Cold War* (Chicago: University of Chicago Press, 1983).

9. Marshall Berman, *All That Is Solid Melts into Air: The Experience of Modernity* (New York: Penguin, 1988), 6.

10. Don Parson, *Making a Better World: Public Housing, the Red Scare, and the Direction of Modern Los Angeles* (Minneapolis: University of Minnesota Press, 2005), xi. Parson articulates the modernist split in postwar Los Angeles as an ideological and political divide between a community modernism representing a leftist vision of a better world and a corporate modernism deploying the tools and resources of the modern city to benefit the powerful. Another work that addresses the conflict between modernist urban planning and community building is Dana Cuff, *The Provisional City: Los Angeles Stories of Architecture and Urbanism* (Cambridge, Mass.: MIT Press, 2000).

11. Together the following offer the most comprehensive examination of southern California art to date: Peter Plagens, *Sunshine Muse: Art on the West Coast, 1945–1970* (Berkeley and Los Angeles: University of California Press, 1999); Paul Karlstrom, ed., *On the Edge of America; California Modernist Art, 1900–1950* (Berkeley and Los Angeles: University of California Press, 1996); Paul Karlstrom and Susan Ehrlich, *Turning the Tide: Early Los Angeles Modernists, 1920–1956* (Santa Barbara: Santa Barbara Museum of Art, 1990); Richard Cándida Smith, *Utopia and Dissent: Art, Poetry, and Politics in California* (Berkeley and Los Angeles: University of California Press, 1995); Stephanie Barron, Ilene Fort and Sheri Bernstein, *Made in California: Art, Image, and Identity, 1900–2000* (Berkeley and Los Angeles: University of California Press); and Cécile Whiting, *Pop L.A.: Art and the City in the 1960s* (Berkeley and Los Angeles: University of California Press, 2006).

12. Whiting, 8.

13. Lawrence Weschler, "Paradise: The Southern California Idyll of Hitler's Cultural Exiles," in *Exiles + Emigrés: The Flight of European Artists from Hitler*, ed. Stephanie Barron (Los Angeles: Los Angeles County Museum of Art, 1997); David E. James, *The Most Typical Avant-Garde: History and Geography of Minor Cinemas in Los Angeles* (Berkeley and Los Angeles: University of California Press, 2005); Kevin Starr, *Material Dreams: Southern California Through the 1920s* (New York: Oxford University Press, 1990); Victoria Dailey, "Art: Naturally Modern," in *LA's Early Moderns: Art/Architecture/Photography* (Los Angeles: Balcony Press, 2003).

14. Klein, 27–72.

15. Rosalyn Deutsche, "Alternative Space" (1991) in *The City Cultures Reader*, ed. Malcolm Miles, Tim Hall, and Iain Borden (London: Routledge, 2000), 200.

16. The best work on collective memory and its historical place as a site of

potential for building social movements is George Lipsitz, *Time Passages: Collective Memory and American Popular Culture* (Minneapolis: University of Minnesota Press, 1990).

Chapter 1

1. The concept of cultural capital as the accumulated education and information through which middle and upper classes learn an informed aesthetic judgment and acquire social status artificially detached from economic status comes from the French sociologist Pierre Bourdieu. Bourdieu develops the concept to explain not only how upper classes learn, internalize, and naturalize class distinctions through culture, or "taste," but also how learned ideas about taste, and its symbolic value, become institutionalized and thereby help maintain distinctive boundaries between classes and ethnic groups which, in turn, may translate into material capital. See Pierre Bourdieu, *Distinction: A Social Critique of the Judgment of Taste* (Cambridge, Mass.: Harvard University Press, 1984).

2. Letter to the Board of Governors, March 25, 1915, from Fine Arts League member J. H. Braly, Fine Arts League Records, general collection 1057, box 1, folder 10, Seaver Center for Western History Research, Natural History Museum of Los Angeles County, Calif.

3. Arthur Millier, "Art and Artists," *Los Angeles Times*, April 15, 1928, C30.

4. Civic Bureau of Music and Art of Los Angeles, *Culture and the Community*, Los Angeles County, 1927, 3–6, Department of Special Collections, California State University, Long Beach.

5. Banham; Victoria Dailey, Natalie Shivers, and Michael Duncan, *LA's Early Moderns: Art/Architecture/Photography* (Glendale, Calif.: Balcony Press, 2003); David Gebhard and Harriette Von Breton, *Los Angeles in the Thirties, 1931–1941* (Los Angeles: Hennessey and Ingalls, 1975); Thomas S. Hines, *Irving Gill and the Architecture of Reform: A Study in Modernist Architectural Culture* (New York: Monacelli Press, 2000); Paul J. Karlstrom and Susan Ehrlich, *Turning the Tide: Early Los Angeles Modernists, 1920–1956* (Santa Barbara, Calif.: Santa Barbara Museum of Art, 1990); Karlstrom.

6. In fact, Bram Dijkstra convincingly argues that, if anything, "the early modernist art of the area represents an embarrassment of riches" and that it was the disproportionate weight that post-World War II art critics placed on East Coast abstractionism that banished them "from our public memory almost overnight." Dijkstra, "Early Modernism in Southern California: Provincialism or Eccentricity?" in *On the Edge of America*, 173–78.

7. Plagens, *Sunshine Muse*, 9.

8. Peter Selz, "The Impact from Abroad: Foreign Guests and Visitors," in *On the Edge of America*, ed. Karlstrom, 98; Susan M. Anderson, "California Progressives, 1910–1930," in *California Progressives Catalog* (Newport Beach, Calif.: Orange County Museum of Art, 1996), 10.

9. *California Graphic*, February 1, 1918, 11, quoted in Nancy Dustin Wall Moure, *Publications in Southern California Art 1, 2, & 3* (Los Angeles: Dustin Books, 1984), B-14; Susan Anderson, 10.

10. Moure, *Publications in Southern California Art*, B5.

11. In 1927 Los Angeles County's Civic Bureau of Music and Art listed the following as active clubs and art organizations in the city, and surrounding environs: the California Art Club, the Sculptors' Guild, the Painters and Sculptors Club, the Arts and Crafts Society, the Hollywood Art Association, the Hollywood

Chamber of Commerce, the Modern Art Workers, Artland, the Printmakers Society of California, the International Artists' Association, the Long Beach Art Association, the Glendale Art Association, and the MacDowell Club of Allied Artists. Listed Under Women's Clubs were the following: the Ruskin Art Club, the Friday Morning Club, and the Ebell Club. See Civic Bureau of Music and Art of Los Angeles, *Culture and the Community*, 12–13.

12. Susan Anderson, 10; Derrick Cartwright, "Appendix: A Chronology of Institutions, Events, and Individuals," in *On the Edge of America*, ed. Karlstrom, 277.

13. Karlstrom and Ehrlich, 89.

14. Victoria Dailey, "Art: Naturally Modern," in Dailey et al., *LA's Early Moderns*, 37.

15. Stanton Macdonald-Wright, "Art News from Los Angeles," *Art News*, n.d.

16. Antony Anderson, "Our American Modernists," *Los Angeles Times*, February 13, 1920.

17. Ilene Susan Fort, "Altered States: California Art and the Inner World," in *Reading California: Art, Image, and Identity, 1900–2000* (Berkeley and Los Angeles: University of California Press, 2000), 37–38; Moure, 4.

18. Winnifred Haines Higgins, "Art Collecting in the Los Angeles Area, 1910–1960" (Ph.D. diss., University of California, Los Angeles, 1963), 70–87.

19. Ibid., 23.

20. Ibid., 56.

21. Ibid., 25.

22. Sam W. Small, Jr., *California Graphic*, 1924. Los Angeles Art Association, printed materials, box 7/8, Archives of American Art, Smithsonian Institution. Washington, D.C.

23. The checklist for this collection also includes works by Charles Dufresne, E. Othon Firesz, Albert Gleizes, Marcel Gromaire, Armand Guilamin, Henri Lebasque, André L'Hote, Jean Marchand, Georges Rouault, André Segonzac, Kees van Dongen, Maurice de Vlaminck, and Henri de Waroquier. See 1953 inventory, file A. 809, Los Angeles County Museum. The checklists for the Mr. and Mrs. William Preston Harrison Collection can be found in Higgins, 56–69.

24. Arthur Millier, "Public Art Gift Listed," *Los Angeles Times*, January 20, 1929, C13.

25. *The Louise and Walter Arensberg Collection: 20th Century Section* (Philadelphia: Philadelphia Museum of Art, 1954).

26. Higgins, 165.

27. Michael Duncan, "Cosmopolitan Californian," *Art in America* 92, no. 3 (March 2004): 63–65.

28. Arthur Millier, "Of Art and Artists," *Los Angeles Times*, November 7, 1926, C32.

29. Duncan, 63–65.

30. Higgins, 206–13.

31. Henry Hopkins, *Painting and Sculpture in California: The Modern Era* (San Francisco: San Francisco Museum of Modern Art, 1977), 72.

32. Antony Anderson, "Of Art and Artists," *Los Angeles Times*, January 14, 1923, 44.

33. Paul J. Karlstrom, "Art School Sketches: Notes on the Central Role of Schools in California Art and Culture," in *Reading California*, 84–109.

34. Letter from John Austin, chairman of the Civic Committee for Los

Angeles County Arts Project, to John Anson Ford, Los Angeles County Board of Supervisors, November 21, 194, box 38, music and art folder of the John Anson Ford Collection, Huntington Library, San Marino, Calif.

35. Ibid., "Otis Institute to Be Big Factor in Art Life," *Los Angeles Times*, December 29, 1918.

36. Chouinard School of Art, Inc., *Season of 1925–1926*, calendar of classes, 5. Los Angeles Art Association printed materials, box 7/8. Archives of American Art, Smithsonian Institution, Washington, D.C.

37. Robert Perine, *Chouinard: An Art Vision Betrayed* (Encinitas, Calif.: Artra Publishing, 1985), 18–19.

38. Ibid., 20.

39. Chouinard School of Art, Inc., *Season of 1925–1926*, calendar of classes, 23.

40. Perine, 52.

41. M. F. K. Fisher, "Pacific Village" (1935), in *Writing Los Angeles: A Literary Anthology*, ed. David L. Ulin (New York: Library of America, 2002), 158.

42. McWilliams, 366.

43. "A Magic Growth," *Land of Sunshine* 10, no. 1 (December 1898): 100, Department of Special Collections, California State University, Long Beach.

44. Kevin Starr, *Inventing the Dream: California through the Progressive Era* (New York: Oxford University Press, 1985), 123; "Maynard L. Dixon, and His Work, Illustrated," *Land of Sunshine* 10, no. 1 (December 1898): 4–12, Department of Special Collections, California State University, Long Beach.

45. Gordon T. McClelland and Jay T. Last, *California Watercolors 1850–1970: An Illustrated History and Biographical Dictionary* (Santa Ana, Calif.: Hillcrest Press, 2002), 104–7; Moure, *Publications in Southern California Art*, 66; Dailey, 29.

46. Dailey, 28.

47. A. H. Naftzger, "Marketing California Oranges and Lemons," *Land of Sunshine* 14, no. 3 (March 1901): 249–50; Rahno Mabel MacCurdy, *The History of the California Fruit Growers Exchange*, Los Angeles, 1925, Department of Special Collections, California State University, Long Beach.

48. For more on citrus labor and the visual promotion of the citrus industry, see Matt Garcia, *A World of Its Own: Race, Labor, and Citrus in the Making of Greater Los Angeles, 1900–1970* (Chapel Hill: University of North Carolina Press, 2001).

49. "Spanish Fiesta Today," *Los Angeles Times*, July 12, 1931; "Art Club Stages Spanish Program Sunday Afternoon," *Los Angeles Herald and Express*, July 11, 1931; "Artists and Writers Have Varied and Gay Affairs" *Santa Ana Register*, July 13, 1931; "Spanish Motif for Art Club Fête," *Hollywood Citizen-News*, July 11, 1931.

50. The role of Helen Hunt Jackson's novel *Ramona* in creating southern California's mission revival and the Spanish fantasy past, in which a violent history of imperial conquest was remembered as a picturesque time of loving Franciscan fathers and amenable Indians, has been carefully documented and its political and cultural implications critiqued. Carey McWilliams first articulated the relationship between the novel and the fabricated constructed history of southern California in his 1946 classic *Southern California: An Island on the Land*. Kevin Starr has traced this literary history further in *Inventing the Dream: California through the Progressive Era*. William Deverell argues that the Spanish fantasy past and the prominence of stereotyped Mexican cultural tropes in southern California helped relegate Mexican workers to the lowest rungs of the region's working class while ensuring that they not assimilate or integrate into the "polity, into the neighborhoods, into the city of the future" (Deverell, 10). Dydia Delyser,

in *Ramona Memories: Tourism and the Shaping of Southern California* (Minneapolis: University of Minnesota Press, 2005), has carefully examined the role of the *Ramona* myth in creating landmark tourism at the dawn of the automobile age. Delyser, a geographer, argues that Helen Hunt Jackson's regional fiction was a critical part of the construction of southern California memory and its place in a broader American popular consciousness. This theme is developed and politicized in Phoebe Kropp's *California Vieja*. Kropp argues that there was nothing benign about the deployment of the Spanish fantasy past as a tool of civic culture and memory; rather, it contributed to the marginalization of Mexican Americans and other people of color in the American West.

51. Helen Hunt Jackson, *Ramona* (1884; New York: Signet Classic [Penguin], 2002), 36.

52. Delyser, *Ramona Memories*, ix–xxiii.

53. Alma May Cook, "What Art Means to California," in *Art in California: A Survey of American Art with Special Reference to Californian Painting, Sculpture, and Architecture Past and Present Particularly as Those Arts Were Represented at the Panama-Pacific International Exposition* (San Francisco: R. L. Bernier, Publishers, 1916), 72.

54. Civic Bureau of Music and Art of Los Angeles, *Culture and the Community*, Los Angeles County, 1927, 5, Department of Special Collections, California State University, Long Beach.

55. For more on tourism and the construction of public memory in southern California, see Kropp, *California Vieja*.

56. Civic Bureau of Music and Art of Los Angeles, *Culture and the Community*, 3–4.

57. "Art Association Banquet Colorful Event," *Los Angeles Evening Express*, February 18, 1928, California Art Club scrapbook, January 1928–July 31, 1928, box 1/5, Archives of American Art, Smithsonian Institution, Washington, D.C.

58. *Historical Census Populations of California State, Counties, Places, and Towns, 1850–2000*, California State Department of Finance, Demographic Research Unit, Sacramento, Calif., 2000.

59. Charles Fletcher Lummis, quoted in Starr, *Inventing the Dream*, 89.

60. Cook, "What Art Means to California," 73.

61. Greg Hise, "Industry and Imaginative Geographies," in *Metropolis in the Making: Los Angeles in the 1920s*, ed. Tom Sitton and William Deverell (Berkeley and Los Angeles: University of California Press, 2001), 13–44.

62. Charles Mulford Robinson, *Modern Civic Art or the City Made Beautiful* (New York: G. P. Putnam's Sons, 1903); William H. Wilson, *The City Beautiful Movement* (Baltimore: Johns Hopkins University Press, 1989).

63. List of members of California Art Club, California Art Club scrapbook, January 1928–July 31, 1928, box 1/5, Archives of American Art, Smithsonian Institution, Washington, D.C.

64. Dana W. Bartlett, *The Better City: A Sociological Study of a Modern City* (Los Angeles: Neuner Company Press, 1907), 106–7.

65. Charles Mulford Robinson, "The City Beautiful," in *Report of the Municipal Art Commission for the City of Los Angeles, California* (Los Angeles: William J. Porter, 1909), Department of Special Collections, University of California, Los Angeles.

66. Municipal Art Commission, *Los Angeles Annual Report 1921–1929*, section 165, California file, no. 128811, Huntington Library, San Marino, Calif.

67. For more on Los Angeles' conflicted relationship with the City Beautiful

movement, see Greg Hise and William Deverell, *Eden by Design: The 1930 Olmsted-Bartholomew Plan for the Los Angeles Area* (Berkeley and Los Angeles: University of California Press, 2000).

68. Municipal Art Commission, *Los Angeles Annual Report 1921–1929.*

69. Ibid.; *The Los Angeles Blue Book: A Society Directory* (Los Angeles: Raymond J. Wolfsohn, 1921–29). I am grateful to Becky Nicolaides, who brought the work of Dana Leventhal to my attention. In an unpublished paper, Leventhal argues that the Municipal Art Commission was closely linked to the local Chamber of Commerce, Hollywood movie studios, and professional art organizations (Dana S. Leventhal, "Public Art and Urban Identity in 1920s Los Angeles" [unpublished seminar paper, University of California, Los Angeles, June 1991], 6).

70. *The Los Angeles Blue Book: A Society Directory* (1921), 33.

71. Municipal Art Commission, *Los Angeles Annual Report 1921–1929.*

72. *Los Angeles Examiner,* June 2, 1926.

73. *Official Report of the Games of the Xth Olympiade, Los Angeles 1932* (Los Angeles: Xth Olympiade Committee, 1933), 33, Department of Special Collections, California State University, Long Beach. For the history of the original La Fiesta de Los Angeles, see Deverell, 49–90.

74. *Official Report of the Games of the Xth Olympiade, Los Angeles 1932,* 33–36; Civic Bureau of Music and Art of Los Angeles, *Culture and the Community,* Los Angeles County, 1927, frontispiece, Department of Special Collections, California State University, Long Beach.

75. Civic Bureau of Music and Art of Los Angeles, *Culture and the Community,* frontispiece.

76. *Official Report of the Games of the Xth Olympiade, Los Angeles 1932.*

77. "Art Convention to Open Today," *Los Angeles Times,* January 2, 1925, A2.

78. Civic Bureau of Music and Art of Los Angeles, *Culture and the Community,* 13.

79. Robert Merrell Gage, *Artland* 1, no. 2 (May 1, 1926): 7, California file no. 259694, Huntington Library, San Marino, Calif.

80. Arthur Millier, "Art and Artists," *Los Angeles Times,* January 30, 1927, C16; Civic Bureau of Music and Art of Los Angeles, *Culture and the Community.*

81. Civic Bureau of Music and Art of Los Angeles, *Culture and the Community,* 18–20.

82. *Los Angeles Examiner,* May 21, 1929.

83. I have adapted the phrase "civic camouflage" from Klein, 75.

84. *Los Angeles Examiner,* May 21, 1929.

85. Arthur Millier, "Art Club Show Below Par," *Los Angeles Times,* November 16, 1930.

86. H. L. Mencken, "Sister Aimee," 1926, in Ulin, ed., 64.

87. Richard Longstreth, *The Drive-in, the Supermarket, and the Transformation of Commercial Space in Los Angeles, 1914–1941* (Cambridge, Mass.: MIT Press, 1999), 10.

88. Ibid., 57–60.

89. Bruce Henstell, *Los Angeles: An Illustrated History* (New York: Knopf, 1980), 126–27. Department of Special Collections, California State University, Long Beach.

90. Ehrhard Bahr, *Weimar on the Pacific: German Exile Culture in Los Angeles and the Crisis of Modernism* (Berkeley and Los Angeles: University of California Press, 2007), 151.

91. Longstreth, 60; Banham; and David Gebhard, with Harriette Von Breton,

Los Angeles in the Thirties, 1931–1941 (Los Angeles: Hennessey and Ingalls, 1975), also make the argument that Los Angeles' vernacular commercial architecture reflected larger trends in avant-garde modernist design.

92. Barbara Rubin, "Aesthetic Ideology and Urban Design," *Annals of the Association of American Geographers* 69, no. 3 (September 1979): 351.

93. McWilliams, 130–1; Starr, *Inventing the Dream*, 79–81.

94. Kathy Peiss, *Cheap Amusements: Working Women and Leisure in Turn-of-the-Century New York* (Philadelphia: Temple, 1986).

95. Forest Lawn promotional brochure, Glendale, Calif., 1997, form no. 1510, rev. June 1997.

96. Emory S. Bogardus, *Southern California: A Center of Culture* (Los Angeles: Caslon Printing Company, 1938), 67, Department of Special Collection, California State University, Long Beach.

97. Arthur Millier, "Mural Rows Due to Artists' Failure to Understand Job," *Los Angeles Times*, August 25, 1935, A6.

98. Bogardus, 56.

99. McWilliams, 162.

100. See McWilliams 259–62; and Kevin Starr, *Material Dreams: Southern California through the 1920s* (New York: Oxford University Press, 1990), 139–44.

101. " 'Apparition over Los Angeles'—A Work of Art," *San Francisco News*, April 19, 1932; "Artist Tells View on Picture Dispute," *Los Angeles Herald and Express*, April 19, 1932; "Clash over Art Grows," *Hollywood Citizen-News*, April 18, 1932; "Miller's Painting Goes on Exhibition," *Los Angeles Examiner*, April 13, 1932, California Art Club scrapbook, January 1932–36, box 4/5, Archives of American Art, Smithsonian Institution, Washington, D.C.

102. See Alice T. Friedman, "A House Is Not a Home: Hollyhock House as 'Art-Theater Garden,'" *Journal of the Society of Architectural Historians* 51, no. 3 (September 1992): 239–60.

103. Kathryn Smith, "Frank Lloyd Wright, Hollyhock House, and Olive Hill, 1914–1924," *Journal of the Society of Architectural Historians* 38, no. 1 (March 1979): 17.

104. Ibid., 18–19; Edmund Teske, interview by Susan Larsen, California Oral History Project, 1980, 45–46, Archives of American Art, Smithsonian Institution, Washington, D.C.

105. "Barnsdall Park Will Be One of Worlds' Fine Art Centers," *Los Angeles Express*, January 12, 1927; "Future Bright for Olive Hill," *Los Angeles Times*, November 1927, A1.

106. Letter from Aline Barnsdall to County Supervisor John Anson Ford, January 17, 1944, John Anson Ford Papers, box 42, folder BIII, file no. 10d bb (1), Huntington Library, San Marino, Calif.

107. For more on Barnsdall's plans for Olive Hill, as well as her support of progressive causes, see Friedman; and Kathryn Smith.

108. E. J. Spencer, "New Home of the California Art Club," *Los Angeles Times*, March 6, 1927, 16.

109. "Future Bright for Olive Hill."

110. Beulah Woodard, founder of the Los Angeles Negro Art Association, was the first African American to have a show at the Los Angeles County Museum. That 1937 exhibition was poorly received by the local art press, who seemed unclear about how to categorize "Afrocentric" art. This will be discussed further in the next chapter.

111. Francis William Vreeland, "City Should Acquire All of Olive Hill," *Cali-*

fornia Graphic, March 31, 1928; "Art Club Takes Over New Home," *Los Angeles Times,* September 12, 1927.

112. Norman Karasick, "Art, Politics, and Hollyhock House" (M.A. thesis, California State University, Dominguez Hills, 1982), 41.

113. "Art Gallery Site Offer May Result in Museum: Dream of Leaders for Organization Free of Politics to Be Realized If Funds Can Be Raised," *Los Angeles Times,* March 31, 1929.

114. Ibid.

115. J. J. Hassett, secretary, Board of Park Commissioners, letter to the *Los Angeles Times,* December 26, 1930, A4.

116. McWilliams, 377.

117. "Council's Plan for Park Vote Brings Protest," *Los Angeles Express,* April 3, 1931.

118. Ibid.

119. "Battle over Barnsdall Gift," *Los Angeles Express,* September 8, 1931.

120. "Park Compromise Asked," *Los Angeles Times,* July 23, 1931; "Battle over Barnsdall Gift."

121. "Land Gift Return Sought," *Los Angeles Times,* August 22, 1931, A1; "Barnsdall Park Plan Explained," *Los Angeles Times,* November 27, 1931, A8; "Return of Gift Approved," *Los Angeles Times,* October 3, 1940, A3.

122. "Oil Heiress Threatened with Sentence to Jail," *Los Angeles Times,* September 1, 1945, A1; "Aline Barnsdall, Oil Heiress, Found Dead," *Los Angeles Times,* December 19, 1946, A1; Higgins, 143.

123. Higgins, 141–46.

124. "Municipal Art Center to Open," *Los Angeles Times,* May 27, 1954, 23; Jules Langsner, "Art News from Los Angeles," *Art News,* October 1954, 56; Kenneth Ross, "Famous Landmarks: Frank Lloyd Wright Left an L.A. Legacy," *Los Angeles Times,* May 5, 1959, B4.

Chapter 2

1. Morrow Mayo, *Los Angeles* (New York: Knopf, 1933), 325.

2. For a discussion of Jake Zeitlin's relationship with the Los Angeles modernist community, see Dailey, 44–55.

3. Merle Armitage, *The Aristocracy of Art: An Address Before the California Art Club Open Forum, Los Angeles, March 4, 1929* (Los Angeles: Jake Zeitlin, 1929)

4. Starr, *Material Dreams,* 319; Dailey, 46–47; Armitage, *The Aristocracy of Art.*

5. Daniel Hurewitz, *Bohemian Los Angeles and the Making of Modern Politics* (Berkeley and Los Angeles: University of California Press, 2007).

6. The generative historical work on Siqueiros's southern California visit is Shifra M. Goldman, "Siqueiros and Three Early Murals in Los Angeles" *Art Journal* 33, no. 4 (Summer 1974): 321–27. Goldman's important study followed the rediscovery of *América Tropical* in the late 1960s and the start of efforts to restore the mural. Other significant historical inquiries into Siqueiros's short but fascinating stint in Los Angeles include Laurance P. Hurlburt, *The Mexican Muralists in the United States* (Albuquerque: University of New Mexico Press, 1989), and Desmond Rochfort, *Mexican Muralists* (San Francisco: Chronicle Books, 1993). A 1971 film by Jesus Treviño, *América Tropical,* also tells the story of Siqueiros in Los Angeles as well as showing conservators' assessments of the mural's condition.

7. Arthur Millier, "Brush Strokes," *Los Angeles Times*, April 17, 1932, B14; Millier, "Mexico's Art Ferment Stirring in Los Angeles," *Los Angeles Times*, May 22, 1932, B13. Millier, "Von Sternberg Dotes on Portraits of Himself," *Los Angeles Times*, June 19, 1932, B13; " 'Guns' Turned on Patio Wall," *Los Angeles Times*, July 3, 1932, B5; "Out of Town," *New York Times*, July 17, 1932, 28.

8. See Anthony W. Lee, *Painting on the Left: Diego Rivera, Radical Politics, and San Francisco's Public Murals* (Berkeley and Los Angeles: University of California Press, 1999), 118–20.

9. Goldman, 321–27; Hurlburt, 283, no. 29.

10. David Alfaro Siqueiros, "The Vehicles of Dialectic-Subversive Painting," 1932, folder 2–32, file no. 960094, David Alfaro Siqueiros Papers, Research Library, Getty Research Institute, Los Angeles, Calif.

11. Rochfort, 145.

12. Hurlburt, 206.

13. Agustin Aragon Leiva, "Eisenstein's Film on Mexico," *Experimental Cinema*, no. 4 (1932): 5.

14. Sergei M. Eisenstein, "The Principles of Film Form," *Experimental Cinema*, no. 4 (1932): 7–12; Morris Helprin, "Que Viva Mexico!: Eisenstein in Mexico," *Experimental Cinema*, no. 4 (1932): 13–14.

15. Hurlburt, 206; Siqueiros, "The Vehicles of Dialectic-Subversive Painting."

16. Siqueiros, "The Vehicles of Dialectic-Subversive Painting."

17. Goldman, 322; Rochfort, 145.

18. Goldman, 322.

19. Arthur Millier, "Mexico's Art Ferment Stirring in Los Angeles," B13.

20. Ibid.

21. Goldman, 322.

22. Goldman references an exhibition at the Plaza Art Center, an exhibit also referenced in the Siqueiros Papers, and mentions that the California Art Club hosted a dinner in the artist's honor.

23. Goldman, 322.

24. Millier, "Von Sternberg Dotes on Portraits of Himself," B13.

25. David Alfaro Siqueiros Papers, folder 3–20, file no. 960094, Research Library, Getty Research Institute, Los Angeles, Calif.

26. The Bloc of Mural Painters included Luis Arenal, Robert Merrell Gage, Philip Guston, Murray Hantman, Reuben Kadish, Harold Lehman, Fletcher Martin, Barse Miller, Phil Paradise, Paul Sample, Myer Schaffer, and Millard Sheets, among others.

27. Siqueiros, "The Vehicles of Dialectic-Subversive Painting."

28. Ibid.

29. David Alfaro Siqueiros Papers, folder 3–32, file no. 960094, Research Library, Getty Research Institute, Los Angeles, Calif.

30. Rochfort, 146.

31. Goldman, 323.

32. David Alfaro Siqueiros Papers, "Technical Revolution," series 2, Los Angeles, 1932, folder 3–14; and "Fresco Unveiled," folder 3–20, file no. 960094, Research Library, Getty Research Institute, Los Angeles, Calif.

33. Arthur Millier, "Huge Fresco for El Paseo," *Los Angeles Times*, August 24, 1932, 15.

34. Kropp, *California Vieja*, 240–41.

35. Millier, "Huge Fresco for El Paseo," 15.

36. David Alfaro Siqueiros Papers, "América Tropical," series 2, Los Angeles,

ca. 1932, folder 3–22, file 960094, Research Library, Getty Research Institute, Los Angeles, Calif.

37. Ibid.

38. Ibid.

39. Goldman, 324.

40. Arthur Millier, "Power Unadorned Marks Olvera Street Fresco: 'Tropical Mexico' Painting by Siqueiros Is Strong Tragic Conception of His Native Land," *Los Angeles Times*, October 16, 1932, B16.

41. David Alfaro Siqueiros, "Mi Experiencia de Hace 20 Años en Arte Publico," *Arte Publico*, February 1953, folder 2–16, file no. 960094. Research Library, Getty Research Institute, Los Angeles, Calif.

42. It remains unclear who ordered *América Tropical* whitewashed, although historical rumor suggests that Harry Chandler of the *Los Angeles Times*, anxious to put down growing, angry protests over the repatriation campaigns, and Christine Sterling, wanting to retain Olvera Street's festive atmosphere, put economic pressure on Ferenz to cover it. Laurance Hurlburt has suggested that perhaps the Los Angeles Police Department's Red Squad, known to have destroyed political paintings after Siqueiros's departure, may have had a hand in the mural's destruction as well.

43. Millier, "Power Unadorned Marks Olvera Street Fresco," B16.

44. Arthur Millier, "Mural Rows Due to Artists' Failure to Understand Job," *Los Angeles Times*, August 25, 1935, A6; Millier, "Critic Looks Back at 30 Years of Art in L.A.," *Los Angeles Times*, April 1, 1956, E6.

45. Seymour Stern, *Experimental Cinema*, ca. 1932, David Alfaro Siqueiros Papers, *Experimental Cinema*, series 2, Los Angeles ca. 1932, folder 3–22, file no. 960094. Research Library, Getty Research Institute, Los Angeles, Calif.

46. E. F. P. Coughlin, "Deportation Looms for Noted Mexican Artist on Eve of Greatest Triumph," Miscellaneous newspaper clipping, October 8, 1932, and Myer Shaffer, "Murals in Southern California," *Jewish Community Press*, September 3, 1937, 153–54, Myer Shaffer Papers. Archives of American Art, Smithsonian Institution, West Coast Regional Center, San Marino, Calif.

47. Rochfort, 147.

48. Hurlburt, 213–15.

49. Ibid.; Philip Stein, *Siqueiros: His Life and Works* (New York: International Publishers, 1994), 80–81; Harold Lehman biography, haroldlehman.com/siqueiros/html, accessed July 8, 2007.

50. See Michael Denning, *The Cultural Front: The Laboring of American Culture in the Twentieth Century* (London: Verso, 1996).

51. "Arts Festival Planned by Chamber Auxiliary," *Los Angeles Times*, November 5, 1933, 15; "Clubs Giving Art Prize Aid," *Los Angeles Times*, January 21, 1934, B4; "Art of Negroes to be Exhibited," *Los Angeles Times*, June 19, 1934, A8; "Art Fete Plans Told," *Los Angeles Times*, May 12, 1935, 29; "Three Important Events to Signalize Southland's Arts," *Los Angeles Times*, May 19, 1935, A7; "Thousands See Pageant Opening Arts Festival," *Los Angeles Times*, May 25, 1935, A1. "Registration Assures Huge Arts Festival," *Los Angeles Examiner*, March 24, 1935.

52. "Parisians See Inside of Hollywood Industry," *Los Angeles Times*, June 26, 1934, A5.

53. "County Museum Closing Protested by Art Lovers," *Los Angeles Times*, March 5, 1934.

54. "Thousands See Museum Reopening," *Los Angeles Times*, March 12, 1934.

55. "Museum to Display Art to Public," *Los Angeles Times*, March 11, 1934.

56. Letter from Howard Franklin of Standard Theaters to Walter Holsinger regarding Art Center in Hancock Park, September 5, 1935, box 42, folder BIII, file no.10d, John Anson Ford Collection, Huntington Library, San Marino, Calif.; "Art Center Proposed," *Los Angeles Times*, March 17, 1936, A2; "Art Center Plan Urged," *Los Angeles Times*, March 24, 1936, 6.

57. Later, in 1937, other Hollywood figures such producer Max Reinhardt and the actors Basil Rathbone (famous for his role as Sherlock Holmes) and Herbert Marshall campaigned in support of a civic theater and an opera house, both of which would eventually open as the Dorothy Chandler Pavilion and the Mark Taper Forum.

58. Max Factor Collection, photography collection P-239, Seaver Center for Western History Research, Natural History Museum of Los Angeles County.

59. Denning, 18–19.

60. Letter from William Preston Harrison to R. F. McClellan, Los Angeles County Board of Supervisors, January 20, 1928, Los Angeles Art Association Archives.

61. "Art Culture Group Formed," *Los Angeles Examiner*, June 6, 1933; Arthur Millier, "Dream of Los Angeles as Real Center of Arts Now Near Fulfillment, *Los Angeles Times*, June 11, 1933; "Art," *Los Angeles Saturday Night*, July 1, 1933; "W. R. Hearst Accepts Post in Art Group," *Los Angeles Examiner*, November 27, 1933; "Art Temple for Los Angeles," *Los Angeles Times*, December 10, 1933, 14; "Art Goes into Business," *Los Angeles Times*, March 3, 1934.

62. Los Angeles Art Association, *The First 80 Years: 1925–2005* (Los Angeles: LAAA, 2005), 26.

63. "$950,000 Sought for Big Art Center Here," *Los Angeles Examiner*, May 27, 1936; "County Plans Expansion of Art Centers, " *Los Angeles Examiner*, June 4, 1938.

64. Letter from Mr. V. R. Seawell, Director of the Los Angeles Office of the WPA, to John Anson Ford, Los Angeles County Board of Supervisors, December 20, 1939, box 38, John Anson Ford Collection, Huntington Library, San Marino, Calif.

65. Letter from E. C. Porter, Los Angeles Art Association, to John Anson Ford, Los Angeles County Board of Supervisors, June 4, 1937; and letter form Isaac Jones, Los Angeles Art Association, to John Anson Ford, Los Angeles County Board of Supervisors, May 26, 1938, box 38, John Anson Ford Collection, Huntington Library, San Marino, Calif. John Anson Ford later wrote that he had initially opposed using county funds to buy the Earl property, hoping that Harry Chandler would buy it himself and give it to Los Angeles as a tribute to Otis. Given the friction between the Earl and Otis families, Chandler never made the offer, and Ford relented and proposed the adopted lease-to-own plan. After three years, the county owned the Earl property outright. See John Anson Ford, *Thirty Explosive Years in Los Angeles County* (San Marino, Calif.: The Huntington Library, 1961),178.

66. Nancy Dustin Moure, "Los Angeles County Museum of Art," unpublished article, p. 23, Los Angeles County Museum of Art Library.

67. "History of Art Association's Interest in Earl Property," meeting minutes, October 1944, Los Angeles Art Association Archives.

68. Los Angeles Art Association, *The First 80 Years*.

69. Heather Becker and Peter J. Schulz, *Art for the People: The Rediscovery and Preservation of Progressive and WPA-Era Murals in the Chicago Public Schools, 1904–*

1943 (San Francisco: Chronicle Books, 2002); Bruce Bustard, *A New Deal for the Arts* (Seattle: University of Washington Press, 1997); Erika Doss, *Benton, Pollock, and the Politics of Modernism: From Regionalism to Abstract Expressionism* (Chicago: University of Chicago Press, 1991); Jonathan Harris et al., *Federal Art and National Culture: The Politics of Identity in New Deal America* (Oxford: Cambridge University Press, 1995); Anthony W. Lee, *Painting on the Left*; Karal Ann Marling, *Wall-to-Wall America: Post-Office Murals in the Great Depression* (Minneapolis: University of Minnesota Press, 2000); Marlene Park and Gerald Markowitz, *Democratic Vistas: Post Offices and Public Art in the New Deal* (Philadelphia: Temple University Press, 1984).

70. W. P. A. Federal Arts Project, "All-California Process Exhibition," Stendahl Galleries, Los Angeles, August 1937, Myer Shaffer Papers, Archives of American Art, Smithsonian Institution, West Coast Regional Center, Huntington Library, San Marino, Calif.

71. The historical murals in the Los Angeles County Hall of Records Board of Supervisors' Hearing Room had WPA murals painted all around portraying such scenes as the signing of the Magna Carta, the landing of Cabrillo, Jedediah Smith, and the Treaty of Guadeloupe-Hidalgo, all of which were historical symbols and events reinforcing Anglo history in California. See California file no. 235756, Huntington Library, San Marino, Calif.

72. Interview with Stanton Macdonald-Wright by Bettie Lochrie Hoag, Pacific Palisades, April 13, 1964, p. 1, Archives of American Art, Smithsonian Institution, Washington, D.C.

73. Ibid., 16.

74. Rochfort, 8.

75. "Artist Paints Clenched Fist Out of Mural," *Los Angeles Times*, March 16, 1938.

76. "Mural Attracts Widespread Attention Here," *Signal*, October 19, 1936, Myer Shaffer Papers, Archives of American Art, Smithsonian Institution, West Coast Regional Center. San Marino, Calif.

77. Martin Wark, "The Sanitarium Murals: Graphic Indictment of Tuberculosis Causes," *Jewish Community Press*, August 19, 1938, Myer Shaffer Papers, Archives of American Art, Smithsonian Institution, West Coast Regional Center, San Marino, Calif.; Michael Kammen, *Visual Shock: A History of Art Controversies in American Culture* (New York: Knopf, 2006), 119.

78. Martin Wark, "The Sanitarium Murals."

79. Myer Shaffer, quoted in "Artist Completes Mt. Sinai Home Fresco," *Hollywood Citizen-News*, July 16, 1937, Myer Shaffer Papers, Archives of American Art, Smithsonian Institution, West Coast Regional Center, San Marino, Calif.

80. Martin Wark, " 'Elder in Relation to Society' Noted for Clear-Cut Symbols," *Jewish Community Press*, n.d., 14, Myer Shaffer Papers, Archives of American Art, Smithsonian Institution, West Coast Regional Center, San Marino, Calif.

81. "Mt. Sinai Art Suit Asks $100,000," *Los Angeles Examiner*, March 11, 1938; "Artist Paints Clenched Fist Out of Mural," *Los Angeles Times*, March 16, 1938.

82. Myer Shaffer, "Murals in Southern California," *Jewish Community Press*, September 3, 1937, 154. Myer Shaffer Papers, Archives of American Art, Smithsonian Institution, West Coast Regional Center, San Marino, Calif.

83. Ibid.

84. For a discussion of 1930s mural controversies nationwide, see Michael Kammen, *Visual Shock: A History of Art Controversies in American Culture* (New York: Knopf, 2006), 119–48.

85. Arthur Millier, "Art Reviews Prefaced by a Letter of Protest," *Los Angeles Times*, June 1933, scrapbook no. 18, Museum of Natural History, Los Angeles County.

86. "Painting Row Brings Crowd to Exhibition," *Los Angeles Examiner*, May 25, 1933, scrapbook no. 18, Museum of Natural History, Los Angeles County.

87. "Negro Artists' Work to be Seen," *Los Angeles Times*, November 29, 1929, A2; "Exhibitions Opened at Art Center," *Los Angeles Times*, December 2, 1929, A8.

88. Arthur Millier, "Negro Art Attracts," *Los Angeles Times*, December 8, 1929, 21.

89. Ibid., 30.

90. Douglas Flamming, "*The Star of Ethiopia* and the NAACP: Pageantry, Politics, and the Los Angeles African American Community," in *Metropolis in the Making: Los Angeles in the 1920s*, ed. Tom Sitton and William Deverell (Berkeley and Los Angeles: University of California Press, 2001), 147–48; W. E. Burghardt Du Bois, "A Negro Art Renaissance," *Los Angeles Times*, June 14, 1925, 26.

91. For more on the struggles within the NAACP's Junior Branch, see Douglas Flamming, *Bound for Freedom: Black Los Angeles in Jim Crow America* (Berkeley and Los Angeles: University of California Press, 2005), 266–70.

92. Alma May Cook, "Beulah Woodard Masks Gain Attention." *Los Angeles Herald Express*, September 9, 1935, scrapbook no. 17, Museum of Natural History, Los Angeles County; Jack Austin, "Dark Laughter in American Art: A Brief Appreciation of the Negro Artists of Southern California," *Critic of Critics*, May 1931, scrapbook no. 17, Museum of Natural History, Los Angeles County; Los Angeles Negro Art Association, "First Annual Exhibition-Painting and Sculpture," Los Angeles, November 15 to 27, 1937, Anton Blazek Papers, microfilm LA 8, no. 565, Archives of American Art, Smithsonian Institution, West Coast Regional Center, Huntington Library. San Marino, Calif.

93. Beulah Woodard is an elusive, yet tenacious shadow in Los Angeles art history deserving of further investigative research. For more on this woman modernist, see Judith Wilson, "How the Invisible Woman Got Herself on the Cultural Map: Black Women Artists in California," in *Art/Women/California: Parallels and Intersections, 1950–2000*, ed. Diana Burgess Fuller and Daniela Salvioni (Berkeley and Los Angeles: University of California Press 2002), 207–10.

Chapter 3

1. See Eva Cockcroft, "Abstract Expressionism, Weapon of the Cold War," in ed. Francis Frascina, *Pollock and After: The Critical Debate*, 2nd ed. (1985; New York: Routledge, 2000), 147–54; Bradford R. Collins, "*Life* Magazine and the Abstract Expressionists, 1948–1951: A Historiographic Study of a Late Bohemian Enterprise," *Art Bulletin* (June 1991): 283–308; and Serge Guilbaut, *How New York Stole the Idea of Modern Art: Abstract Expressionism, Freedom, and the Cold War* (Chicago: University of Chicago Press, 1983).

2. "Climax Near in Art Row," *Los Angeles Evening Herald and Express*, May 24, 1947.

3. Taylor D. Littleton and Maltby Sykes, *Advancing American Art: Painting, Politics, and Cultural Confrontation at Mid-Century* (Tuscaloosa, Ala.: University of Alabama Press, 1990), 19–56.

4. Fred Orton, "Footnote One: The Idea of the Cold War," in Fred Orton

and Griselda Pollock, *Avant Garde and Partisans Reviewed* (Manchester: Manchester University Press, 1996), 207.

5. Sanka Knox, "President Links Art and Freedom," *New York Times*, October 20, 1954, 30.

6. Los Angeles' recent historiography is vigilant in its attention to the processes of racial segregation, often making the point that the relative fluidity of racial boundaries preceding World War II would be systematically replaced by calcified racial lines after the war. This hardening of the lines between neighborhoods took place as a result of the processes of suburbanization, freeway construction, the racialized nature of federally subsidized home loan projects, and the destruction of public housing. A select historiographical list includes Eric Avila, *Popular Culture in the Age of White Flight: Fear and Fantasy in Suburban Los Angeles* (Berkeley and Los Angeles: University of California Press, 2004); George Lipsitz, *The Possessive Investment in Whiteness: How White People Profit from Identity Politics* (Philadelphia: Temple University Press, 1998); Becky M. Nicolaides, *My Blue Heaven: Life and Politics in the Working-Class Suburbs of Los Angeles, 1920–1965* (Chicago: University of Chicago Press, 2002); Parson; Raphael J. Sonenshein, *Politics in Black and White: Race and Power in Los Angeles* (Princeton, N.J.: Princeton University Press, 1993); and Josh A. Sides, *L.A. City Limits: African Americans in Los Angeles from the Great Depression to the Present* (Berkeley and Los Angeles: University of California Press, 2004).

7. Richard Cándida Smith, *Utopia and Dissent*, 80–85.

8. Important Los Angeles artists who attended art school on GI Bill subsidies include Lee Mullican, Nathan Oliveira, Robert Irwin, John Outterbridge, and Noah Purifoy, among many others. See Richard Cándida Smith, *Utopia and Dissent*, 80–85.

9. Richard Cándida Smith, *Utopia and Dissent*, 82.

10. "Veterans Picket School of Art," *Los Angeles Times*, May 17, 1946, California Art Club scrapbook, box 3/5, Archives of American Art, Smithsonian Institution, Washington D.C.

11. "Defense Art Classes Ready," *Hollywood Citizen-News*, January 10, 1942, Perret File, Archives of American Art, Smithsonian Institution, West Coast Regional Center, Huntington Library, San Marino, Calif.

12. The county museum was the Otis Art Institute's directing body until 1947, when the Otis Art Institute separated institutionally from it. At that time Otis was placed under a separate county department, with its own advisory council, and renamed the Los Angeles County Art Institute, Los Angeles County Art Institute pamphlet, 1956, box 38, folder B III of the John Anson Ford Papers, Huntington Library, San Marino, Calif.

13. Letter from A. H. Campion, acting chief administrative officer of the Board of Governors, County Museum of History, Science, and Art, to Otis Art Institute, March 28, 1945, box 38, music and art folder, John Anson Ford Papers, Huntington Library, San Marino, Calif.

14. Letter from Edwin Roscoe Shrader, dean of the Otis Art Institute, to the Board of Governors, County Museum of History, Science, and Art, 1945, box 38, music and art folder, John Anson Ford Papers, Huntington Library, San Marino, Calif.

15. "Supervisors Advise against Change at Otis Art Institute," *Los Angeles Times*, May 23, 1945.

16. "Museum Ends Club Exhibitions: Decision Close Contentions of L.A. Art Groups," *Los Angeles Evening Herald and Express*, June 13, 1945.

17. Arthur Millier, "Double-Barreled Battle Rages over Art Institute," *Los Angeles Times,* June 17, 1945.

18. Ibid.

19. "Winner Selected at Exhibit of Southland Artists' Work," *Los Angeles Times,* January 16, 1943, A1.

20. "Prizewinning GI Art," *Los Angeles Times,* August 3, 1946; "Art of GIs Has Quality and Virility," *Los Angeles Times,* August 11, 1946; Kay English, "GI Artists Open First Exhibition," *Los Angeles Examiner,* August 11, 1945.

21. Kammen, 107.

22. James B. Byrnes, curator of contemporary art, *1948 Annual Exhibition Artists of Los Angeles and Vicinity Catalog,* County Museum of History, Science, and Art, University of California, Santa Barbara Arts Library.

23. "Municipal Art Center Plan under Study: Barnsdall Park Site Proposed for City Establishment," *Hollywood Citizen-News,* September 30, 1941.

24. "Prizes Awarded Top Artists in Big Exhibition," *Wilshire Citizen,* May 16, 1947.

25. "Artist Picket Hits Show at Exposition Park," *Hollywood Citizen-News,* May 21, 1947; "Museum Art Show Blasted as Subversive," *Los Angeles Times,* May 21, 1947; "Museum Show Blasted as Communistic: Art Club Hits L.A. Exhibit as 'Subversive,'" *Hollywood Citizen-News,* May 21, 1947; California Art Club *Art Bulletin* (May 1947).

26. "Museum Art Show Blasted as Subversive."

27. "Art Battle: Conservative Los Angeles Painters Protest 'Radicals' Hung in Museum," *Life,* May 28, 1947, 40.

28. Ibid.

29. Vincent Price, quoted in "Art Tempest Brings Shift," *Los Angeles Times,* May 28, 1947.

30. "Airs Art Charges," *Los Angeles Evening Herald and Express,* May 27, 1947.

31. Soja, 196–97; Roger Keil, *Los Angeles: Globalization, Urbanization, and Social Struggle* (New York: John Wiley, 1998).

32. "Fight Ban in Vet Housing," *California Eagle,* September 1950, microfilm reel 37, Southern California Library for Social Research, Los Angeles.

33. The "death" of convenient public transit in Los Angeles has a history predating the postwar freeways. From early 1901 to the 1930s Henry Huntington's Pacific Electric Railway Company (later the Southern Pacific Railroad when Huntington sold the company in 1910) ran electric railway cars ("Red Cars") throughout the city. This transformation was cheap and relatively fast (forty to fifty miles an hour), and Angelenos could travel one thousand miles of track. The railroad went into decline in the late 1930s because of the popularity of the private automobile and because the automobile and freeway lobby (made up of General Motors, Standard Oil, Firestone Tire, Phillips Petroleum, and Mack Truck Manufacturing) fought subsidized public transit. These companies bought up and dismantled railroad lines in Los Angeles and in other cities. With Huntington's Red Cars dismantled, and post World War II prosperity making automobiles and suburban life accessible to more people than ever before, the new freeway system of the 1950s sounded the death knell for public transit in Los Angeles. See Scott L. Bottles, *Los Angeles and the Automobile: The Making of the Modern City* (Berkeley and Los Angeles: University of California Press, 1987); and Kenneth T. Jackson, *Crabgrass Frontier: The Suburbanization of the United States* (New York: Oxford University Press, 1987).

34. For the contribution of freeways to the construction of whiteness and segregation in Los Angeles, see Avila.

35. The "loyalty" investigation was hotly contested by leftist groups such as the Los Angeles Communist Party, as well as moderate organizations such as the American Veterans' Committee, who argued against the tests on the grounds that serving in World War II should more adequately establish one's loyalty to the United States. See *Communist Party Resolution on Loyalty Checks of County Employees* and letter of protest by American Veterans' Committee to the Los Angeles County Board of Supervisors, September 25, 1947, box 46, folder BIII, (d) (15), John Anson Ford Papers, Huntington Library, San Marino, Calif.

36. The Hollywood Ten were Alvah Bessie, Herbert Biberman, Lester Cole, Edward Dmytrk, Ring Lardner, Jr., John Howard Lawson, Albert Maltz, Samuel Ornitz, Adrian Scott, and Dalton Trumbo. See House Un-American Activities Committee, *Hearings Regarding Communist Infiltration of the Hollywood Motion-Picture Industry,* Eightieth Congress, first session, October 27, 28, 30 1947.

37. For an excellent discussion of Los Angeles' postwar housing crisis, see Parson, 76–102.

38. Ibid., 108.

39. "The Show Parade: Midget Notations of Current Happenings," ca. November 1937, Perret File, microfilm 3875, no. 951, Archives of American Art, Smithsonian Institution, West Coast Regional Center, Huntington Library, San Marino, Calif.

40. "Adult Civic Chorus Program Activities for Fall Announced," and "Band Concert in Exposition Park Sunday," *California Eagle,* August 18, 1950; "Co-op Art Club" *California Eagle,* September 14, 1950, microfilm Reel no. 37, Southern California Library for Social Research, Los Angeles.

41. "Mexican Culture Night Offered at Soto Center," *California Eagle,* September 14, 1950, microfilm reel no. 37, Southern California Library for Social Research, Los Angeles.

42. Other ethnic community papers also covered civic art activities in Los Angeles. In the 1930s, as documented in the previous chapter, the *Jewish Community Press* promoted civic art through coverage of mural production and other art activities. In 1951 the Japanese American paper *Rafu Shimpo* reported that the Municipal Art Gallery in City Hall was showing 119 paintings by Japanese and American schoolchildren as part of an international goodwill art exchange program between Japan and the United States (*Rafu Shimpo,* January 1951, box 92, Fletcher Bowron Papers, Huntington Library, San Marino, Calif.). The *California Eagle* covered civic art activities taking place throughout Los Angeles, including general municipal art events and art activities geared specifically toward African American, Mexican American, and other ethnic communities more thoroughly than other papers I have seen.

43. "NAACP Protests County Civic Center at Lakewood," *California Eagle,* October 19, 1950, microfilm reel no. 37, Southern California Library for Social Research, Los Angeles.

44. Parson, 76.

45. "Petition Mayor for Housing: Bowron to Be Asked to Proclaim Policy," *Communist Party Record,* September 4, 1943, box 46, folder BIII, file no. II d (10), John Anson Ford Papers, Huntington Library, San Marino, Calif.

46. Ibid.

47. Ibid.

48. Perhaps much to the annoyance of the municipal and county governments, in 1944 Aline Barnsdall offered her property (now free of the California Art Club) to returning GIs in need of housing. In a letter to John Anson Ford,

Barnsdall wrote that the Frank Lloyd Wright house in Barnsdall Park "would be ideal as a home for the rehabilitation of discharged soldiers. This house is controlled by the Park Department and the City of Los Angeles and was restricted to uses of art but I who made these restrictions cannot see that they would be in any way broken if used by discharged soldiers . . . I offer this as a suggestion so that these houses may not be wasted at this critical time." Letter from Aline Barnsdall to John Anson Ford, January 17, 1944, box 42, folder BIII, file no. 10 d bb (I), John Anson Ford Papers, Huntington Library, San Marino, Calif.

49. Norman Stanley, *No Little Plan: The Story of the Los Angeles Chamber of Commerce*, 1956, California file no. 359116, Huntington Library, San Marino, Calif.

50. For the full story of the red-baiting and undermining of the 1949 Housing Act and the public housing program in Los Angeles, see Parson, 103–35.

51. For the social effects of the Red Scare and the end of public housing in Los Angeles, see ibid., 187–200.

52. See Davis and Klein for critical accounts of the Bunker Hill development, 1948–63.

53. "City Takes New Approach to Art," *Los Angeles Times*, April 23, 1951.

54. Kenneth Ross, "Large Art Center City's Greatest Lack: Cultural Facilities Drop behind Needs of Growing Population," *Los Angeles Times*, August 23, 1953, 8.

55. Sandra Rivken, interview by the author, February 20, 2001, Public Relations Office, Cultural Affairs Department, Los Angeles.

56. These art clubs occupied an important space in Los Angeles' civic culture from the 1890s until World War II. They primarily served as social circles for the city's elite and as centers for booster efforts to sell Los Angeles to white bourgeois Americans. The civic function of the art clubs was to organize fund-raising efforts to build cultural centers such as art museums and opera houses in order to increase Los Angeles' cosmopolitan appeal. Some of the most active clubs included the Friday Morning Club of Los Angeles (1891), the Painters Club of Los Angeles (1906), the California Art Club (1909), the Painters and Sculptors Club (1923), and Artland (1925).

57. Ibid.

58. "Outdoor Art Shows Chairmen Appointed," *California Eagle*, September 14, 1950; "South Park Art Festival Success," *California Eagle*, October 19, 1950, microfilm reel no. 37, Southern California Library for Social Research, Los Angeles.

59. The economic conditions of the 1930s forced Los Angeles' civic culture to grow and absorb modernist art trends and socialist muralism because of the infusion of Federal Arts Project funds into California. The art clubs found that fund-raising was limited because of a lack of economic resources and that any success in building an art center of any repute would depend on a cooperative effort between local government and Hollywood. This combination of changes in both cultural power and civic art forms weakened the art clubs' political clout.

60. "Art Temple for Los Angeles," *Los Angeles Times*, December 10, 1933, 14.

61. *Who's Who in American Art*, 1976, Huntington Library, San Marino, Calif.

62. Vincent Price, interviewed by Paul J. Karlstrom, August 1992, Oral History Transcript, p. 34, Archives of American Art, Smithsonian Institution, West Coast Regional Center, Huntington Library, San Marino, Calif.; Derrick R. Cartwright, "Appendix: A Chronology of Institutions, Events, and Individuals," in *On the Edge of America*, ed. Karlstrom, 285; *Los Angeles Daily News*, January 20, 1951, 3.

63. Letter from the Painters and Sculptors Club of to the city council, October 7, 1949, Los Angeles City Council file no. 39915, Los Angeles City Archives.

64. Letter from the California Art Club to the city council, October 4, 1949, Los Angeles City Council file no. 39915, Los Angeles City Archives.

65. Kenneth Ross, "Wanted—A Patron," *Pasadena Star-News,* October 28, 1944.

66. National Art Week Program, radio broadcast by Research Art Library Sponsoring Committee of the Academy of Public Affairs, Station K.M.T.R., November 17, 1941, Perret File, Archives of American Art, Smithsonian Institution, West Coast Regional Center, Huntington Library, San Marino, Calif.; "3000 Artists to Be Shown," *Los Angeles Examiner,* September 8, 1941; "Artists' Week to Stimulate Appreciation," *Los Angeles Examiner,* October 5, 1941; "Art Week Annually Urged by Roosevelt, " *Los Angeles Times,* November 30, 1941.

67. "Dollar-Down Art to Be Shown Here This Week," *Los Angeles Daily News,* November 17, 1941; "Artists Show How It's Done," *Los Angeles Evening Herald and Express,* November 18, 1941; "Committee to Aid Local Artists," *Los Angeles Examiner,* October 25, 1941.

68. "Art Week Annually Urged by Roosevelt."

69. Arthur Millier, "Los Angeles Events," *Art Digest,* January 1, 1950.

70. See Los Angeles City Council file no. 50460, Los Angeles City Archives.

71. "Reactions of Viewers at Art Show," *Los Angeles Times,* October 22, 1951.

72. Arthur Millier, "Reaction and Censorship in Los Angeles," *Art Digest,* November 15, 1951, 9.

73. Building and Safety Committee Report, November 5, 1951, Los Angeles City Council file no. 50460, Los Angeles City Archives.

74. "Red Influence Charge Spurs Council Study of Art Exhibit," *Los Angeles Times,* October 24, 1951, 1.

75. Building and Safety Committee Report, November 5, 1951, Los Angeles City Council file no. 50460, Los Angeles City Archives.

76. Public Hearings Proceedings, October 24, 1951, Los Angeles City Council file no. 50460, Los Angeles City Archives.

77. Ibid.

78. Ibid.

79. Millier, "Reaction and Censorship in Los Angeles."

80. Ibid.

81. Ibid.

82. Public Hearings Proceedings, October 24, 1951, Los Angeles City Council file no. 50460, Los Angeles City Archives.

83. Letter to the Los Angeles City Council from Byron Reynolds, South Hope Street, Los Angeles, filed October 27, 1951, Los Angeles City Council file no. 50460, Los Angeles City Archives.

84. Letter to the Los Angeles City Council from Gertrude Mallory, filed November 7, 1951, Los Angeles City Council file no. 50460, Los Angeles City Archives.

85. Letters from Thomas B. Owen and H. B. printed in "Art Show Row Warms Up," *Los Angeles Times,* October 29, 1951.

86. Letter to the Los Angeles City Council from A. S. Harvey, Chester, Montana, November 7, 1951, Los Angeles City Council file no. 50460, Los Angeles City Archives.

87. "Sculpture Used to Protest Red Influence on Art," *Los Angeles Times,* October 26, 1951, 1.

88. "Art Exhibit at Griffith Park" hearings transcript, October 31, 1951, Los Angeles City Council file no. 50460, Los Angeles City Archives.

89. "Greek Theater Paper," October 31, 1951, Los Angeles City Council file no. 50460, Los Angeles City Archives.

90. Building and Safety Committee Report, November 5, 1951, submitted to the city council on November 6, 1951, Los Angeles City Council file no. 50460, Los Angeles City Archives.

91. Ibid.

92. Letter to Councilman J. Win Austin from Mrs. Richard Hawes, November 12, 1951, Los Angeles City Council file no. 50460, Los Angeles City Archives.

93. Letter to the city council from Joe Waano-Gano, November 16, 1951, Los Angeles City Council file no. 50460, Los Angeles City Archives.

94. Transcript of council proceedings, November 6, 1951, Los Angeles City Council file no. 50460, Los Angeles City Archives.

95. Letter from Walter D. Calkins to the city council, December 9, 1951; letter from Mrs. Richard Hawes to Councilman J. Win Austin, November 12, 1951; letter from Theodore A. Heinrich to the city council, November 7, 1951. Los Angeles City Council file no. 50460, Los Angeles City Archives.

96. Letter to the Los Angeles City Council from James N. Hastings, James Real, and William Tara of the Art Directors Club of Los Angeles, West Fifth Street, filed December 24, 1951, Los Angeles City Council file no. 50460, Los Angeles City Archives.

97. Letter to the Los Angeles City Council from the Screen Cartoonists Guild, filed January 8, 1952, Los Angeles City Council file no. 50460, Los Angeles City Archives.

98. "Harby Balks at Petitions," *Los Angeles Daily News*, January 15, 1952; motion by Ernest Debs and Edward Roybal, adopted January 15, 1952, Los Angeles City Council file no. 50460, Los Angeles City Archives.

99. Motion by Ernest Debs and Edward Roybal, adopted January 15, 1952,

100. "Housing Row Echo Heard in Art Talk: City Councilmen's Ill Humor Bounces Back in Near Revival of Fracas over Paintings," *Los Angeles Times*, January 15, 1952.

101. Art Commission Proposal for 1952–53 Fiscal Year, submitted by Kenneth Ross to the Building and Safety Committee, April 15, 1952, Los Angeles City Council file no. 50460, Los Angeles City Archives.

102. Harby's continuing animosity toward Ross may have been provoked, at least in part, by Harby's failed attempt to have Edmund Kohn's 1953 surrealist painting *Bird on the Moon* banned from the Municipal Art Gallery in City Hall. A gift to the city by the philanthropist Howard Ahmanson, the painting was fiercely defended by Ross. Throughout the 1951 hearings, and even the 1949 efforts to block his appointment to the Municipal Arts Department, Kenneth Ross rarely responded directly to his accusers, preferring to let them undermine themselves in the press and in the court of public opinion. When Harby attacked Kohn's painting, Ross wrote the city council a scathing letter asking that the councilmen cease "to express themselves in fields in which they have no qualifications." See letter to the city council from Kenneth Ross, Municipal Arts Department, December 30, 1953, Los Angeles City Council file no. 61479, Los Angeles City Archives.

103. Letter to the city council from Kenneth Ross, Municipal Arts Department, December 30, 1953.

104. Letter to the city council from Kenneth Ross, August 10, 1954 and letter to the Municipal Art Commission from the city clerk, September 1, 1955, Los Angeles City Council file no. 64886, Los Angeles City Archives.

105. Letter to the Municipal Art Commission from the city clerk, June 24, 1957, Los Angeles City Council file no. 79872, Los Angeles City Archives.

106. "Art Row of '51 Recalled," *Los Angeles Examiner,* July 25, 1954.

107. "City Art Chief Denies Board OK'd Statue," *Los Angeles Examiner,* July 26, 1954.

108. "Statue Issue Stirs Council," *Los Angeles Examiner,* July 27, 1954; "Ex-Commissioner Contradicted," *Los Angeles Examiner,* July 29, 1954.

109. "Ex-Commissioner Contradicted."

110. "City Art Chief Denies Board OK'd Statue."

111. "Disputed Status OK: Council Lacks Power to Cancel Pact," *Los Angeles Examiner,* August 27, 1954.

112. Letter to the city council from June C. Wayne, filed August 16, 1954, Los Angeles City Council file no. 64746, Los Angeles City Archives.

113. Telegram to the city council from Irving Stone, Beverly Hills, n.d., Los Angeles City Council file no. 64746, Los Angeles City Archives.

114. Letter to the city council from Richard F. Cassady, filed July 30, 1954, Los Angeles City Council file no. 64746, Los Angeles City Archives.

115. Letters to the city council from E. Nealund, the Highland Park Art Guild, the Women's Club of Hollywood, and F. A. Lydy, no dates, Los Angeles City Council file no. 64746, Los Angeles City Archives.

116. *Los Angeles Examiner,* January 21, 1955.

117. For more on the relationship between family, domesticity, and cold war ideology, see Elaine Tyler May, *Homeward Bound: American Families in the Cold War Era* (New York: Basic Books, 1988).

118. *New York Times,* March 21, 1955.

119. "Statue Issue Stirs Council."

120. Arthur Millier, "Critic Looks Back on 30 Years of Art in L.A.: Colony Now the Second Largest in the U.S," *Los Angeles Times,* April 1, 1956.

Chapter 4

1. *Art in America* (April 1963): 127; *Art News* (March 1965): 29–61; *Vogue,* November 1, 1967, 184–233; *Time,* August 30, 1968, 38; *New York Times,* May 29, 1969.

2. John Coplans, "Art Blooms," *Vogue,* November 1, 1967, 184–233.

3. Ibid., 186.

4. Michael Duncan, "Landscape Seen and Thought," *Art in America,* April 2005. In the opening paragraph of his piece on Helen Lundeberg, Duncan wrote, "Los Angeles at last seems to be acknowledging that its art history did not begin with the Ferus Gallery, Ed Kienholz, and Ed Ruscha."

5. "Place in the Sun," *Time,* August 30, 1968, 38.

6. "Assemblage" refers to artwork constructed of a variety of detritus and found objects built into something new. "Assemblage" can mean a collage of different textures of paper; paintings containing nonart materials such as string, broken glass, or ashes; or freestanding sculptures incorporating consumer products from everyday life. Assemblage startles viewers by reminding us of the passage of time and the way we reference ephemera and commercial items to mark its passing. In so many assemblage pieces, particularly those created in the United States, one is often amused to see "old" 7 Up bottles, outdated calendars, defunct newspapers, or familiar brand names on unfamiliar packaging.

7. Jules Langsner, "Art News from Los Angeles," *Art News* (October 1958): 44.

8. Jules Langsner, "Art News from Los Angeles," *Art News* (October 1954): 56; Jules Langsner, "Art News from Los Angeles," *Art News* (Summer 1952): 85.

9. Herman Cherry, "Los Angeles Revisited," *Arts* (March 1956): 18.

10. The main schools included Otis, Chouinard, Jepson, and the Pasadena Art Center.

11. June Wayne, interview by Paul Cummings, August 4, 1970, 27, Archives of American Art, Smithsonian Institution, Washington, D.C.

12. Ibid., 28.

13. Richard Cándida Smith, *Utopia and Dissent*, 80.

14. Santa Monica Art Gallery Records, 1953–65, box 1/1, Archives of American Art, Smithsonian Institution, Washington, D.C. Los Angeles Art Association exhibition inventories show photographs of handsome young men, many pictured in their uniforms. Captions include art education, much of it local, and dates and places of army and navy service. Of thirty-six featured artists in a Santa Monica show, only four were women, which exemplifies the masculine nature of the local arts community, a feature exaggerated in the Ferus and Venice art circles.

15. Helen Wurdemann, "Los Angeles: A Stroll on La Cienega," *Art in America* (October–November 1965): 115–18; "The Art Walk Is on Again on La Cienega," *Sunset* (May 1977): 64–65, Los Angeles Art Association Archives.

16. Los Angeles Art Association scrapbook, 1960, box 5/8, Archives of American Art, Smithsonian Institution, Washington, D.C.

17. Plagens, *Sunshine Muse*, 117.

18. Edward Kienholz, interview by Lawrence Weschler, "Los Angeles Art Community: Group Portrait," Oral History Project, University of California, Los Angeles, 1977, xiii–xv.

19. Ibid., 79.

20. Ibid., 87; Jules Langsner, "Los Angeles," *Art News* (April 1958): 49.

21. Kienholz, 87.

22. Edward Ruscha, interview, October 29, 1980, 19, California Oral History Project, Archives of American Art, Smithsonian Institution, Washington D.C.

23. Ibid., 20.

24. Craig Kauffman, "Art in America," oral history interview with Jan Butterfield. Kauffman Papers, box 3/6, Archives of American Art, Smithsonian Institution, Washington, D.C.

25. Peter Plagens, "Art in Los Angeles: Seventeen Artists in the Sixties," *Art Journal* 41, no. 4 (Winter 1981): 375.

26. Kauffman, "Art in America."

27. "A Painting Surfboarder," *Life*, October 19, 1962. For more on the relationship between California beach culture and the arts see the Laguna Art Museum's catalog *Surf Culture: The Art History of Surfing* (Laguna Beach, Calif.: Gingko Press, 2002).

28. Andrew Perchuk, "Billy Al Bengston," *Artforum* (January 2001).

29. John Arthur Maynard, *Venice West: The Beat Generation in Southern California* (New Brunswick: Rutgers University Press, 1991).

30. Lawrence Lipton, *The Holy Barbarians* (New York: Julian Messner, Inc., 1959), preface.

31. Patrick McNulty, "Beatniks and Venice Square off in Fight," *Los Angeles Times*, August 3, 1959.

32. Ibid.

33. Frank Laro, "Tourists Make Beatniks Flee Coffeehouses," *Los Angeles Times*, June 2, 1959.

34. *Los Angeles Mirror News*, June 2, 1959.

35. "Judge Hears Beat Café Suit," *Los Angeles Examiner*, December 17, 1959.

36. Ibid.

37. "All-Night Coffeehouses to Pay Entertainment Tax," *Los Angeles Examiner*, January 28, 1959; McNulty; "Police Oppose Permit: Beatnik Hearing Becomes Fuzzy," *Los Angeles Examiner*, September 2, 1959; "Gas House Defended," *Los Angeles Examiner*, September 3, 1959; "Beatniks 'Cut Out' of Hearings: Police Examiner Biased, They Say," *Los Angeles Examiner*, September 9, 1959; "Square-ville Heatnik Scorches Beatniks," *Los Angeles Examiner*, October 28, 1959; "Judge Hears 'Beat' Café Suit."

38. "Spy Can't Wash," *Los Angeles Examiner*, January 25, 1960; "Beatnik Dicks," *Los Angeles Examiner*, November 18, 1959; " 'Beatnik' Police Nab 85 in New York Dope Raids," *New York Times*, November 9, 1959.

39. Laro.

40. Leon Charles, *How to Spot a Communist, or "Psychological Warfare": A True Story of the Communist Plot to Destroy America; Will You Help?* (Hollywood: Trojan Press, 1951).

41. "Beats Want to Be Pals, Dig It?," *Los Angeles Examiner*, August 29, 1959.

42. Ted Thackery, Jr., "Gas House Hearing a 'Drag, Man,' " *Los Angeles Examiner*, August 28, 1959.

43. "Gas House Hearing: Beatniks Described as New Religion," *Los Angeles Evening Herald Express*, September 3, 1959; "Gas House Defended," *Los Angeles Examiner*, September 3, 1959; Thackery.

44. "Beatniks Lose New Round on Gas House," *Los Angeles Examiner*, December 22, 1959.

45. "Gas House Real Gone in Venice," *Los Angeles Examiner*, April 1, 1960; "Gas House Operator Guilty—No License," *Los Angeles Examiner*, February 16, 1961; Serge Guilbaut, "The Bingo-Bongo Art Scene," *Journal of the Los Angeles Institute of Contemporary Art* 5 (April-May 1975): 22–27.

46. Maynard, 166–68.

47. "Squaresville, U.S.A. vs. Beatsville," *Life* (September 1959).

48. Calvin Tompkins, "A Touch for the Now," *New Yorker*, July 29, 1991, 35–37; Walter Hopps interview, UCLA Oral History Program, 1990, UCLA Department of Special Collections.

49. Henry Hopkins, interview, October 24, December 3 and 7, 1980, 20, California Oral History Project, Archives of American Art, Smithsonian Institution, Washington, D.C.

50. Diana Burgess Fuller and Daniela Salvioni, eds., *Art/Women/California: Parallels and Intersections, 1950–2000* (Berkeley and Los Angeles: University of California Press, 2002), 242.

51. Betty Turnbull, *The Last Time I Saw Ferus* (Newport Beach, Calif.: Newport Harbor Art Museum, 1976), 3

52. Announcement of the ACTION I exhibit, reprinted in ibid., 7.

53. Hans-Ulrich Obrist, "Walter Hopps Hopps Hopps-Art Curator," *Artforum* 34 (February 1996).

54. Letter to the Municipal Finance Committee from the mayor's office, June 24, 1957, Los Angeles City Council file no. 79872, Los Angeles City Archives.

55. Letter to the Municipal Arts Department from Sherman Sternberg, financial analyst for the city council, June 17, 1957, Los Angeles City Council file no. 79872, Los Angeles City Archives.

56. Kienholz, 93–94.

57. Ibid.

58. Letter to the Municipal Arts Department from Sherman Sternberg, June 17, 1957.

59. Jules Langsner, "Local Avant-Garde," *Art News* (November 1956): 63.

60. Ibid.

61. Kienholz, 95.

62. Los Angeles owed its new success as an art center to postwar prosperity. With more private money, and therefore more private collectors, there was a ready-made market for art. The sociologist Diana Crane's study of the avant-garde and contemporary art market in New York City reveals that the American art market as a whole underwent an enormous expansion after 1940. By studying the *American Art Directory, Arts Yearbook*, and other regularly published guides to American art collections and galleries, Crane found that art museums, corporate collections, commercial galleries, and community art centers throughout the United States multiplied between four and five times in the thirty years following the war, with the first significant gains occurring in the 1950s. See Diana Crane, *The Transformation of the Avant-Garde: The New York Art World, 1940–1965* (Chicago: University of Chicago Press, 1987).

63. Before the gallery explosion on La Cienega in the 1950s, there were several important art galleries in Los Angeles. These opened in the 1920s and 1930s, with the Earl Stendahl gallery opening as early as 1915. Among these early Los Angeles galleries were the Dalzell Hatfield Gallery, specializing in the European impressionists and postimpressionists; the Alexander Cowie Gallery, which focused on American Western painters such as Charles Russell and Frederic Remington; and the Stendahl Gallery, which specialized in pre-Columbian and East Asian art. See Arthur Millier, "Three Views of La Cienega," *Los Angeles Magazine* (July 1966): 31–33; Janice Lovoos, "Galleries in Los Angeles," *Studio International* (December 1963): 260–62; Gerald Nordland, "City's Amazing Art Expansion Evident in Tour of Galleries," *Los Angeles Mirror*, December 5, 1960; Henry J. Seldis, "L.A. Becomes Hub for Art: City West's Most Active Market; La Cienega Is 'Gallery Row,'" *Los Angeles Times*, February 8, 1959, 12.

64. Millier, "Three Views of La Cienega;" Lovoos; Nordland; Seldis.

65. Peter Selz, "Los Angeles," *Arts* (February 1958): 20–21; Seldis; Nordland; Alfred Frankfurter, "Los Angeles: The New Museum," *Art News* (March 1965): 30–63; John Coplans, "Los Angeles: The Scene," *Art News* (March 1965): 29–61; Grace Glueck, "Los Angeles Regains Vigor as an Art Center," *New York Times*, May 29, 1969.

66. Plagens, *Sunshine Muse*, 28.

67. Kienholz, 287.

68. Jules Langsner, "America's Second Art City," *Art in America* (April 1963): 127.

69. Jules Langsner, "Art News from Los Angeles," *Art News* (May 1955): 10.

70. Lovoos, 260.

71. Walter Hopps, interview, October 4, 1975, in Turnbull.

72. For a thorough discussion of Berman's use of Verifax reprographic technology and Hebrew lettering, see Richard Cándida Smith, *Utopia and Dissent*, 283–94. For further interpretations of Jewish influences in Berman's work, see Stephen Fredman, "Surrealism Meets Kabbalah: Wallace Berman and the Semina Poets," in *Semina Culture: Wallace Berman and His Circle*, ed. Michael Duncan and Kristine McKenna (Santa Monica, Calif.: Santa Monica Museum of Art, 2005), 40–48.

73. Richard Cándida Smith, *Utopia and Dissent,* 215–16.

74. For a comprehensive discussion of *Semina* and the artists involved in its production, see Duncan and McKenna, *Semina Culture.*

75. Rebecca Solnit, *Secret Exhibition: Six California Artists of the Cold War Era* (San Francisco, Calif.: City Lights Books, 1991), 22.

76. Richard Cándida Smith, *Utopia and Dissent,* 226.

77. Ibid., 227; Solnit, 23; Turnbull, 7.

78. Kienholz, 148–50.

79. Ibid.

80. Charles Brittin, discussion panel at the Getty Research Institute, November 18, 2003, author's notes.

81. Craig Krull, *Photographing the L.A. Art Scene: 1955–1975* (Santa Monica, Calif.: Smart Art Press, 1996).

82. George B. Leonard, "The Bored, the Bearded, and the Beat," *Look,* August 19, 1958, 64–68.

83. Duncan and McKenna, *Semina Culture.*

84. Turnbull.

85. Thomas Crow, *The Rise of the Sixties: American and European Art in the Era of Dissent* (New York: Harry N. Abrams, Inc., 1996).

86. Irving Blum, oral history interview by Paul Cummings, 1977, Archives of American Art, Smithsonian Institution, Washington, D.C.

87. Kienholz, 99, 122–23.

88. Irving Blum, quoted in Laura de Coppert and Alan Jones, *The Art Dealers* (New York: Clarkson N. Potter, Inc., 1984), 151.

89. Tompkins, 44.

90. Kienholz, 199.

91. Andy Warhol and Pat Hackett, *Popism: The Warhol Sixties* (San Diego and New York: Harcourt Brace and Co., 1980), 45.

92. Krull, 14–15.

93. David E. James, "Artists as Filmmakers in Los Angeles," *October* 112 (Spring 2005): 119.

94. Henry Hopkins, in Krull, 34, Henry Hopkins interview, California Oral History Project, 1980, 25, Archives of American Art, Smithsonian Institution, Washington, D.C.

95. Hopkins, in Krull, 34.

96. Phil Leider, quoted in Amy Newman, *Challenging Art: Artforum 1962–1974* (New York: Soho Press, 2000), 119.

97. Caroline A. Jones, *Machine in the Studio: Constructing the Postwar American Artist* (Chicago and London: University of Chicago Press, 1996).

98. Matsumi Kanemitsu, interview with Marjorie Rogers, Oral History Program, University of California, Los Angeles, 1977.

99. John Baldessari, quoted in Amy Newman, 118.

100. Irving Blum, "At the Ferus Gallery," interview with Lawrence Weschler and Joann Phillips, Oral History Program, University of California, Los Angeles, 1984, 93.

101. Letter from Warren M. Dorn, supervisor, Fifth District, to Edward W. Carter, president, Board of Governors, Los Angeles County Museum of Art, March 17, 1966, Jan Butterfield scrapbook, Archives of American Art, Smithsonian Institution, West Coast Regional Center, Huntington Library, San Marino, Calif.

102. City council resolution presented by Councilmen John S. Gibson and

Louis R. Nowell, March 29, 1966, Los Angeles City Council file no. 129016, Los Angeles City Archives.

103. Harry Timborn, "Art Show to Open with Heavy Guard," *Los Angeles Times,* March 30, 1966, 3.

104. Ibid.

105. Kienholz, 298.

106. Blum, "At the Ferus," 143.

107. For more on Judy Chicago and the sexism of the Los Angeles scene in the late 1950s, see Gail Levin, *Becoming Judy Chicago: A Biography of the Artist* (New York: Harmony Books, 2007), 102–10.

108. Elizabeth A. Sackler, ed., *Judy Chicago* (New York: Watson-Guptill Publications, 2002), 22.

109. Laura Meyer, "From Finish Fetish to Feminism: Judy Chicago's *Dinner Party* in California Art History," in *Sexual Politics: Judy Chicago's* Dinner Party *in Feminist Art History,* ed. Amelia Jones (Berkeley and Los Angeles: University of California Press, 1996).

110. Joan Brown, interview, 1975, California Oral History Project, Archives of American Art, Smithsonian Institution, Washington, D.C.

111. Glueck.

Chapter 5

1. Sabato Rodia has been referred to in the historical literature as both Simon and Sam but I have chosen to use his Italian name. The city of Los Angeles and the Committee for Simon Rodia's Towers in Watts use "Simon."

2. Sarah Schrank, "Picturing the Watts Towers: The Art and Politics of an Urban Landmark," in *Reading California: Art, Image, and Identity, 1900–2000,* ed. Stephanie Barron, Ilene Fort, and Sheri Bernstein (Berkeley and Los Angeles: University of California Press, 2000), 373–86.

3. Sides, 170.

4. George J. Sánchez, " 'What's Good for Boyle Heights Is Good for the Jews': Creating Multiracialism on the Eastside during the 1950s," *American Quarterly* 56, no. 3 (September 2004): 633–61.

5. See ibid.; Sides; Avila; and Lipsitz.

6. Los Angeles County Museum, *Los Angeles History Division 1900–1961,* 53, California file no. 371134, Huntington Library, San Marino, Calif.

7. Avila, 166–67.

8. "L.A. Shows World How to End Slums," *Los Angeles Examiner,* special edition reprint, October 11–12, 1959, California Ephemera Collection 200, box 61, Department of Special Collections, University of California, Los Angeles.

9. See Avila; and Lipsitz.

10. Bud Goldstone and Arloa Paquin Goldstone, *The Los Angeles Watts Towers* (Los Angeles: Getty Conservation Institute, 1997), 84; "Watts Towers Face Threat from Freeway," *Los Angeles Times,* June 5, 1963, 25.

11. Jeanne Morgan, "Rodia's Towers: Nuestro Pueblo, A Gift to the World," in *Personal Places: Perspectives on Informal Art Environments,* ed. Daniel Franklin Ward (Bowling Green, Ohio: Bowling Green State University Popular Press, 1984), 80.

12. Leon Whiteson, *The Watts Towers of Los Angeles* (Oakville, Ontario: Mosaic Press, 1989), 25.

13. Goldstone and Goldstone; Calvin Trillin "I Know I Want to Do Something," *New Yorker*, May 29, 1965, 72–120; Whiteson.

14. Goldstone and Goldstone, 25–28.

15. There is new work on the towers' meaning as an immigrant intervention into the American cultural landscape, particularly that of Teresa Fiore, "Pre-Occupied Spaces: Re-Configuring the Italian Nation through Its Migrations" (Ph.D. diss., University of California, San Diego, 2002).

16. Joe Seewerker and Charles Owens, "Nuestro Pueblo: Glass Towers and Demon Rum," *Los Angeles Times*, April 28, 1939, 2.

17. "Immigrant Builds Towers to Show His Love for U.S.," *Los Angeles Times*, June 8, 1952, A26.

18. *The Towers*, dir. William Hale (Los Angeles: University of Southern California, 1953), film.

19. Richard Cándida Smith, "The Elusive Quest of the Moderns," in *On the Edge of America*, ed. Karlstrom, 32.

20. Banham, 111.

21. *The Towers*.

22. I. Sheldon Posen and Daniel Franklin Ward, "Watts Towers and the Giglio Tradition," in *Folklife Annual 1985* (Washington, D.C.: American Folklife Center at the Library of Congress, 1985), 143–57.

23. Jeanne Morgan, correspondence with the author, August 6, 2005.

24. "Flashing Spires Built as Hobby," *Los Angeles Times*, October 13, 1937, 2.

25. "Immigrant Builds Towers to Show His Love for U.S," *Los Angeles Times*, June 8, 1952, A26; Paul V. Coates, "Confidential File," *Los Angeles Mirror News*, October 4, 1955, 6; Richard Cándida Smith, "The Elusive Quest of the Moderns."

26. Goldstone and Goldstone.

27. Ibid.; Jo Farb Hernandez, "Watts Towers," *Raw Vision* 37 (Winter 2001): 34.

28. Goldstone and Goldstone, 85.

29. "Are They Fine Art or Junk?," *Los Angeles Examiner*, April 3, 1959; "Hearing to Preserve Watts Towers Opens at City Hall," *Los Angeles Examiner*, July 7, 1959; "Watts Towers Pass Safety Test," *Los Angeles Examiner*, October 11, 1959.

30. Goldstone and Goldstone, 92–95.

31. "Are They Fine Art or Junk?"; "Hearing to Preserve Watts Towers Opens at City Hall"; "Watts Towers Pass Safety Test."

32. Committee for Simon Rodia's Towers in Watts, "The Simon Rodia Arts Workshops," 1966, box 2, folder 1, collection 1388, Committee for Simon Rodia's Towers in Watts, Department of Special Collections, University of California, Los Angeles.

33. Letter to Kate Steinitz from Louis Stoumer, April 2, 1959, correspondence folder 4, box 1, collection 1388, Committee for Simon Rodia's Towers in Watts, Department of Special Collections, UCLA.

34. Letter to Kate Steinitz from Frank Waters, April 27, 1959, correspondence folder 4, box 1, collection 1388, Committee for Simon Rodia's Towers in Watts, Department of Special Collections, UCLA.

35. Letter to the Committee for Simon Rodia's Towers in Watts from Richard Neutra, n.d., correspondence folder 4, box 1, collection 1388, Committee for Simon Rodia's Towers in Watts, Department of Special Collections, UCLA.

36. Letter to Mayor Norris Poulson from the Los Angeles Art Association, June 25, 1959, folder 5, box 1, Collection 1388, Committee for Simon Rodia's Towers in Watts, Department of Special Collections, UCLA.

37. Letter to Mayor Norris Poulson from Tri-Arts, Advertising Art and Design, June 25, 1959, folder 5, box 1, collection 1388, Committee for Simon Rodia's Towers in Watts, Department of Special Collections, UCLA.

38. Henry J. Seldis, "NY Art Critic Asks Saving of Towers," *Los Angeles Times*, July 23, 1959, B1.

39. "Sandburg Pleads for Watts Towers," *Los Angeles Times*, July 9, 1959, C7; "Disputed Towers Face Stress Test: Coast Art Lovers Rally to Save Spires Erected over 33-Year Span," *New York Times*, July 26, 1959, 59.

40. Jules Langsner, "Sam of Watts," *Art and Architecture* (July 1951): 25–30; Barbara Jones, *Follies and Grottoes* (London: Constable and Co., 1953), 278; "Un Italiano Nella L.A. Amara," *Architettara* 5 (January 1960): 579; Ulrich Conrads, "Phantastiche architektur Unterstomungen in er arhitektur des 20 jahrhunderts," *Zodiac* (1959): 117–37; John Craven, "Les Tours de Watts," *Connaissance des Arts* 170 (Avril 1966): 110–13.

41. "Flashing Spires Built as Hobby," *Los Angeles Times*, October 13, 1937, 2; Joe Seewerker and Charles Owen, "Nuestro Pueblo: Glass Towers and Demon Rum," *Los Angles Times*, April 28, 1939, 2.

42. Susan Sontag, *On Photography* (New York: Farrar, Straus and Giroux, 1977), 68.

43. Lawrence Alloway in William C. Seitz, *The Art of Assemblage* (New York: Doubleday, 1961), 73.

44. Richard Cándida Smith, "The Elusive Quest of the Moderns," 31.

45. Marylou Luther, "L.A. Has Many Attractions Not Included in Guidebooks," *Los Angeles Times*, March 17, 1960, A1; "Watts Towers Topic of L.A. Art Panel," *Los Angeles Times*, March 13, 1960, 16; Beverly E. Johnson, "The Watts Towers," *Los Angeles Times*, April 24, 1960, L28.

46. Whiteson, 83. The towers were officially designated as a Los Angeles Cultural Heritage Monument in 1963. Their current status as a National Landmark was achieved in 1990.

47. *Committee for Simon Rodia's Towers in Watts*, exhibition catalog, Los Angeles County Museum of Art, 1962, 6.

48. Noah Purifoy quoted in Ronald H. Silverman, "Watts, the Disadvantaged, and Art Education," *Art Education* 19, no. 3 (March 1966): 16–20.

49. Noah Purifoy, *African-American Artists of Los Angeles*, oral history transcript, interview by Karen Anne Mason, Oral History Program, UCLA c. 1992; transcribed interview with Dale Davis, John Outterbridge, Cecil Ferguson on July 29, 1994, John Outterbridge Papers, Archives of American Art, Smithsonian Institution, West Coast Regional Center, Huntington Library, San Marino, Calif.

50. Ibid., 58–63,

51. Committee for Simon Rodia's Towers in Watts, *The Watts Towers*, pamphlet, n.d.

52. Trillin, 107.

53. Purifoy, *African-American Artists of Los Angeles*, oral history transcript, 69.

54. Judson Powell, interview with the author, April 15, 2007.

55. California, Department of Parks and Recreation, Division of Beaches and Parks, *Watts Towers Study: Requested by House Resolution No. 464, Statutes of 1965*, June 1965, 3.

56. Ibid., 3–4.

57. Jeanne Morgan, correspondence with the author, March 7, 2005.

58. Governor's Commission on the Los Angeles Riot, *McCone Commission Report! Complete and Unabridged, December 2, 1965* (Los Angeles, Kimtrex Corp,

1965); Gerald Horne, *Fire This Time: The Watts Uprising and the 1960s* (Charlottesville: University Press of Virginia, 1995).

59. Chester Himes, *The Quality of Hurt: The Autobiography of Chester Himes* (Garden City, N.Y.: Doubleday, 1972), 73–74.

60. Jack Jones, "Visions Point to Park-Like Future for Watts," *Los Angeles Times,* January 17, 1966, A1.

61. Peter Bart, "Center Planned at Watts Towers," *New York Times,* March 20, 1966, 84.

62. Ibid.

63. Jones, "Visions Point to Park-Like Future for Watts."

64. Drawing of the Simon Rodia Community Arts Center, Watts, California, miscellaneous, folder 2, box 1, collection 1388, Committee for Simon Rodia's Towers in Watts, Department of Special Collections, UCLA.

65. Committee for Simon Rodia's Towers in Watts, "The Simon Rodia Workshops," collection 1388, box 2, folder 1, Department of Special Collections. UCLA.

66. "Rodia Towers Art Center Drive Begins," *Los Angeles Times,* August 10, 1966, A2.

67. "Watts Holds 'Dig-in' for Community Art Center," *Los Angeles Times,* June 25, 1967; Governor's Commission on the Los Angeles Riot, *McCone Commission Report.*

68. Lizetta LeFalle-Collins, *Noah Purifoy: Outside and in the Open,* exhibition catalog, California Afro-American Museum Foundation, 1997, 10–11.

69. Art Berman, "Watts Easter Week Art Festival Puts Riot Debris to Cultural Uses," *Los Angeles Times,* April 8, 1966, A1.

70. Joyce E. Widoff, "Out of the Ashes . . . Art and Understanding," *Tuesday,* August 1968, 5–15, Noah Purifoy Papers, Archives of American Art, Smithsonian Institution, West Coast Regional Center, Huntington Library, San Marino, Calif.; Purifoy, *African-American Artists of Los Angeles,* oral history transcript, 70, 138.

71. Thanks to Victoria Holly Scott for pointing out the irony of exporting American ruins to Europe.

72. Thomas Pynchon, "A Journey into the Mind of Watts," *New York Times,* June 12, 1966. The author thanks Brett Mizelle for pointing out the value of this piece for understanding post-1965 views of Los Angeles.

73. Ibid.

74. Jeanne Morgan correspondence with the author, March 7, 2005; "Suit Assails City's Handling of Watts Towers, Calls for Private Ownership," *Los Angeles Times,* October 27, 1978, 8; *Los Angeles Times,* April 24, 1979, 8; "Private Boost for Watts Towers," *Los Angeles Times,* February 22, 1985.

75. Mike Davis, 182–86.

76. Letter to Mae Babitz from the Office of the Mayor, June 28, 1978, correspondence folder 16, box 12, collection 1388, Committee for Simon Rodia's Towers in Watts, Department of Special Collections, UCLA.

77. Keil, 82.

78. It is significant that the city now claims its murals as important emblems of cultural activity and "diversity" or "multiculturalism," particularly since the 1984 Olympics when the Bradley administration commissioned freeway murals as part of its controversial downtown "clean-up." In appropriating murals, the city has acknowledged, even legitimated, the wall as civic space. However, even as the city cleaves art from its politics (this is made obvious by the appalling police murals on the 110 freeway) graffiti writers remind us when they tag offi-

cially civic murals that wall space is at a premium and claims to the exterior wall
are hotly contested, despite city efforts to render murals conflict-free. I am grate-
ful to Marcos Sanchez-Tranquilino for his discussion of the political conflict
between Chicano muralists, representing an "official" form by the late 1970s,
and graffiti artists, who in Los Angeles, remain on the margins. This is useful
for understanding why civic appropriation of the mural form attracts so much
attention from taggers throughout the city. See Marcos Sanchez-Tranquilino,
"Space, Power, and Youth Culture: Mexican American Graffiti and Chicano
Murals in East Los Angeles, 1972–1978," in *Looking High and Low: Art and Cul-
tural Identity*, ed. Brenda Jo Bright and Liza Bakewell (Tucson: University of Ari-
zona Press, 1995), 55–88.

79. "Save the Watts Towers," *Los Angeles Herald Examiner*, April 22, 1985, 1.
80. Davis, 78.
81. Charles Mingus, *Beneath the Underdog: His World as Composed by Mingus*, ed.
Nel King (New York: Knopf, 1971).
82. See California State University, Long Beach, Department of Special Col-
lections and University Art Museum.
83. Tricia Rose, *Black Noise: Rap Music and Black Culture in Contemporary
America* (Hanover and London: Wesleyan University Press, 1994), 2.
84. *Colors*, dir. Dennis Hopper, Orion Pictures, 119min, 1988.
85. *Ricochet*, dir. Russell Mulcahy, Silver Pictures, 105min, 1991.
86. Tyrese, *2000 Watts*, RCA Records, 2001.
87. Levi's advertisement, *The Big Issue* (Summer 1999): 20–21.
88. Community Redevelopment Agency of the City of Los Angeles, Watts
Redevelopment Project Biennial Report, November 4, 1991, John Outterbridge
Papers. Archives of American Art, Smithsonian Institution, West Coast Regional
Center, Huntington Library, San Marino, Calif.
89. William Fulton, *The Reluctant Metropolis: The Politics of Urban Growth in Los
Angeles* (Baltimore: Johns Hopkins University Press 2001), 297.
90. James Woods cited in Daniel B. Wood, "Activists Build Culture from the
Ground Up," *Christian Science Monitor*, June 8, 1992, 9.
91. Matea Gold, "A New Watts Awaits Visit by President," *Los Angeles Times*,
July 7, 1999, A1; Steve Schmidt, "Watts Shows off New Look, Tourists Invited to
Site of '65 Riots," *San Diego Union-Tribune*, August 29, 1999, A3; Paul Chavez,
"Promises Linger in Watts: Despite Federal Pledge to Help, Area Still a Blight,"
San Diego Union-Tribune, November 4, 1999, A3.
92. Jennifer Kelleher, "In Watts, Towers Stand for Hope," *San Diego Union-
Tribune*, September 27, 2001, E1.

Conclusion

1. Peter Selz, *Art of Engagement: Visual Politics in California and Beyond* (Berke-
ley and Los Angeles: University of California Press, 2006).
2. Claudine Isé, "Considering the Art World Alternatives: LACE and Commu-
nity Formation in Los Angeles," in *The Sons and Daughters of Los: Culture and Com-
munity in L.A.*, ed. David E. James (Philadelphia: Temple University Press, 2003),
93; Chon Noriega, "From Beats to Borders: An Alternative History of Chicano
Art in California," in *Reading California: Art, Image, and Identity, 1900–2000*, ed.
Stephanie Barron, Ilene Fort, and Sheri Bernstein (Berkeley and Los Angeles:
University of California Press, 2000), 361–63.
3. Sanchez-Tranquilino, 55–88.

4. Catherine Grenier, ed., *Los Angeles 1955–1985: Birth of an Art Capital* (Paris: Éditions de Centre Pompidou, 2006).

5. David Harvey, *Spaces of Hope* (Berkeley and Los Angeles: University of California Press, 2000), 168.

6. Elizabeth H. Ondaatje and Kevin F. McCarthy, "A Vision for the Arts in Los Angeles," RAND Corporation, 2007, 1.

7. Ibid., 4.

Index

Acknowledgments

While writing this book I accumulated staggering intellectual and emotional debts. Brief mentions are inadequate repayment but they are a start, and I have looked forward to writing these acknowledgments for some time. I am grateful to a long list of institutions, colleagues, and friends who have supported the book from the beginning.

Much of the first full draft of *Art and the City* was written during the 2004–5 academic year while I was a fellow at the Shelby Cullom Davis Center for Historical Studies at Princeton University. I drew ideas and inspiration from the weekly seminars and colloquia, and I am extremely grateful for the opportunity to spend a year working closely with Gyan Prakash, Kevin Kruse, Sheila Crane, David Frisby, Pamela Long, Frank Mort, Martin Murray, and Jordan Sand, each of whom played a part in shaping the manuscript. Financial support also came from the Huntington Library, the Historical Society of Southern California, and the John Randolph Haynes and Dora Haynes Foundation. I am grateful to California State University, Long Beach, for its support of the book through Scholarly and Creative Activities Committee awards that reduced my course load and allowed me to write while teaching and performing professional service. I would also like to thank the California State University, Long Beach, Department of History and the College of Liberal Arts for providing financial assistance to help offset the expense of copyright clearances. My colleagues in history, American studies, and across the university have been generous with their time and their help. I offer them my heartfelt thanks.

At the University of California, San Diego, Rachel Klein, Michael Bernstein, Becky Nicolaides, David Gutiérrez, Susan Smith, Derrick Cartwright, Susan Davis, and Michael Davidson were important intellectual influences. Ryan Moore, René Hayden, Christina Jiménez, Alberto Loza, Eric Boime, Krista Camenzind, Mark Wild, Phoebe Kropp, and Susan Fitzpatrick Behrens have been supportive friends and helpful readers of my work. I would also like to thank George Lipsitz, who has shaped so much of my thinking, and that of my colleagues, about collective memory and the historical relationships between social struggle and American culture.

I am especially grateful to Bill Deverell for building a wonderful community of scholars through The Huntington-USC Institute on California and the West. Bill's energy and brilliant scholarship inspires everyone who comes in contact with it, and the field of Los Angeles history has flourished because of his efforts. My work has benefited tremendously from the feedback of the Los Angeles Research Group. Clark Davis, Mike Willard, Natalia Molina, R. J. Smith, and Anthony Macías provided useful comments early in the project.

Portions of *Art and the City* have appeared elsewhere. Many thanks to Raúl Villa and George Sánchez for including my work in the *American Quarterly* 56, no. 4 (September 2004) special issue and the reprinted volume, *Los Angeles and the Future of Urban Cultures* (Baltimore: Johns Hopkins University Press, 2005). Chapter 5 is a version of an article that originally appeared in *Reading California: Art, Image, and Identity, 1900–2000*, edited by Stephanie Barron, Sheri Bernstein, and Ilene Fort (Berkeley and Los Angeles: LACMA and the University of California Press, 2000). Other ideas and prose have been published in "*Nuestro Pueblo*: The Spatial and Cultural Politics of Los Angeles' Watts Towers," in *The Spaces of the Modern City: Imaginaries, Politics, and Everyday Life*, edited by Gyan Prakash and Kevin Kruse (Princeton, N.J.: Princeton University Press, 2008). Sections of Chapter 1 appeared in *Varieties of Urban Experience: The American City and the Practice of Culture*, edited by Michael Ian Borer (Lanham, Md.: University Press of America, 2006). All of these works are reprinted with permission.

One of the most challenging tasks in the production of *Art and the City* was the securing of photographs and artwork and the accompanying permissions to reproduce them. I would like to thank the following for their help, time, and generosity: Kristine McKenna; Cheryle T. Robertson and Piper Wynn Severance at the Rights and Reproductions Department, Los Angeles County Museum of Art; Betty Uyeda, Seaver Center for Western History Research; Carolyn Cole and Bettie Webb of the Los Angeles Public Library; Pilar Castillo, Social and Public Art Resource Center; Elizabeth East and Melissa Tolar, L.A. Louver; Andrea Mihalovic-Lee, Visual Arts and Galleries Association; Thierry Demont, Demont Photo Management; Jane Fujimoto, Getty Conservation Institute; Peter Mays and Sinéad Finnerty, Gallery 825; Wendy and Billy Al Bengston; Simon Elliot, Department of Special Collections, University of California, Los Angeles; Sue Welsh of the Noah Purifoy Foundation and Joshua Tree Desert Museum; Lou Jacobs, Jr; Dace Taube, Doheny Memorial Library, University of Southern California; Kathryn and Dan Winters; Jo Farb Hernandez, SPACES; Glenn Bassett of the Mabel Alvarez Estate; and Nancy Reddin Kienholz.

As all historians know, we would not make much progress without the

help of librarians and archivists who know their institutions inside and out. I wish to thank Jay Jones of the Los Angeles City Archives; Dace Taube of the Regional History Center, University of Southern California; Kristie French, Department of Special Collections, California State University, Long Beach; Eric Merrell, California Art Club; and Ann Caiger, Jeff Rankin, and Octavio Olvera, Department of Special Collections, University of California, Los Angeles. My research was further aided by the staffs of the Archives of American Art in San Marino and Washington, D.C.; the Huntington Library; and the Arts Library at the University of California, Santa Barbara.

Without the help of many of the artists and activists about whom I write, I could never have completed this book. Seymour Rosen offered up his archives and photocopier, and I wish he had lived to see this project completed. Longtime members of the Committee for Simon Rodia's Towers in Watts, Bud Goldstone and Jeanne Morgan, read and commented on early drafts while Mike Cornwell offered much needed perspective on Los Angeles' contemporary municipal art politics. Billy and Wendy Al Bengston read an early version of my Ferus Gallery chapter, offering creative support and allowing me to use Billy's work in my book. I am grateful for interviews I conducted with Marv Grayson, June Wayne, and Noah Purifoy, who shared his art with me at his home in Joshua Tree. Joan-Claire Kleihauer generously spent an afternoon explaining her career at the Watts Towers Art Center and Barnsdall Park, and Judson Powell helped by being a phone call away whenever questions arose. Judson was a source of wisdom and an example of grace, and I appreciate the time he took to share his artwork and his experience with me.

Many readers and colleagues have helped with the writing and editing. My editor, Robert Lockhart, has been a model of patience as he diligently read multiple chapter drafts and helped me with every stage of the publication process. Bob saw potential in my early work, and I am grateful for his support. I must thank Richard Cándida Smith, whose lengthy and insightful comments went far beyond a typical reader critique and have been essential to the manuscript's revision. I also thank Nicholas Dagen Bloom, whose comments proved very helpful indeed. Pat Coate's meticulous reading and skilled expertise made copyediting a productive experience. Christina Cleary translated David Alfaro Siqueiros's papers from Spanish, and Eileen Luhr offered substantive editorial suggestions that made my conclusions far richer.

I am lucky to have good friends who have made important contributions to the book through their generosity of spirit and fine sense of humor. Caitlin Pepperell, Lori Seay, Marni Zatzman, and Victoria Scott have always offered highly valued perspectives while Eric Avila cheered me on when I felt overwhelmed. Many thanks to Leonard Moore and

Max Dorsinville, my mentors from McGill University, for expressing early confidence in me. Patricia Cleary, Houri Berberian, Tim Keirn, Kathleen DiVito, Vincent Del Casino, Catherine Brooks, Sean Smith, and Amy Bentley-Smith frequently provided emotional and intellectual support and wine. Brett Mizelle's boundless enthusiasm for discovering the new and unusual provides daily reminders of the joy to be found in small things. His generosity, energy, and smart insights have made me a better scholar, a better traveler, and a better person. Brett is a brilliant reader, and I am grateful for his editing assistance and loving companionship.

My family has lived with *Art and the City* as long as I have. My parents, Bill and Bernice, are much-relied-upon authorities on all things and are fonts of love, inspiration, and intellectual guidance. I have benefited tremendously from astute and savvy advice gleaned from their own scholarship and their many years spent in the trenches of academic activism. My brother, Joe, and my sister, Rachel, always offer encouragement and the protective net of collective memory and personal history that only siblings can provide and upon which I frequently rely. I dedicate this book to my family.